TYPOGRAPHY 27

COLLINS | DESIGN

An Imprint of HarperCollins*Publishers*

TYPOGRAPHY 27

THE ANNUAL OF THE TYPE DIRECTORS CLUB

HarperCollins books may be purchased
for educational, business, or sales
promotional use. For information,
please write: Special Markets
Department, HarperCollins Publishers,
10 East 53rd Street,
New York, NY 10022.

First Edition

First published in 2006 by:
Collins Design
An Imprint of
HarperCollins*Publishers*
10 East 53rd Street
New York, NY 10022
Tel: (212) 207-7000
Fax: (212) 207-7654
collinsdesign@harpercollins.com
www.harpercollins.com

Distributed throughout the world by:
HarperCollins*Publishers*
10 East 53rd Street
New York, NY 10022
Fax: (212) 207-7654

Library of Congress Control Number:
2006926986

ISBN-10: 0-06-114423-1
ISBN-13: 978-0-06-114423-3

Printed in China
First Printing, 2006

ACKNOWLEDGMENTS

The Type Directors Club gratefully
acknowledges the following for their
support and contributions to the
success of TDC52 and TDC2 2006:

Design: Andrew Kner
Associate Designer: Michele L. Trombley
Cover photographer: Isidore Seltzer
Editing: Susan E. Davis

Judging Facilities: Fashion Institute
of Technology
Exhibition Facilities: The One Club
Chairpersons' and Judges' Photos:
Christian DiLalla

TDC52 Competition (call for entries):
Design: Andrew Kner
Associate Designer: Michele L. Trombley
Photographer: Isidore Seltzer
Printer: Anderson Lithograph
Paper: Smart Paper
Prepress Services:
A to A Graphic Services, Inc.
TDC2 2006 Competition
(call for entries):
Design: Ilene Strizver

The principal typefaces used in the
composition of *Typography 27* are:
Futura Light and Futura Book,
ITC Garamond Condensed Book,
and Latin MT Condensed

Carol Wahler
Executive Director
TYPE DIRECTORS CLUB
127 West 25 Street, 8th Floor
New York, NY 10001

212-633-8943
212-633-8944 fax
www.tdc.org
director@tdc.org

Produced by Crescent Hill Books

Contents

TDC Chairman's Statement

Diego Vainesman

Born in Argentina, Diego Vainesman is the senior art director at MJM Creative Services, Inc. in New York City. HIs list of clients ranges from global corporations such as Canon, IBM, Pfizer to nonprofit organizations such as Congregation B'nai Jeshurun and PS 158. His work has included logos, corporate identities, promotional materials, collateral materials, signage, videos, books, CDs, and interactive media. Diego is also the New York correspondent for tipoGráfica, *the leading typographic magazine in South America, and he has taught at Pratt and Parsons School of Design. Diego is the co-editor/designer of* Letterspace, *the TDC newsletter, and was the designer of* Typography 25.

As we celebrate the 60th anniversary of the Type Directors Club, the winning pieces featured in this annual represent the highest standards of typographical excellence as established by the TDC over the years.

From hand-set foundry type to machine composition, through photo- and computer-generated images, it is, however, the skills and sensitivity of the typographers/craftspeople/designers that establish the standards by which the aesthetics of these wonderful abstract shapes we call letters are judged.

To the typographers/craftspeople/designers who submitted work to the competition, to the people who contributed their talent and time, to the judges who patiently reviewed the thousands of entries, and to our crew of volunteers: Thank you. To the winners: Congratulations.

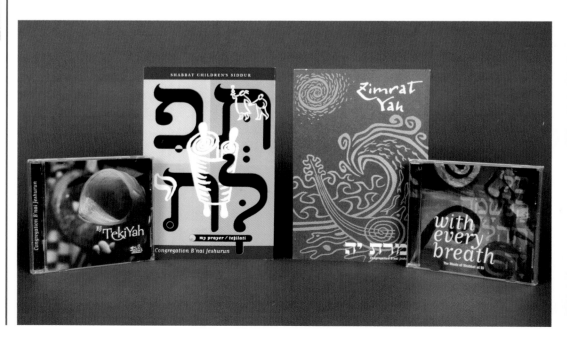

TDC52 JUDGES

Andy Altmann

Andy Altmann graduated in graphic design from the Royal College of Art in 1987 and almost immediately formed the multidisciplinary design group Why Not Associates with fellow graduates David Ellis and Howard Greenhalgh. Located in London, Why Not Associates gained an international reputation based on its creative and experimental approach. Over the past 18 years they have worked on projects ranging from exhibition design to postage stamps and done designs for advertising, commercials, corporate identity, publishing, and television titles. Their clients include Channel 4, Malcolm McClaren, Nike, the Royal Academy of Arts, the Royal Mail, Paul Smith, and Virgin Records.

A book was published in 1998 by Booth-Clibborn Editions documenting the first ten years of their work. A second was published in 2004 by Thames and Hudson which documented another five years. Andy, David, and Howard still strive to push the boundaries of graphic design. More recent projects collaborating with artist Gordon Young have moved them into the world of public art.

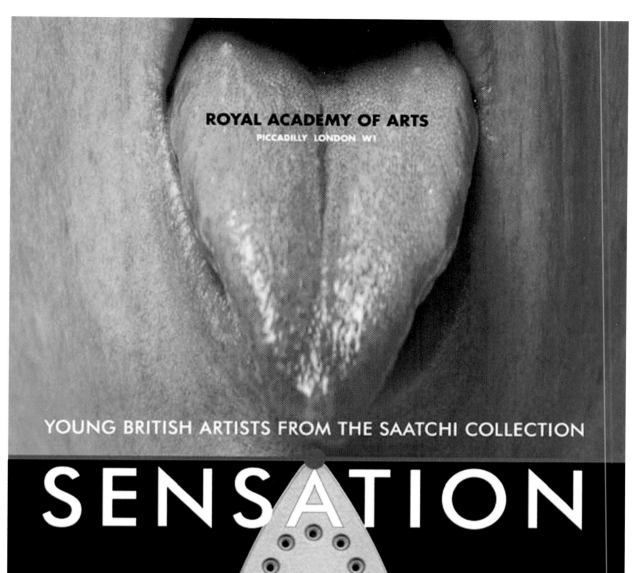

ROYAL ACADEMY OF ARTS
PICCADILLY LONDON W1

YOUNG BRITISH ARTISTS FROM THE SAATCHI COLLECTION

SENSATION

18 SEPTEMBER – 28 DECEMBER 1997
CLOSED 25 DECEMBER
OPEN DAILY 10AM-6PM

Mike Joyce

Mike Joyce is the founder of Stereotype Design in New York City and was formerly an art director at MTV Networks. Before that, he was the creative director at Platinum Design. He has designed CD packaging for established artists and upstarts, from Iggy Pop and Natalie Merchant to Fall Out Boy and Robbers on High Street. Mike has also designed countless T-shirts for bands like The All American Rejects, Maroon 5, and The Strokes and has produced books for Tony Hawk and KISS.

Stereotype's work has been featured in such publications as *Communication Arts, Coupe, HOW, IdN, New York Magazine, Plus 81, Print,* and *Rolling Stone*. Mike has designed exhibitions for the AIGA 365, the Art Directors Club's first Young Guns show, the One Show, and the Type Directors Club. His work is included in the Permanent Collection of the Library of Congress. In 2004 Mike was selected to co-chair the Art Directors Club's Young Guns 4. The following year he licensed a line of typographic T-shirts to the design-driven clothing company 2K. Mike also teaches typography and design to third- and fourth-year students at the School of Visual Arts.

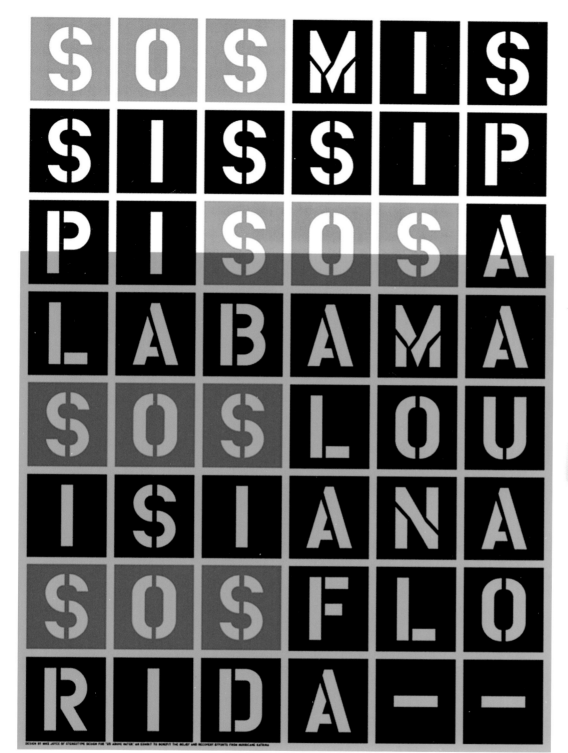

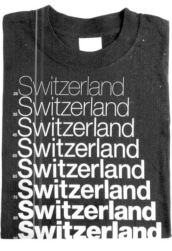

Alexa Nosal

Alexa Nosal studied communication design at Parsons School of Design and the Fashion Institute of Technology in New York City after receiving degrees in fine arts and economics. She worked in partnership with Martin Solomon from 1983 to 2006. Together they developed a diverse collection of internationally recognized work, including corporate identities, fine press books, posters, promotional material, and typeface designs. She continues her graphic career as an independent designer.

Alexa currently teaches typography and design at the Fashion Institute of Technology and Parsons School of Design. She was honored to receive the first University Teaching Award presented by New School University.

Alexa presents national and international typography and design workshops, the latest a training session for the U.S. Government Printing Office in 2006. She lectured at Altos de Chavon Design School in the Dominican Republic from 1998 to 2003; was the keynote speaker at Grandestypos, a typographical seminar sponsored by the Instituto Superior Comunicacion Visual in Rosario, Argentina, in 2001; participated in Los Secretos del Diseño Grafico Exitoso, an international conference held in Santo Domingo in 2002; and presented a three-day workshop at the II Encuentro Internacional de Enseñanza del Deseño sponsored by the Instituto Superior Deseño Industial in Havana, Cuba, in 2003.

Alexa writes articles about design and typography, including those published by *a! Diseño, Between, Japan, Mexico,* and the Argentine publications *Suma+* and *tipoGráfica*. She also serves on the *tipoGráfica* advisory board.

Emily Oberman

Emily Oberman, a graduate of Cooper Union, founded Number Seventeen in the summer of 1993 with her partner Bonnie Siegler. The company is a multidisciplinary design firm working in television, film, print, products, and the web.

Some of their recent work includes designing the newly reinvented *Colors* magazine, creating the identity and advertising for Air America Radio, the advertising and design for New York's River-to-River Festival, and the identity and packaging for a new line of modern organic baby food called Homemade Baby. They have also designed books for *In Style Magazine*, "Will & Grace," and "Desperate Housewives." Other clients include Condé Nast, HBO, Hyperion, The Maritime Hotel, The Mercer Hotel, the MGM Grand in Las Vegas, MTV, NBC, Nickelodeon, and "Saturday Night Live."

Before starting Number Seventeen, Emily was a senior designer at Tibor Kalman's wonderful, crazy design studio, M&Co. She recently concluded a two-year stint as president of the New York Chapter of the American Institute of Graphic Arts; before that she served on its national board for three years. In 2004 Emily was chosen for the Augustus St. Gaudens Award for Alumni of the Year by Cooper Union.

In her spare time, Emily teaches design for television at Cooper Union and is a visiting critic for the Yale University Graduate Design Program.

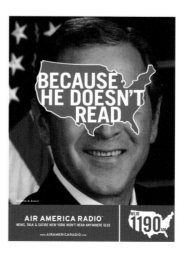

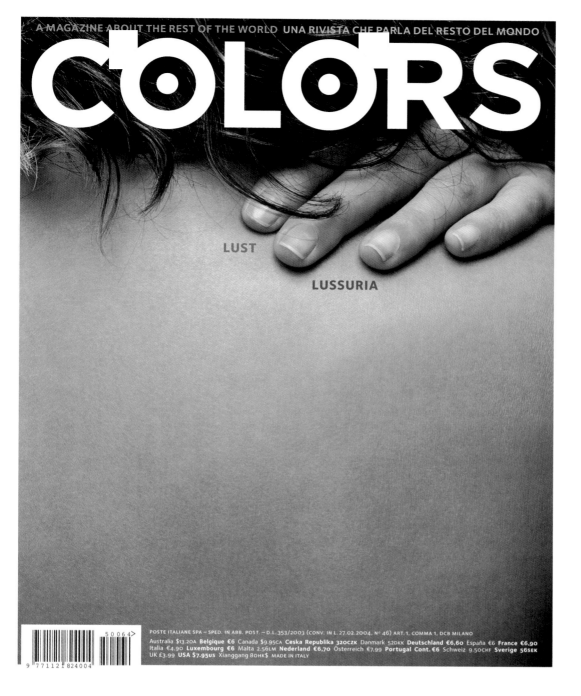

COLORS

LUST

LUSSURIA

POSTE ITALIANE SPA — SPED. IN ABB. POST. — D.L.353/2003 (CONV. IN L.27.02.2004, N° 46) ART.1, COMMA 1, DCB MILANO

Australia $13.20A **Belgique €6** Canada $9.95CA **Ceska Republika 320CZK** Danmark 52DKK **Deutschland €6,60** España €6 **France €6,90** Italia €4,90 **Luxembourg €6** Malta 2.56LM **Nederland €6,70** Österreich €7,99 **Portugal Cont. €6** Schweiz 9.50CHF **Sverige 56SEK** UK £3.99 **USA $7.95US** Xianggang 80HK$ MADE IN ITALY

Woody Pirtle

Woody Pirtle established Pirtle Design in Dallas in 1978. Over the next 10 years the firm produced some of the most important and celebrated work of the decade for a broad spectrum of clients. In 1988 Woody merged Pirtle Design with Pentagram, the international design consultancy founded in London in 1972. For nearly 20 years as a partner in Pentagram's New York office, Woody worked on some of the firm's most prestigious projects for many of its A-list clients. In 2005 Woody left Pentagram to re-establish Pirtle Design.

Today, Pirtle Design continues to provide unparalleled design and consulting services that run the gamut of business and cultural endeavors while producing work for a broad range of national and international clients. Because of its simple structure and lean profile, Pirtle Design is able to retain the entrepreneurial spirit and creative freedom necessary for producing fresh, original work, while continuing to receive interdisciplinary support from the partners and staff at Pentagram. The firm's organization assures the best of both worlds for clients: like a small private firm, Woody is intimately involved with the design work and communicates directly with the client; like a large international firm, the office maintains a sophisticated support structure and a wide network of professional resources.

Recent projects include identity and website redevelopment for the international law firm, Wachtel Lipton Rosen & Katz; design development of architectural and graphic components for The William Stafford Center in Portland, Oregon; and identity and/or signage programs for the American Folk Art Museum, Amnesty International, Brooklyn Ballet, Callaway Golf, international publisher Graphis, the Hudson Valley Preservation Commission, Rizzoli International, and the Virginia Museum of Fine Art.

Woody's work has been exhibited worldwide and is in the permanent collections of the Cooper-Hewitt Museum and Museum of Modern Art in New York, the Neue Sammlung Museum in Munich, the Victoria & Albert Museum in London, and the Zurich Poster Museum. Woody has taught at the School of Visual Arts, lectured extensively, is a member of the Alliance Graphique Internationale, and has served on the board of the American Institute of Graphic Arts (AIGA) and *HOW* magazine. In October 2003 he was awarded the prestigious AIGA Medal for his contribution to the design profession.

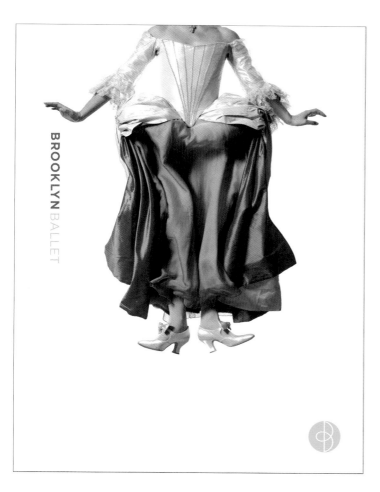

BROOKLYN BALLET

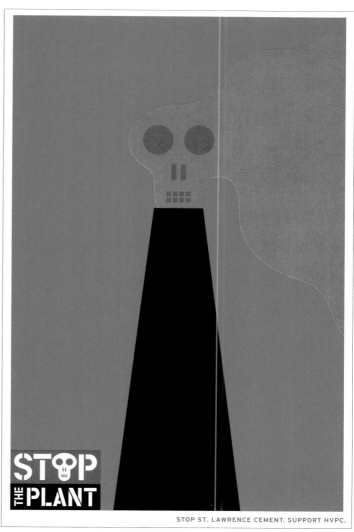

STOP THE PLANT

STOP ST. LAWRENCE CEMENT. SUPPORT HVPC.

Steve Sandstrom

Steve Sandstrom is creative director and partner of Sandstrom Design in Portland, Oregon. Clients have included Adidas, Converse, Coca-Cola, The Cost Vineyard, ESPN, Fiskars, Full Sail Brewing, Levi Strauss & Co., Marriott, Microsoft, Miller Brewing, Nike, Nissan, Seagrams, Sony Pictures, Steppenwolf Theatre, Tazo Tea, and Virgin Mobile. Advertising agency relationships have included GSD&M, JWT, McKinney, Ogilvy & Mather, Publicis, TBWA/ChiatDay, Wieden-Kennedy, and Young & Rubicam. Prior to founding Sandstrom Design in November 1988, Steve was a senior art director at Nike, responsible for brand image and collateral materials for the apparel division.

Steve's firm has been featured in several publications, including *Adweek, @Issue, Communication Arts, Creativity, Critique, Graphis, HOW, Novum* (Germany) and in numerous books on design, packaging, and corporate identity. Steve was integrally involved with the creation of Tazo, an eclectic premium tea brand, and the development of its brand personality. He was primarily responsible for Tazo's award-winning packaging and general design aesthetic. Tazo is the number one brand in natural foods sales in the United States.

Steve has won numerous design and advertising awards, including Andys, Beldings, Clios, and Kellys, and those given by the American Advertising Federation, *Communication Arts,* D&AD (London), *Graphis* Top Ten in Design, *I.D.* magazine, London International Advertising, the New York Art Directors Club, The One Show, and the Type Directors Club. In 1994 he was the youngest to be honored as Advertising Professional of the Year by the Portland Advertising Federation. He also won a Blue Ribbon at the 1961 Oregon State Fair for a crayon drawing of a cow.

Steve serves on the board of directors for The One Club; is a board member for BodyVox, an acclaimed contemporary dance group; and is currently president of the Portland Advertising Federation—the first designer elected to that position in its 100-year history. Steve also serves on the Board of Visitors for the University of Oregon School of Architecture and Allied Arts.

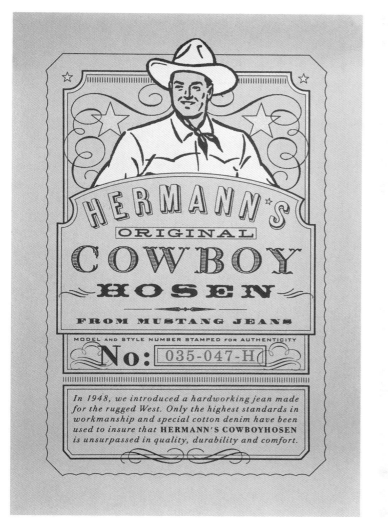

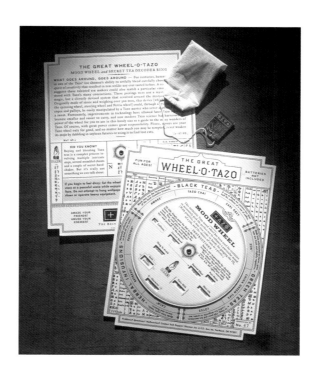

Brady Vest

Brady Vest is the owner and founder of Hammerpress, a letterpress and design studio located in Kansas City, Missouri. Since graduating from the Kansas City Art Institute with a BFA in printmaking in 1994, Brady Vest and Hammerpress have churned out tons of posters, CD packages, postcards, promotional pieces, books, and many other types of print-candy. From the very first projects for mysteriously legendary rock bands such as Quitters Club and Giants Chair to more recent and strangely varied design and print jobs for clients, ranging from Houlihan's Restaurants and Domino Records to wedding invitations for Kansas City's tasteful newlyweds-to-be, Brady Vest and his Hammerpress robots have continued to create a body of work that has a strong connection to traditional typography and the craft of letterpress while presenting it in a new and unusual way. Top five favorite things are (in no particular order): chocolate, beer, Lindsay Laricks, steel guitars, and run-on sentences.

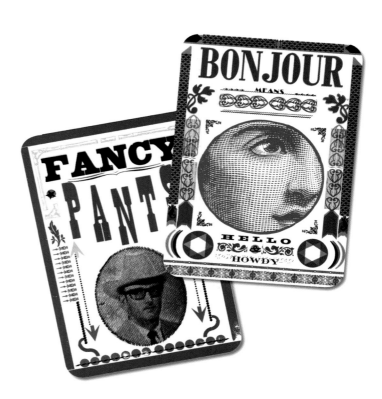

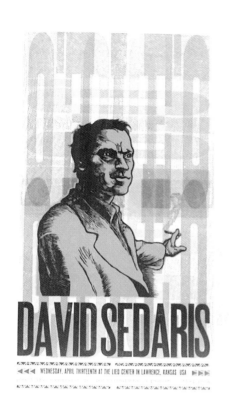

DAVID SEDARIS

WEDNESDAY, APRIL THIRTEENTH AT THE LIED CENTER IN LAWRENCE, KANSAS USA

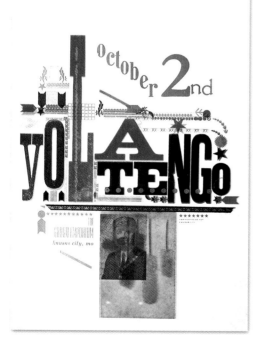

october 2nd

yo LA TENGo

THE GRANADA EMPORIUM
kansas city, mo

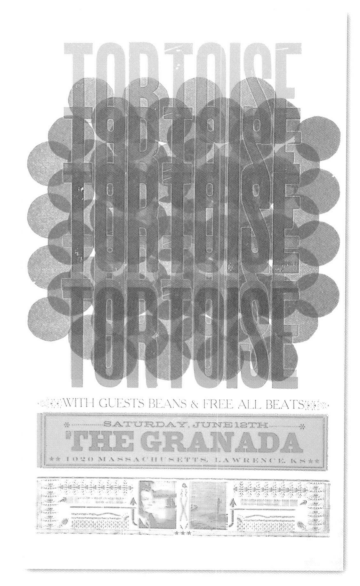

TORTOISE

WITH GUESTS BEANS & FREE ALL BEATS

SATURDAY, JUNE 12TH
'THE GRANADA
1020 MASSACHUSETTS, LAWRENCE, KS

TDC52 JUDGES' CHOICES AND DESIGNERS' STATEMENTS

Andy Altmann | JUDGE

The first thing that attracted me to these posters was obviously the beautiful, powerful imagery of the distorted roses, not the typography. But on closer observation the letterforms of the verse appeared to be constructed from dots created from the rose imagery. This seemed to be a very sympathetic way of combining the text and the image.

When all the posters were laid out on the floor for us to judge, I then had to go down on my hands and knees to take a closer look. It was at this point that the true subtlety of the typography appeared. The letterforms of the title of the exhibition were again constructed from dots, but this time they were actually punched through the paper. This was fantastic attention to detail, but I am sure that it will be imperceptible when reproduced in this book, so you will just have to take my word for it! But I'm glad I took the time and trouble to crawl around a dusty university floor in the name of typography

Hideki Nakajima | DESIGNER

I created this poster for "Seven Exhibition" curated by Benny Au from Hong Kong. The image of roses is based on work I created for the German magazine *032c*. Following creative director Joerg Koch's suggestion, I quoted a verse from "The Inner Rose" by Rainer Maria Rilke. My primary challenge was to express "sensuality and beauty."

Roses have been the motif in so many creators' works in the past and will keep attracting people in the future. It seems that my turn has come, and now I am really into the beauty of roses. I created the font for the verse with dots. I feel honored to receive this prestigious award.

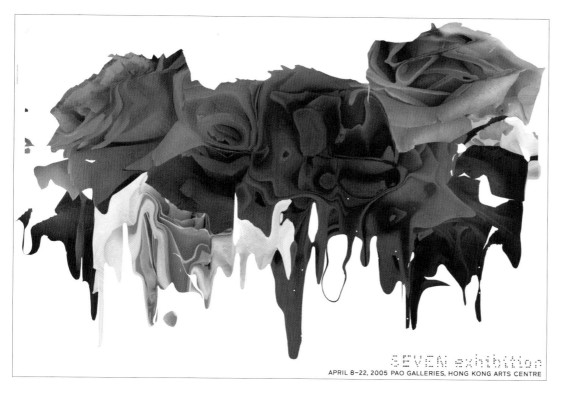

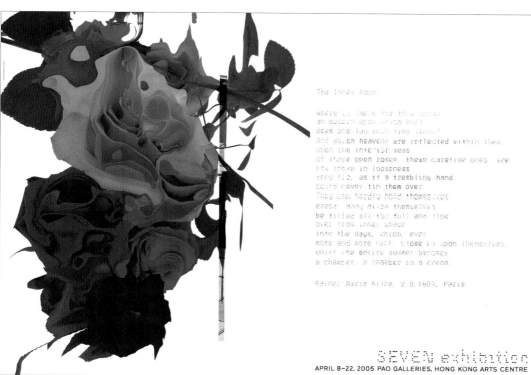

DESIGN
Hideki Nakajima
Tokyo, Japan

ART DIRECTION
Hideki Nakajima

DESIGN OFFICE
Nakajima Design Ltd.

CLIENT
Hong Kong Art Centre

PRINCIPAL TYPE
Custom

DIMENSIONS
57.3 x 40.6 in.
(145.6 x 103 cm)

Mike Joyce JUDGE

For me, this enormous poster is what the TDC Annual is all about—*all type!* At first glance it's an explosion of fragmented typographic elements, but then you quickly realize it's something more. It's a city street plan and a skyline all in one—a well-constructed, meticulously assembled mass of characters lining up and locking up to create a structure with heart—literally. Fernando Távora would be proud.

Lizá Defossez Ramalho and Artur Rebolo DESIGNERS

We were asked to create an image for an event that paid tribute to the architect Fernando Távora, who died recently. The title "I Love Távora" came from a slogan that he himself used on a T-shirt when he was a teacher at the Oporto Fine Arts School. It reflects the feeling that one has today about the architect and his work.

Without using any photographs of Fernando Távora or any of his designs, we wanted to create a poster that would evoke the modernist and humanist strands that characterize his work. In the project we developed, the text and image blend, forming an organic mass, suggesting an urban plan within which you can "read" a heart.

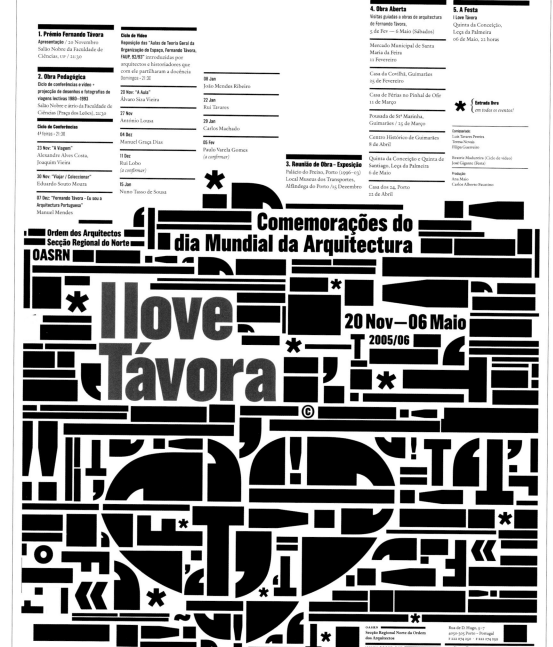

Alexa Nosal JUDGE

The diverse array of visual directions represented in this TDC competition was an obvious reminder of how dynamic and exciting our graphic world is. Many different design styles got my attention and my vote. Yet, what attracted me to the Max Bill book were qualities akin to my own design philosophy.

One theme that is central to my philosophy is the concept of totality. The strength of this book lies in its conception and execution as a unified product. The front cover with its large, black, singular statement, "bill," aptly begins the book. This visual transforms into a flowing stream of vividly colored words that lead to the table of contents. Here, the reader pauses to recap what proceeded and prepare for what will come. The ensuing text pages are a wonderful contrast of bold and light, large and small typography. The grid structure is classic, yet contemporary, with an aesthetic sensitivity to the period in which Bill worked. Each of the text sections and their corresponding illustrations are linked together by reintroducing the cover's typographical statement. The book then ends as it visually began: cover and contents projecting a cohesive visual direction.

The book's design demonstrates a particular sensitivity to the interplay among the elements. The calculated relationship of space and typography makes the book very readable. The typography, set in Monotype Grotesque, composed in all lowercase, is exact in its details. The design is clean, uncluttered by superficial inclusions. The clear structure of the book supports the verbal and illustrative contents, enabling the reader to concentrate on each element without competition from the other items on the spread. This is extremely appropriate to the book's function, showcasing the work of Max Bill.

The Max Bill book is a successful harmony of aesthetic and function. My compliments to the designers on a job well done.

Sascha Lobe and Ina Bauer DESIGNERS

Max Bill wrote in 1937: "Typography is the design of a space that results from function and matter. The determination of function, the choice of matter, the interconnection with the order of space, are the tasks of the typographer.... Typography can be used in very different ways. The simple solution however most closely corresponds to its innermost nature...."

For us, 70 years after his typographical main works, designing a Bill catalog doesn't mean imitating Bill's design concept, but translating it into a contemporary form.

For the differentiation of text pages and picture pages we chose different types of paper, and within the layout we developed a clear, strongly structured typography with distinct contrasts in size and type style. The breadth of Bill's work as painter, designer, sculptor, and architect is expressed in large-sized lines of writing that, in the book introduction, run off the page format and are cited in the individual chapters as introductions or closings.

bill, itekt, desig

max bill
die unendlichkeit als plastisches thema

in der «kontinuität» habe ich versucht, eine seit langem in mir schwebende idee zu realisieren, die darstellung eines unendlichen raumes in unendlicher bewegung. ursprünglich – es war im jahr 1935 – hatte ich eine elementarere plastik gemacht, in der ähnliches ausgedrückt war: die «unendliche schleife». später stellte es sich heraus, dass jene plastik in formal ausgewogener, künstlerisch interpretierter form das in der mathematik bekannte möbius-band darstellte. in der folge beschäftigte ich mich mit den darin realisierten problemen, die ausserordentlich spannend sind. jene plastik besteht aus einem überall gleich breiten band, dessen kanten also parallel sind. scheinbar ist es also eine zweiseitige fläche, die durch parallel laufende linien aus dem sie umgebenden raum abgetrennt ist und einen neuen raum bildete. das phänomen dieses «körpers» ist jedoch, dass diese neue raumbildende fläche nur eine einzige seite hat und dass die scheinbar parallelen zwei linien in wirklichkeit nur eine einzige linie ist, also eine linie, die mit sich selbst parallel läuft! seither habe ich einige solche «doppelflächner» gemacht, die nur eine einzige fläche und nur eine einzige begrenzungslinie aufweisen

und in ihrer formulierung weit über jene erste «unendliche schleife» hinausgehen.
in der «kontinuität» beabsichtigte ich etwas ähnliches zu erreichen: eine fläche, eine begrenzung, rein theoretisch hätte aus einem zwillingsband, das zwei mal ein halbes mal um sich selbst gedreht ist und verwachsen ist mit einem solchen, das nur ein halbes mal gedreht ist, eines ergeben sollen, das ähnlich der unendlichen schleifen nur eine fläche und eine begrenzung aufweist. aus mir unbekannten gründen ist das nicht zustande gekommen, so besteht also die «kontinuität», trotz dem theoretisch anders erwarteten ergebnis, aus zwei parallel begrenzten flächen, bestehend aus unendlich vielen geraden. diese erläuterung liest sich vielleicht ein wenig trocken und primitiv, und doch ist es das einzige, das ich selbst darüber aussagen kann. ich kann aber noch weiter erklären, dass für mich eine solche plastik etwas darstellt wie ein knoten im raum», ein konzentrationspunkt verschiedener latent vorhandener richtungen, und dass durch ihre existenz der raum geordnet, neu geformt, ihm ziel und richtung gegeben werden. [...]

grafil

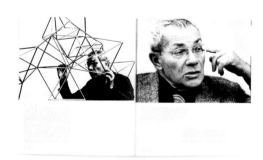

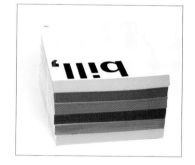

CATALOG
DESIGN
Sascha Lobe and Ina Bauer
Stuttgart, Germany

CREATIVE DIRECTION
Sascha Lobe

DESIGN OFFICE
L2M3 Kommunikationsdesign GmbH

CLIENT
Institut für Kulturaustausch,
Tübingen, Germany

PRINCIPAL TYPE
Monotype Grotesque

DIMENSIONS
9.1 x 10.6 in.
(23 x 27 cm)

Emily Oberman JUDGE

This piece is amazing. As far as I can tell this guy did everything: he designed the fonts, as well as the piece, wrote the copy, and even printed the thing while on an internship at a printer. That's pretty great.

But the real beauty of this piece, to me, was that it is simple and complex at the same time. The fonts are beautiful, smart, funny, and dexterous. They seem timeless and trendy. I love how beautifully they work together. I also love the use of the two colors (plus black) to support the fact that the faces overlap each other in their style and use. It gives the booklet a nearly 3-D quality that implies an animation and a liveliness that leaps off the page at you. The fonts (and the dingbats) feel Germanic and Texan at the same time. Each spread reveals a different aspect of the personality of the face. I especially love the interview with the typeface that actually requires 3-D glasses to read. Oh, and the cover folds out to be a spec sheet of the whole font family. Very nice.

The fact that this is a student piece makes the whole thing even more wonderful and inspiring—though this piece would be award-worthy even outside the student category.

Peter Brugger DESIGNER

The concept of Gringo is a fusion and merging of type cultures to cross borders and create something new. Gringo is presented in a limited edition letter-size brochure printed on a letterpress.

The Gringo typeface family contains 27 different varieties divided into three groups: sans, Slab, and Tuscan. The three styles have different backgrounds, but they're like a journey from Europe to Texas or vice versa. Due to the family's consistent structure, the single groups can be mixed as you wish. Furthermore, every variety comes in light, medium, and bold. There are three widths from narrow to wide. There is also a Dingbats font.

SANS • LIGHT

After the tragic war between the states, America turned to the winning of the West. The symbol of this era was the building of the trans-continental railroads. The advance of the railroads was in some cases, predatory and unscrupulous. Whole communities found themselves victimized by an ever-growing ogre – the Iron Horse. It was this uncertain and lawless age that gave to the world, for good or ill, its most famous outlaws, the brothers Frank and Jesse James.

SLAB MEDIUM

After the tragic war between the states, America turned to the winning of the West. The symbol of this era was the building of the trans-continental railroads. The advance of the railroads was in some cases, predatory and unscrupulous. Whole communities found themselves victimized by an ever-growing ogre – the Iron Horse. It was this uncertain and lawless age that gave to the world, for good or ill, its most famous outlaws, the brothers Frank and Jesse James.

TUSCAN BOLD

AFTER THE TRAGIC WAR BETWEEN THE STATES, AMERICA TURNED TO THE WINNING OF THE WEST. THE SYMBOL OF THIS ERA WAS THE BUILDING OF THE TRANS-CONTINENTAL RAILROADS. THE ADVANCE OF THE RAILROADS WAS IN SOME CASES, PREDATORY AND UNSCRUPULOUS. WHOLE COMMUNITIES FOUND THEMSELVES VICTIMIZED BY AN EVER-GROWING OGRE – THE IRON HORSE. IT WAS THIS UNCERTAIN AND LAWLESS AGE THAT GAVE TO THE WORLD, FOR GOOD OR ILL, ITS MOST FAMOUS OUTLAWS, THE BRO

ABCDEFGHIJKLMNOPQRSTUVWXYZ
abcdefghijklmnopqrstuvwxyz •
0123456789 [Sans Light Narrow]

After the tragic war between the states, America turned to the winning of the West. The symbol of this era was the building of the trans-continental railroads. The advance of the railroads was in some cases, predatory and unscrupulous. Whole communities found themselves victimized by an ever-growing ogre – the Iron Horse. It was this uncertain and lawless age that gave to the world, TUSCAN LIGHT

GRINGO

SANS LIGHT NARROW

AFTER THE TRAGIC WAR BETWEEN THE STATES, AMERICA TURNED TO THE WINNING OF THE WEST. THE SYMBOL OF THIS ERA WAS THE BUILDING OF THE TRANS-CONTINENTAL RAILROADS. THE ADVANCE OF THE RAILROADS WAS IN SOME CASES, PREDATORY AND UNSCRUPULOUS. WHOLE COMMUNITIES FOUND THEMSELVES VICTIMIZED BY AN EVER-GROWING OGRE – THE IRON HORSE. IT WAS THIS UNCERTAIN AND LAWLESS AGE THAT GAVE TO THE WORLD, FOR GOOD OR ILL, ITS MOST FAMOUS OUTLAWS, THE

SLAB MEDIUM NARROW

After the tragic war between the states, America turned to the winning of the West. The symbol of this era was the building of the trans-continental railroads. The advance of the railroads was in some cases, predatory and unscrupulous. Whole communities found themselves victimized by an ever-growing ogre – the Iron Horse. It was this uncertain and lawless age that gave to the world, for good or ill, its most

SANS MEDIUM

Whole communities found themselves victimized by an ever-growing ogre – the Iron Horse. It was this uncertain and lawless age that gave to the world, for good or ill, its most famous outlaws, the brothers Frank and Jesse James.

K

Slab Bold Wide

Dingbats

TUSCAN BOLD WIDE

ABCDEFGHIJKLMNOPQRST
UVWXYZabcdefghijklmnop
qrstuvwxyz • 0123456789

0607

WELCOME TYP MEA

STUDENT PROJECT

DESIGN
Peter Brugger
Karlsruhe, Germany

LETTERING
Peter Brugger

SCHOOL
Hochschule Pforzheim

PROFESSORS
Michael Throm and Lars Harmsen

PRINCIPAL TYPE
Gringo

DIMENSIONS
8.7 x 11.2 in.
(22 x 28.5 cm)

Woody Pirtle JUDGE

Circular is the magazine of the London-based Typographic Circle, an organization dedicated to the advancement of, and exposure to, the best of the typographic arts. Published once each year, this eclectic piece is conceived and designed to reflect the organization's goals, aspirations, and continually evolving nature.

The magazine is designed to command the attention of its recipients, keeping them well informed, challenged, and inspired by a collection of essays on a variety of subjects centered on typography. Peter Bain's piece on the evolution of blacklettering is a perfect case in point.

What I love about this particular issue is its refined sense of eclecticism. It is a beautiful example of British restraint, on one hand, and a playful exercise in contrasts of subject matter, papers, and scale, on the other. I particularly like the divider spreads, incorporating clever monograms of each of the featured artists against solid red backgrounds. These function as chapter openers for each of the various subjects, providing pacing and effective exercises in "typographic tinkering."

This piece is a perfect example of letting design take a back seat to content within each article, while bracketing the articles with powerful spreads that are each examples of typographic discovery.

As trade publications go, this is one of the best I've seen recently. Clearly, this designer has exhibited the confidence to use restraint, where others might have misused the opportunity and let design get in the way.

Domenic Lippa DESIGNER

The problem for issue 13 of the Typographic Circle's magazine *Circular* is the same problem we have with every issue: How to create an eclectic publication that reflects the Circle's aims and aspirations?

Because the magazine is published once a year, we are not under the same continuity issues as other magazines. In fact, our past issues have all had different designs, often based on different formats and binding methods. I suppose the biggest challenge is to produce something that visually excites the most demanding of audiences—designers and typographers!

The solution rested in the interplay among the different personalities' initials, which we turned into typographic monograms. With just black and red as the primary color palette, the magazine was printed on a playful mix of different paper stocks, all left unbound.

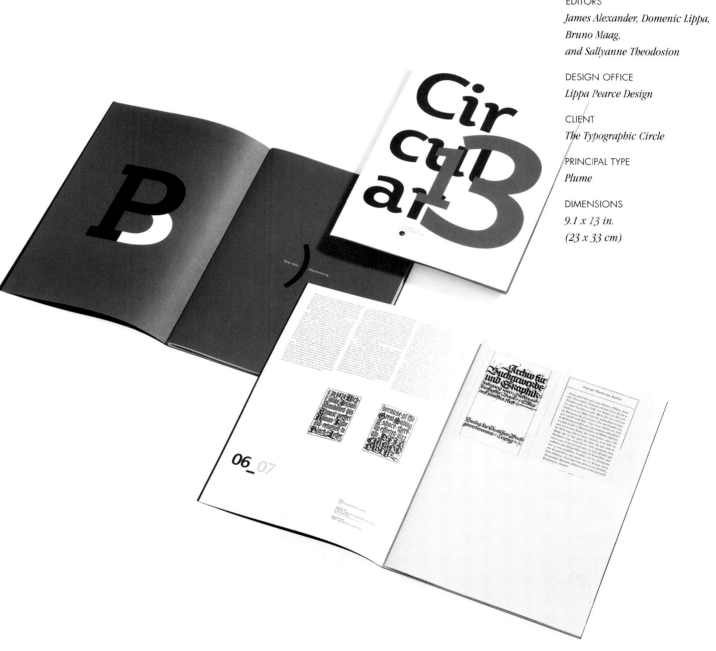

DESIGN
Domenic Lippa
London, England

ART DIRECTION
Domenic Lippa

CREATIVE DIRECTION
Domenic Lippa

TYPOGRAPHER
Domenic Lippa

EDITORS
*James Alexander, Domenic Lippa,
Bruno Maag,
and Sallyanne Theodosion*

DESIGN OFFICE
Lippa Pearce Design

CLIENT
The Typographic Circle

PRINCIPAL TYPE
Plume

DIMENSIONS
*9.1 x 13 in.
(23 x 33 cm)*

Steve Sandstrom | JUDGE

I selected a piece of work that was a remarkable effort entitled "Trans-Sensing/Seeing Music" by a student named Wen-Hua Hu from California College of the Arts. The piece is a 144-page thesis project, case bound with a cloth cover—a meticulous execution at that. The designer's balance of white space to text and imagery is beautiful. If you don't read a single word, you will still be held captive by the detail, depth, and fascinating graphic quality of the book.

The book is Wen-Hua Hu's attempt to visualize music, which is demonstrated in three phases: (1) semi-empirical mappings, utilizing a grid system based on a timeline; (2) intuitive, based on the designer's own feelings applied to a more complex grid; and (3) emotional/expressive, based on the spirit of the music without any grid or rational analysis. If this sounds complicated, it is. This is not going to make any literary best-seller list.

The typography and layout have both structure and lyrical qualities. There is a sense of the geometry and mathematics of music throughout. Its formality appears to me to represent a symphony of classical music. As a piece of literature, it may be challenged. As a piece of science, it might not be. But as a piece of visual art and as a demonstration of the subject, it succeeds very nicely. It gets a "Wow" from everyone I've shown it to.

Wen-Hua Hu | DESIGNER

This project was my BFA thesis submission at the California College of the Arts. There was no assigned topic. Instead, we were challenged to develop an original, compelling, rich design project that embodied the sum of our training and the statement "great design must communicate."

Inspired by the phenomenon of synaesthesia, a neurological condition where people experience cross-modal sensory perception—hearing colors or tasting shapes—I originally set out to decode the visual arts of the blind by translating colors to sound. I started exploring audio-to-visual mappings using empirical methods and identified three mappings: color to sound, shape to rhythm, and size to beat. In the next phrase I began to introduce more intuitive elements and finally embraced a completely expressive/emotional approach.

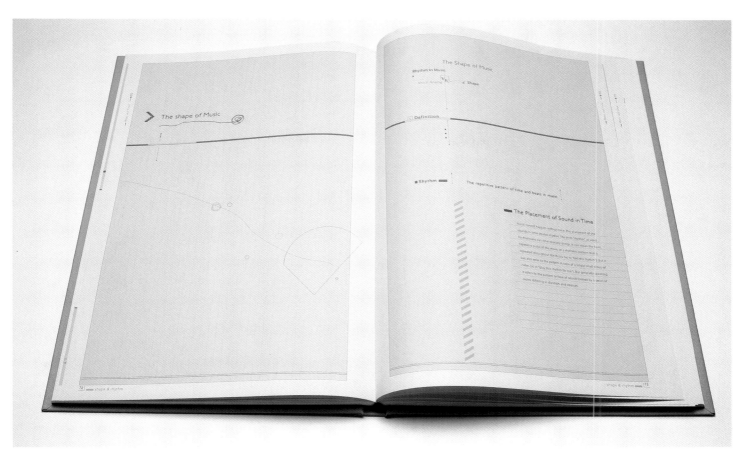

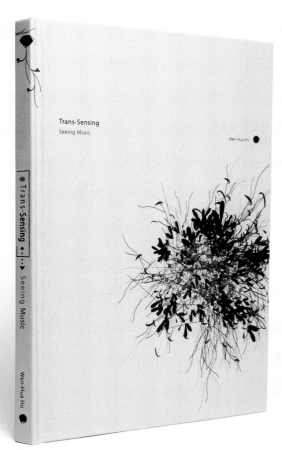

DESIGN
Wen-Hua Hu
San Francisco, California

SCHOOL
California College of the Arts

INSTRUCTORS
*Leslie Becker, David Karam,
and Michael Vanderbyl*

PRINCIPAL TYPE
*Avenir, Gill Sans, Adobe Jenson,
and Myriad Pro Light*

DIMENSIONS
*10 x 14 in.
(25.4 x 35.6 cm)*

Brady Vest JUDGE

OK, it was a lot of work to look through all the submissions, each commanding a different focus or a sensitivity in judging why one was or was not to be given a thumbs-up. But only a few very nearly jumped off the table out of sheer beauty, elegance, punch, and a true sense of craft. This was one of those pieces. I seem to recall every judge flipping over this one—probably because it's a student entry.

This piece did a really nice job of presenting the history of wood type and referencing the history of type specimen books, while, I think, packaging and presenting that in a very non-nostalgic way. With all these really fresh, almost irreverent typographic illustrations sitting next to this amazingly sturdy and well-crafted specimen book and box, the piece looked like it could have come right out of a museum. All these elements went together seamlessly and communicated the project as an investigation into type— specifically wood type—and a personal expression of craft and art. If it wasn't so huge, I would have stolen it.

Daniel Janssen DESIGNER

The publication *Wood Type Manufacture Hamburg: History and Future* was developed to accompany the exhibition workshop in the graphical crafts department of the Museum of Work in Hamburg. The idea was to give the exhibition workshop a corporate design of wood type manufacture to make the technique and use of the produced letters more illustrative and obvious to the visitor. The material—a type specimen book, examples of use, and a project book—shows the rich variety of the exhibition workshop: It documents its history and builds a bridge between the old technique and innovative uses. The type specimen book shows the historical type models. The examples of use could be a source of inspiration for new typographical work.

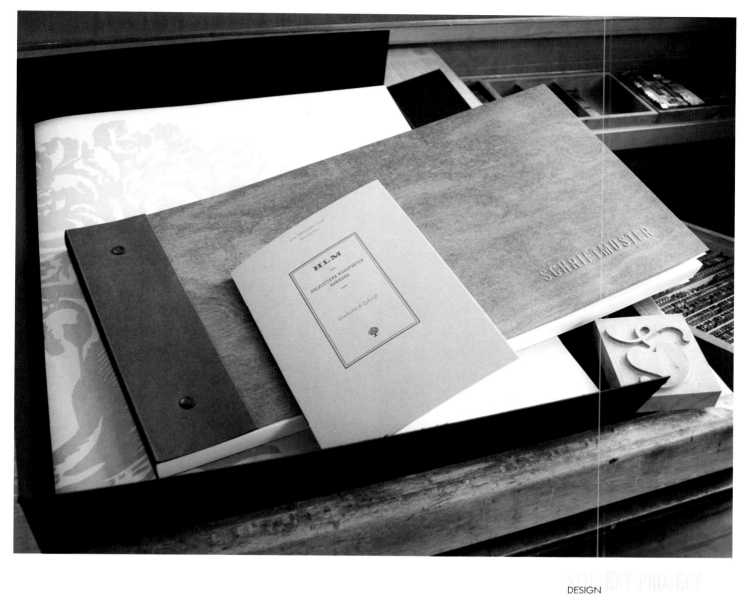

DESIGN
Daniel Janssen
Hamburg, Germany

SCHOOL
University of Applied Sciences
Hamburg

PROFESSORS
Jovica Veljovic and Peter Kabel

PRINCIPAL TYPE
Historical wood type

DIMENSIONS
16.5 x 20.5 x 3.5 in.
(42 x 52 x 9 cm)

DESIGN
Liza Butler
Napa, California

CREATIVE DIRECTION
David Schuemann

DESIGN OFFICE
CF Napa

CLIENT
John Anthony Vineyards

PRINCIPAL TYPE
Centaur and HTF Requiem

DIMENSIONS
4 x 5.25 in.
(10.2 x 13.3 cm)

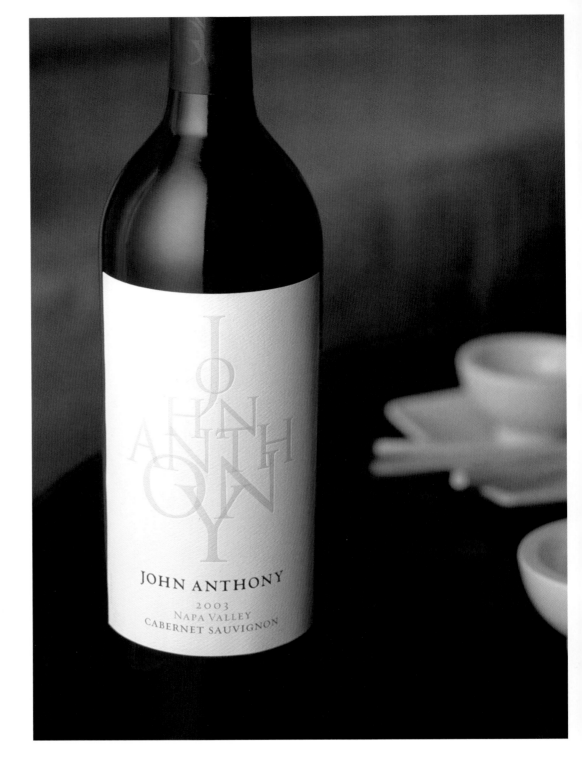

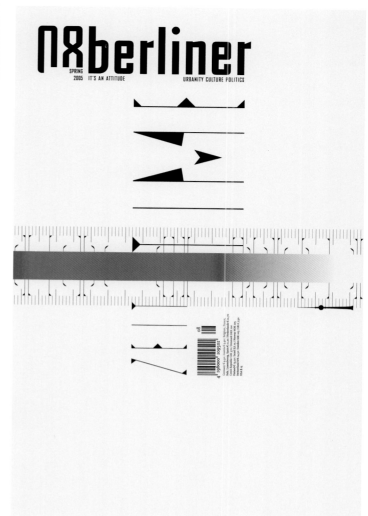

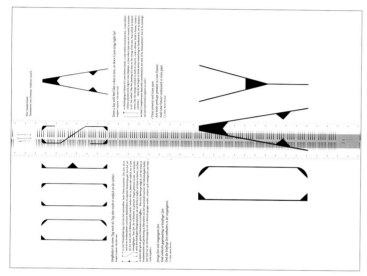

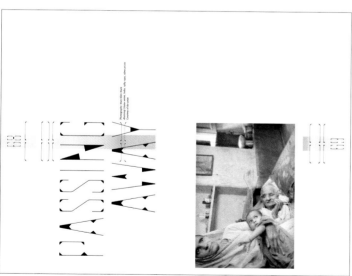

MAGAZINE

DESIGN
Thees Dohrn, Christina Poth,
and Philipp von Rohden
Berlin, Germany

ART DIRECTION
Thees Dohrn and Philipp von Rohden

CREATIVE DIRECTION
Thees Dohrn and Philipp von Rohden

DESIGN OFFICE
Zitromat

CLIENT
Berliner Magazine

PRINCIPAL TYPE
Timeless Regular and
FF Quadraat Regular

DIMENSIONS
8.5 x 13 in.
(21.5 x 33 cm)

DESIGN
Nadine Nill
Moessingen, Germany

DESIGN OFFICE
Nadine Nill

PRINCIPAL TYPE
Bauer Bodoni

DIMENSIONS
Various

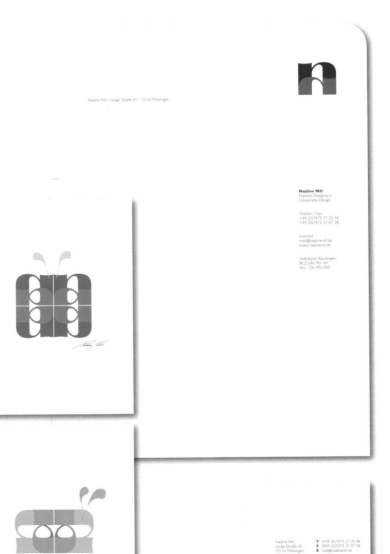

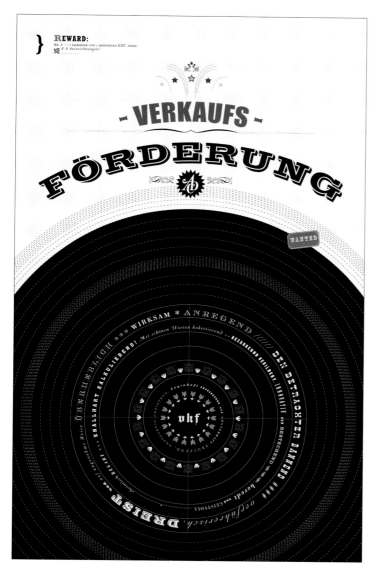

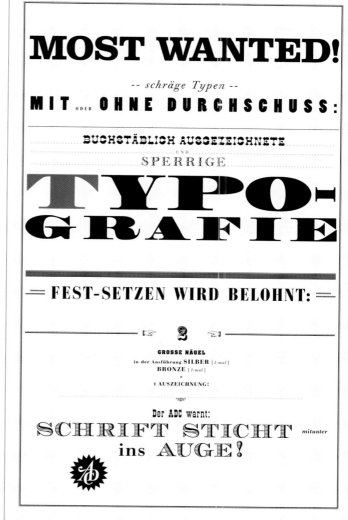

POSTER

DESIGN
Susanne Hörner
Stuttgart, Germany

ART DIRECTION
Kirsten Dietz

CREATIVE DIRECTION
Jochen Rädeker and Felix Widmaier

LETTERING
Susanne Hörner

AGENCY
strichpunkt

CLIENT
Art Directors Club Deutschland

PRINCIPAL TYPE
Various

DIMENSIONS
27.4 X 44.3 in.
(69.5 x 112.5 cm)

DESIGN
Shinnoske Sugisaki
Osaka, Japan

ART DIRECTION
Shinnoske Sugisaki

DESIGN OFFICE
Shinnoske, Inc.

CLIENT
*Alliance Graphique
Internationale (AGI)*

PRINCIPAL TYPE
Helvetica Neue Black

DIMENSIONS
*20.3 x 28.7 in.
(51.5 x 72.8 cm)*

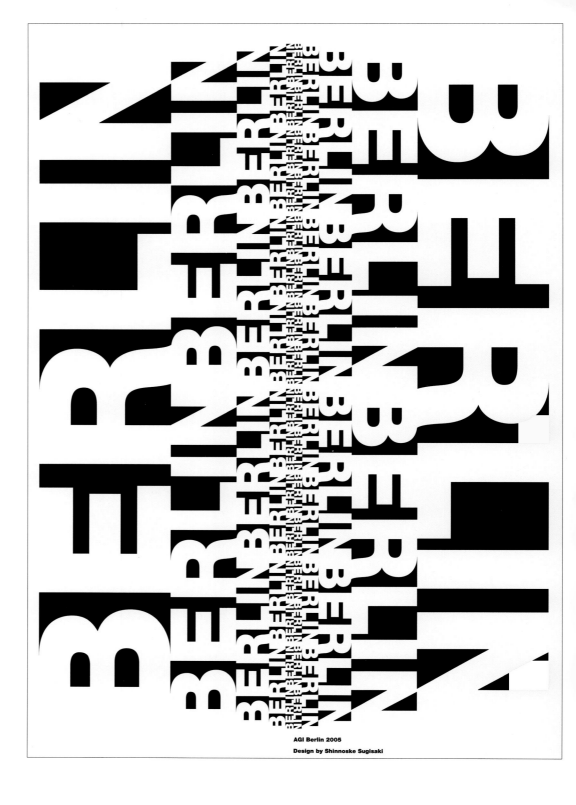

DESIGN
Nedjeljko Spoljar and Kristina Spoljar
Zagreb, Croatia

ART DIRECTION
Nedjeljko Spoljar

CREATIVE DIRECTION
Nedjeljko Spoljar

DESIGN OFFICE
Sensus Design Factory

CLIENT
Croatian Designers' Society

PRINCIPAL TYPE
Fobia Gothic and FF Profile

DIMENSIONS
6.7 x 11.8 in.
(17 x 30 cm)

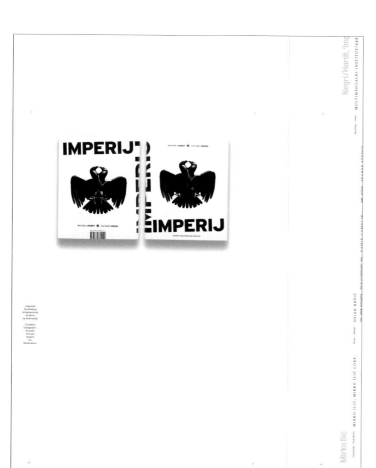

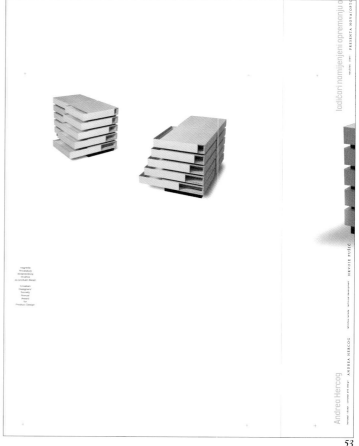

DESIGN
Belinda Bowling, Sonja Max,
Tiffany Place, Yuri Shvets,
and James Tee
Seattle, Washington

ART DIRECTION
James Tee

CREATIVE DIRECTION
Jack Anderson

DESIGN STUDIO
Hornall Anderson Design Works

CLIENT
Allconnect

allconnect

DESIGN
Buck Smith
St. Louis, Missouri

ART DIRECTION
Buck Smith

DESIGN OFFICE
Fleishman-Hillard Creative

CLIENT
The Joy Foundation

PRINCIPAL TYPE
New Century Schoolbook

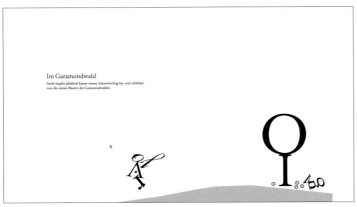

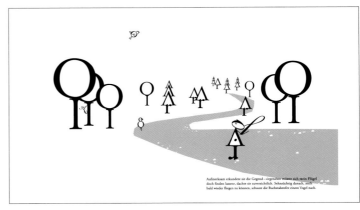

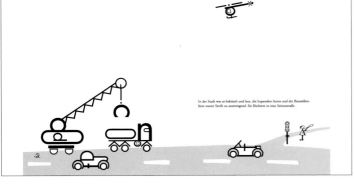

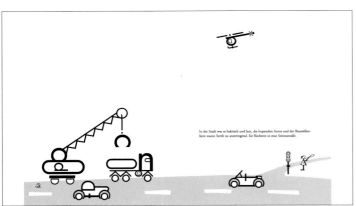

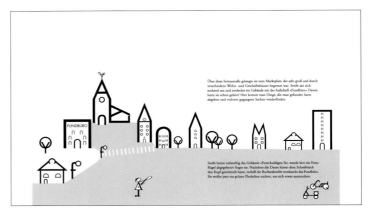

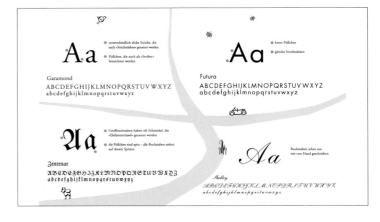

DESIGN
René Siegfried
Kiel, Germany

SCHOOL
Muthesius Kunsthochschule Kiel

PROFESSORS
Silke Juchter and Klaus Detjen

PRINCIPAL TYPE
Futura Book, Adobe Garamond,
Shelley Andante Script, and
Zentenar-Fraktur

DIMENSIONS
6.3 x 8.3 in.
(16 x 21 cm)

56

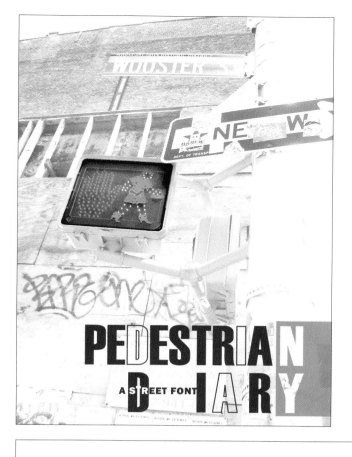

PEDESTRIAN DIARY
NY
A STREET FONT

STUDENT PROJECT

DESIGN
Hsin-Yi Wu
Brooklyn, New York

SCHOOL
Pratt Institute

INSTRUCTOR
Olga de la Roza de Gutierrez

PRINCIPAL TYPE
Garamond

DIMENSIONS
9 x 12 in.
(22.9 x 30.5 cm)

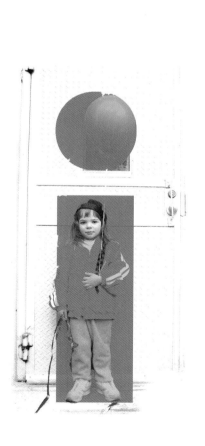

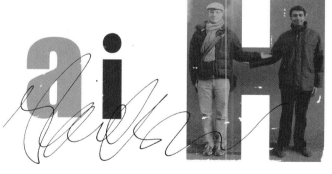

i was a boring letter if not treated carefully. Therefore I left this letter for someone special, such as a child holding a ball. As it happened, the girl with a balloon was perfect. Besides, she happened to appear near a pretty gray door. She was with her mother and older sisters and I thought they might be annoyed, but they weren't. Her mother was really kind and instructed her little girl to stand straight and hold the balloon right above her head, and told her to smile. I gave them chocolates as usual. Most people only took one or gracefully declined the offer. Lindsey took a lot. Her sisters also enjoyed the chocolates. I loved to see that.

F He was a cute guy. Most people would do a reverse letter at the beginning, but he didn't. He was very careful, seriously thinking about what to do. I really didn't want to ask him too much. He then corrected the angles to perfection and it was greatly appreciated. By the way...I was freezing to death by that time, however, I didn't want to give up the red wall setting I found. Lucky I met him, it was worth it!

H I later discovered another setting that appealed to me. It was a pink wall but, unfortunately, located on the corner of a very busy street. People came and went pretty fast. I was afraid to bother any of them. By this time most letters were done and I decided to take an "H". Therefore my objects would be two guys of approximately the same height and weight. That made the mission even more difficult. I saw two guys coming toward me smiling with delight. All my hesitation was gone. I quickly walk toward them and asked for a help. They were really happy there, and even ask to take a picture with me. It's funny. But, well, appreciated it.

DESIGN
Tivy Davies
London, England

ART DIRECTION
Mark Norcutt and Laurence Quinn

CREATIVE DIRECTION
Nick Bell

AGENCY
JWT London

CLIENT
Diageo-Smirnoff

PRINCIPAL TYPE
Unit 3 Extra

DIMENSIONS
24 x 11 in.
(61 x 27.9 cm)

DON'TNUT

Approximately 30% of adolescents ages 12 to 19 in America are overweight and

15% percent are obese. Obesity in adolescents increases their chances of developing asthma,

diabetes, high blood pressure, and sleep apnea—conditions likely to persist in adulthood.

Don't succumb to unhealthy food temptations.

American Obesity Association

STUDENT PROJECT

DESIGN
Julyanne Liang
San Francisco, California

SCHOOL
California College of the Arts

INSTRUCTOR
Mark Fox

PRINCIPAL TYPE
Frankfurter and Futura

DIMENSIONS
20 x 40 in.
(50.8 x 101.6 cm)

DESIGN
Richard Boynton
Minneapolis, Minnesota

ART DIRECTION
Richard Boynton and Scott Thares

CREATIVE DIRECTION
Richard Boynton and Scott Thares

LETTERING
Richard Boynton

DESIGN OFFICE
Wink

CLIENT
Target

DESIGN
Ramon Grendene
Weimar, Germany

SCHOOL
*Faculty of Art and Design,
Bauhaus University, Weimar*

PROFESSOR
Alexander Branczyk

PRINCIPAL TYPE
FF DIN and Chalet Book

DIMENSIONS
Various

DESIGN
Moyeenul Alam
Miami, Florida

SCHOOL
Miami Ad School

INSTRUCTOR
Judy Penny

PRINCIPAL TYPE
ITC Stone Sans modified

DIMENSIONS
10 x 15 in.
(25.4 x 38.1 cm)

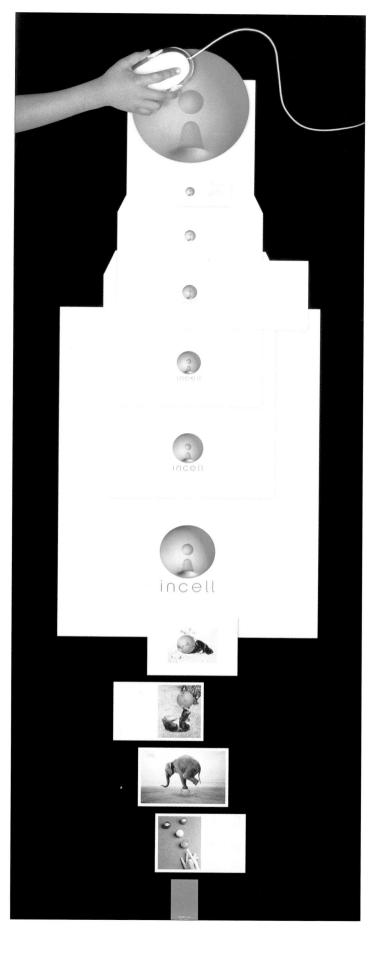

CORPORATE IDENTITY

DESIGN
Jun Takechi
Tokyo, Japan

ART DIRECTION
Jun Takechi

CLIENT
incell corp.

PRINCIPAL TYPE
Custom

DIMENSIONS
Various

DESIGN
Muy Billy
Winston-Salem, North Carolina

ART DIRECTION
Muy Billy

CREATIVE DIRECTION
Hayes Henderson

DESIGN OFFICE
HENDERSONBROMSTEADART

CLIENT
Musicmaker Relief Foundation

PRINCIPAL TYPE
HTF Champion and Brothers Bold

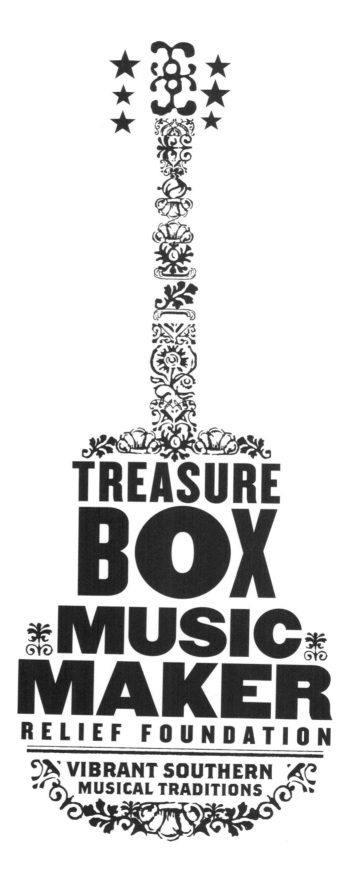

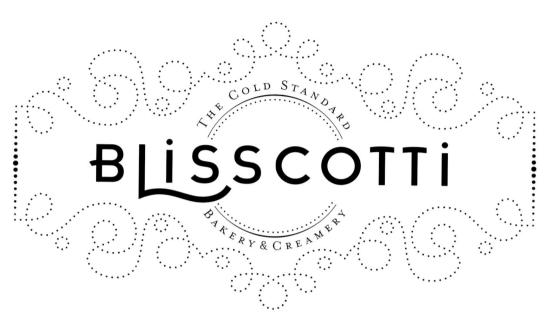

LOGOTYPE

DESIGN
Larry Anderson, Holly Craven,
Chris Freed, and Jay Hilburn
Seattle, Washington

ART DIRECTION
Larry Anderson

CREATIVE DIRECTION
Jack Anderson

DESIGN STUDIO
Hornall Anderson Design Works

CLIENT
Blisscotti

LALEH HAAS

0421 ' 33 65 815 · 0421 ' 33 65 816 · 0172 ᴹ 44 50 558 · post@lolue.de
Richard-Wagner-Straße 31 · 28209 Bremen

Richard-Wagner-Straße 31 · 28209 Bremen

CORPORATE IDENTITY

ART DIRECTION
Anne-Lene Proff
Berlin, Germany

COPYWRITER
Barbara Kotte

DESIGN OFFICE
scrollan

CLIENT
Lolü – Kids Wear, Laleh Haas
Bremen, Germany

PRINCIPAL TYPE
*FF Quadraat Small Caps and
FF Quadraat Italic*

DIMENSIONS
Various

DEPARTMENT OF MERRIMENT
CURO FINANCIAL MANAGEMENT
108 4TH AVE. SOUTH, SUITE 207
FRANKLIN, TENNESSEE 37064

NOTICE NUMBER: CW-2005
EFFECTIVE DATE: 12/25/2005
TAX YEAR: 2005
EGG NOG: YES

DON.T U LOOOOOOVE TH3 HOL1DAY5?

|..||I|..||I..||I..||I..||I..||I..||I..||I..||I..||I

CLAUDE P. HOOT
100 STABLE COURT
FRANKLIN, TN 37069-1608

FOR ASSISTANCE CONTACT THE
OFFICE OF: Office of S. Clause

Non Toll Free #: 1-615-599-1300

XMA5

OFFICIAL NOTICE
We intend to levy holiday cheer. Please respond NOW.

At the end of Calendar year 2005 all parties receiving this notice will be required to have a magnificently happy Holiday season. If you have already had, or are now having, or are planning to have a magnificently happy Holiday season, you may disregard this notice.

Thank you for your cooperation.

If you have any questions regarding compliance or seek warmest wishes for a happy 2006, please contact: Jason Childress, Noel Hartough, Leslie Tolman or Jennifer Knutson at Curo Financial Management.

M3RRY-CHR1STMA5 2 U
FROM CURO F1NANC1AL (2005)

DESIGN
Clark Hook
Nashville, Tennessee

AGENCY
Lewis Communications

CLIENT
Curo Financial Management

PRINCIPAL TYPE
OCR B

DIMENSIONS
8.5 x 11 in.
(21.6 x 27.9 cm)

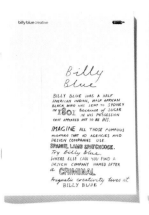
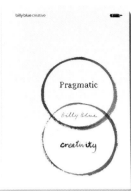
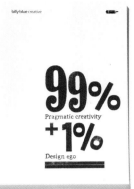
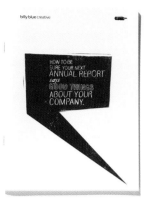

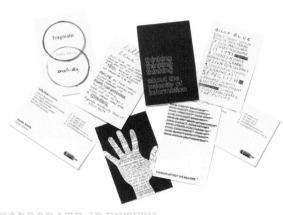

CORPORATE IDENTITY

DESIGN
Justin Smith
North Sydney, Australia

ART DIRECTION
Justin Smith and Mick Thorp

CREATIVE DIRECTION
Mick Thorp

LETTERING
Justin Smith

DESIGN OFFICE
Billy Blue Creative

PRINCIPAL TYPE
Custom

DIMENSIONS
Brochure: 5.9 x 8.3 in.
(15 x 21 cm)
Business Cards: 3.4 x 2.2 in.
(8.5 x 5.5 cm)

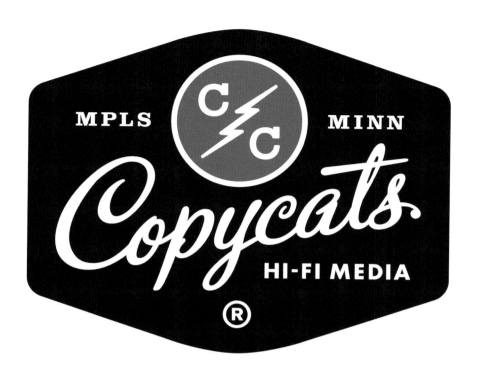

LOGOTYPE

DESIGN
Richard Boynton
Minneapolis, Minnesota

ART DIRECTION
Richard Boynton and Scott Thares

CREATIVE DIRECTION
Richard Boynton and Scott Thares

LETTERING
Richard Boynton

DESIGN OFFICE
Wink

CLIENT
Copycats

PRINCIPAL TYPE
*Futura, Monterey, and
Trade Gothic Extended*

DESIGN
Ed Benguiat
Hasbrouck Heights, New Jersey

ART DIRECTION
Silas Rhodes

CREATIVE DIRECTION
Ed Benguiat

LETTERING
Ed Benguiat

DESIGN OFFICE
Ed Benguiat/Design, Inc.

CLIENT
School of Visual Arts

PRINCIPAL TYPE
Handlettering

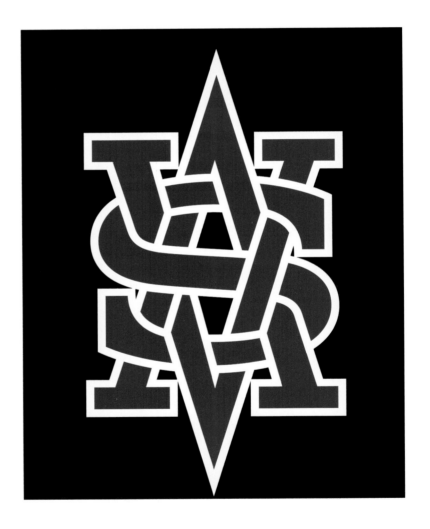

L2M3 KOMMUNIKATIONSDESIGN GMBH
HÖLDERLINSTRASSE 57 D-70193 STUTTGART
T +49 711/99 33 91 60 F 99 33 91 70 ISDN 99 33 91 80
INFO@L2M3.COM WWW.L2M3.COM
L2M3

WWW.L2M3.COM

L2M3 KOMMUNIKATIONSDESIGN GMBH
HÖLDERLINSTRASSE 57 D-70193 STUTTGART
T +49 711/99 33 91 60 F 99 33 91 70
ISDN 99 33 91 80 INFO@L2M3.COM

Kathrin Löser
Diplom Designerin (FH)
T +49 711/99 33 91 63
Kathrin.Loeser@L2M3.com

L2M3 KOMMUNIKATIONSDESIGN GMBH
HÖLDERLINSTRASSE 57 D-70193 STUTTGART
T +49 711/99 33 91 60 F 99 33 91 70 ISDN 99 33 91 80
INFO@L2M3.COM WWW.L2M3.COM

NEUE ADRESSE AB 14.03.2005

CORPORATE IDENTITY

DESIGN
Sascha Lobe and Ina Bauer
Stuttgart, Germany

DESIGN OFFICE
L2M3 Kommunikationsdesign GmbH

PRINCIPAL TYPE
Wilma

DIMENSIONS
Various

71

DESIGN
Christian Lenz
Steinfurt, Germany

ART DIRECTION
Christian Lenz

PRINTER
Einblatt-Druck
Kiel, Germany

LASER PERFORATION
Kremo
Mosbach, Germany

STUDIO
Lenz/Typografie & Design

CLIENT
Stöhrmann Fotografie
Hamburg, Germany

PRINCIPAL TYPE
Folio SB Bold Condensed

DIMENSIONS
Various

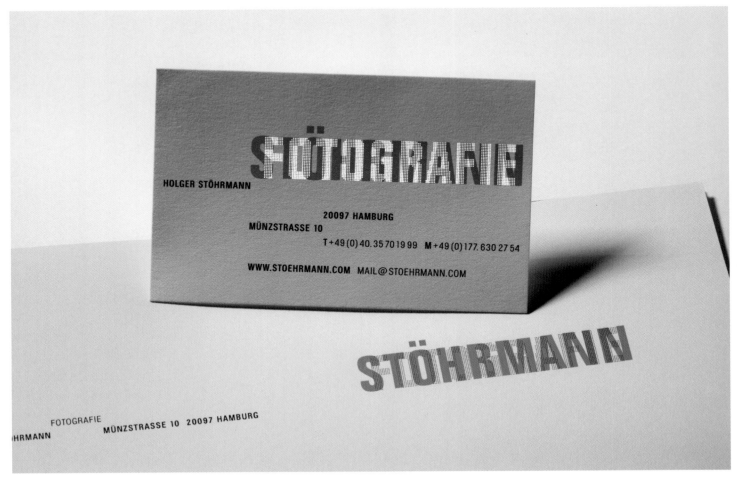

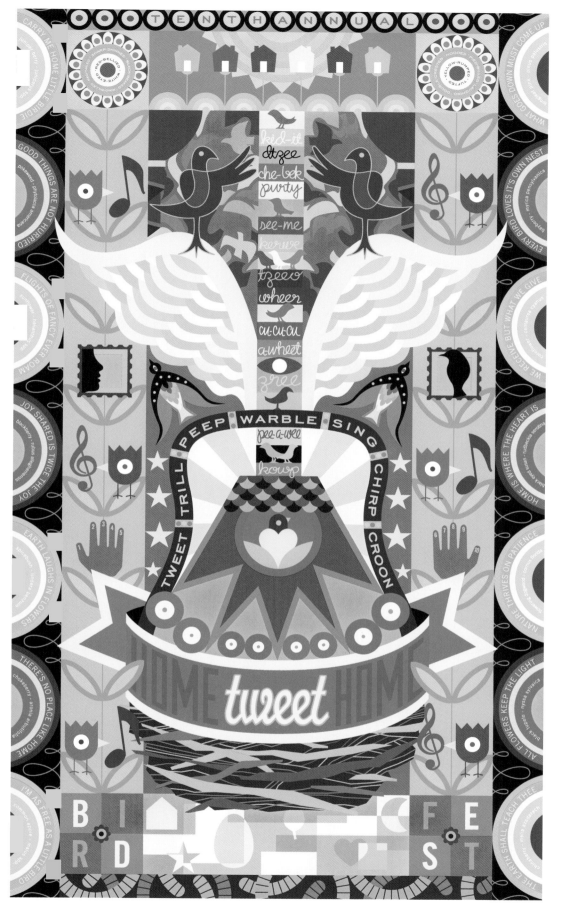

POSTER

DESIGN
Kris Hendershott
Winston-Salem, North Carolina

ART DIRECTION
Kris Hendershott

CREATIVE DIRECTION
Hayes Henderson

DESIGN OFFICE
HENDERSONBROMSTEADART

CLIENT
Habitat for Humanity

PRINCIPAL TYPE
*Chisel Wide, Radio, Trade Gothic,
and custom*

DIMENSIONS
*15.5 x 26 in.
(39.4 x 66 cm)*

CORPORATE IDENTITY

DESIGN
Kirsten Dietz
Stuttgart, Germany

ART DIRECTION
Kirsten Dietz

CREATIVE DIRECTION
Kirsten Dietz

LETTERING
Kirsten Dietz

AGENCY
strichpunkt

PRINCIPAL TYPE
FF DIN

DIMENSIONS
Various

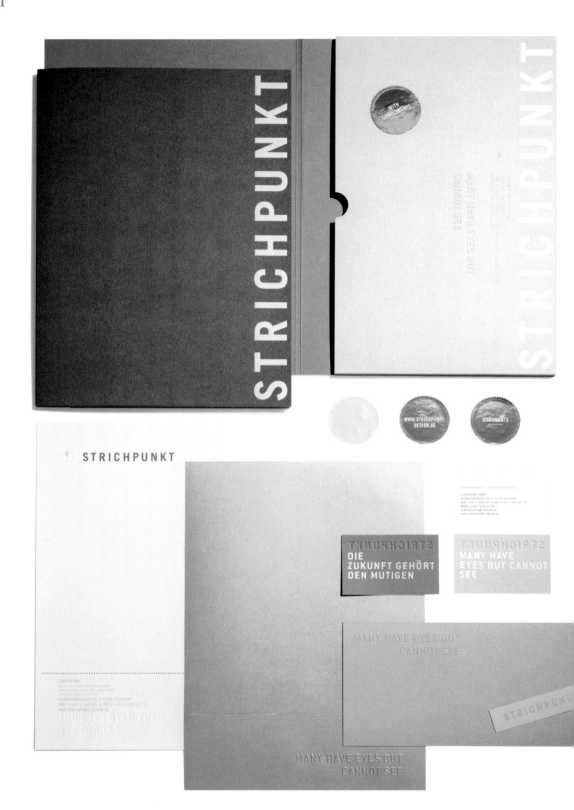

White Mischief

ONE MINUTE, SHE'S THE ARCHANGEL
GABRIEL, AND THE NEXT, MARILYN MANSON.
TILDA SWINTON,
AS LYNN HIRSCHBERG DISCOVERS, IS A
WOMAN OF EXTREMES.
Photographs by Raymond Meier

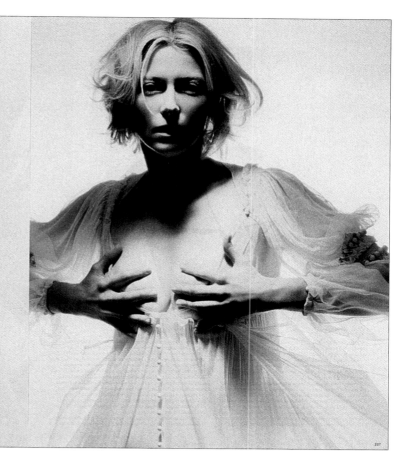

One of Tilda Swinton's ancestors on her very posh, very
military Scottish family tree was painted by John Singer Sargent, and it is easy to imagine Swinton, with her alabaster skin,
otherworldly green eyes and regal 5-foot-11 bearing, captured in oils. "I do look like all those old paintings," Swinton joked
over a midsummer lunch of raw oysters at the Mercer hotel. "But I'm afraid my temperament does not conform. At all."
 She said this, as she said nearly everything, with a mix of direct authority and engaged enthusiasm that was both
immediately ingratiating and commanding. Swinton, who is 44, was wearing no trace of makeup, a print sundress and flip-
flops, and her hair, which is naturally red, was dyed white-blond. "I love the roots," she said, as she tilted her scalp forward
for inspection. "That's the best part of being this blond."
 Her unique looks, her ease with herself and her voracious interest in the more esoteric worlds of cinema and style have
made Swinton a kind of goddess of the avant-garde. In her movies, she has continually transformed herself — changing
class, nationalities, gender. For "Orlando," perhaps her most famous film, she played multiple incarnations of the title
character, including a man. In "Thumbsucker," opening in theaters on Sept. 16, she is utterly convincing as a suburban
American mom. The director Jim Jarmusch cast her as an ex-girlfriend of Bill Murray's in the recent "Broken Flowers," in
which she is terrifying, her face half-obscured by a foreboding curtain of long brown hair. For "The Chronicles of Narnia:
The Lion, the Witch and the Wardrobe," a big-budget movie that is due out from Disney at the end of the year, Swinton

ART DIRECTION
David Sebbah

CREATIVE DIRECTION
Janet Froelich
New York, New York

PHOTOGRAPHY
Raymond Meier

PUBLICATION
The New York Times Style Magazine

PRINCIPAL TYPE
Various

DIMENSIONS
11.5 x 19 in.
(29.2 x 48.3 cm)

POSTER

DESIGN
Ohsugi Gaku and Shinozaki Mika
Tokyo, Japana

ART DIRECTION
Ohsugi Gaku

DESIGN OFFICE
702 Design Works Inc.

CLIENT
JAGDA and 702 Design Works, Inc.

DIMENSIONS
28.7 x 40.6 in.
(72.8 x 103 cm)

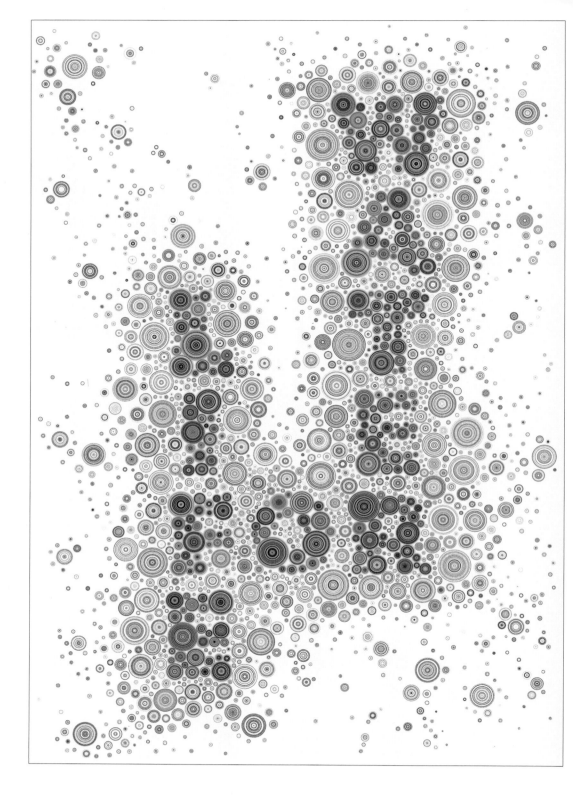

SCHRÖDERSTIFTSTRASSE 22
20146 HAMBURG

 EROTIK ELITÄR

SCHRÖDERSTIFTSTRASSE 22
20146 HAMBURG
TELEFON 040/41 35 60 95
WWW.CLUBNOBEL.DE

DESIGN
Karsten Kummer
Hamburg, Germany

CREATIVE DIRECTION
Robert Neumann

LETTERING
Karsten Kummer

DESIGN OFFICE
*Delikatessen Agentur für Marken
und Design GmbH*

CLIENT
Club Nobel

PRINCIPAL TYPE
*Copperplate modified
and handlettering*

DIMENSIONS
*8.3 x 11.4 in.
(21 x 29 cm)*

DESIGN
Ken Sakurai
Minneapolis, Minnesota

CREATIVE DIRECTION
Dan Olson

DESIGN OFFICE
Duffy & Partners

CLIENT
Thymes

PRINCIPAL TYPE
Bryant

DIMENSIONS
Various

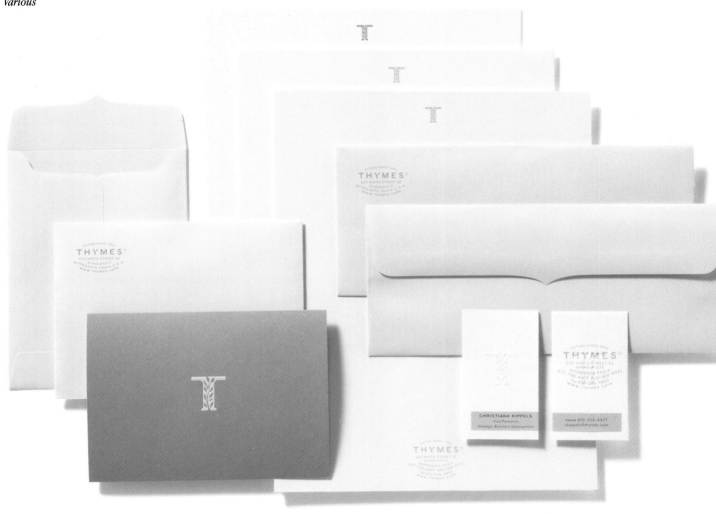

DESIGN
Masood Ahmed
Bronx, New York

SCHOOL
School of Visual Arts, MFA Design

INSTRUCTOR
Gail Anderson

PRINCIPAL TYPE
*Gravur Condensed, Milk Script,
Stereopticon, and Tiki Holiday*

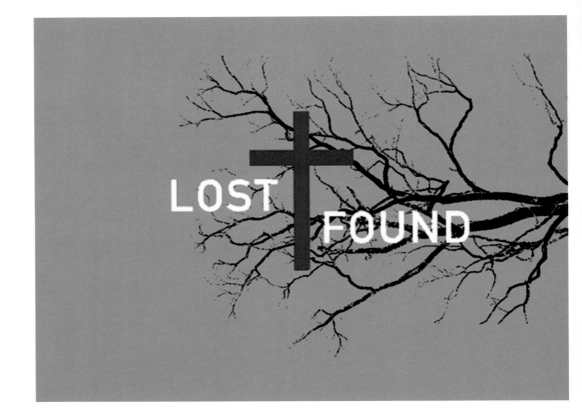

MOTION GRAPHICS

DESIGN
Jeff Miller
Kansas City, Missouri

ART DIRECTION
Jeff Miller

ANIMATOR
Jeff Miller

DESIGN OFFICE
Muller + Company

CLIENT
Church of the Nazarene

PRINCIPAL TYPE
DIN Mittelschrift and MeMimas

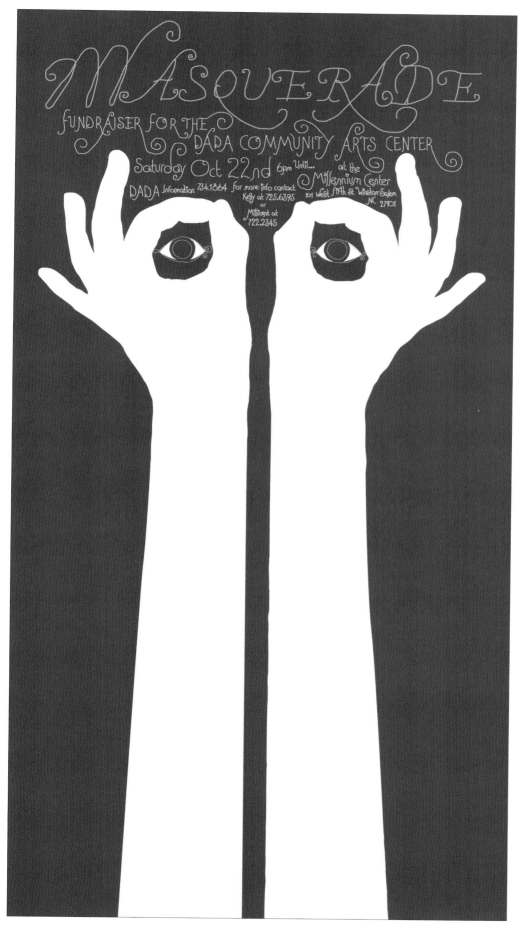

POSTER

DESIGN
Muy Billy
Winston-Salem, North Carolina

ART DIRECTION
Muy Billy

CREATIVE DIRECTION
Hayes Henderson

CALLIGRAPHY
Muy Billy

DESIGN OFFICE
HENDERSONBROMSTEADART

CLIENT
Downtown Arts District Association

PRINCIPAL TYPE
Handlettering

DIMENSIONS
12.5 x 23 in.
(31.8 x 58.4 cm)

DESIGN
*Todd Richards and
Nicholas Davidson*
San Francisco, California

ART DIRECTION
*Bill Cahan, Steve Frykholm,
and Todd Richards*

CREATIVE DIRECTION
Bill Cahan

DESIGN OFFICE
Cahan & Associates

CLIENT
Herman Miller

PRINCIPAL TYPE
Helvetica and Sabon

DIMENSIONS
*9.25 x 11.75 in.
(23.5 x 29.9 cm)*

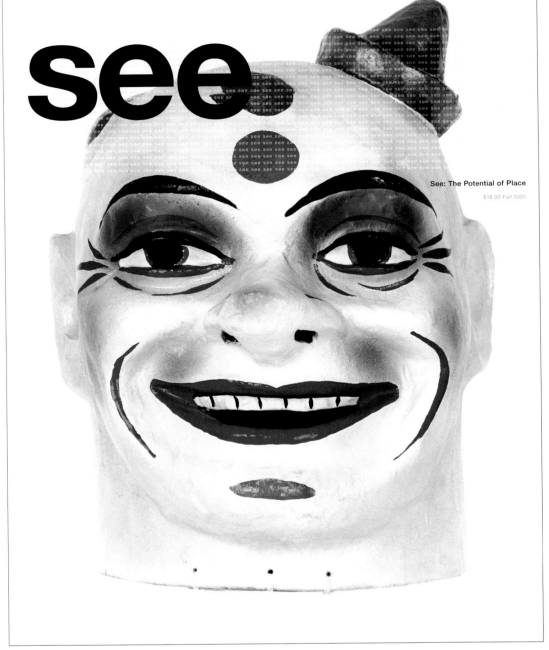

See: The Potential of Place
$18.00 Fall 2005

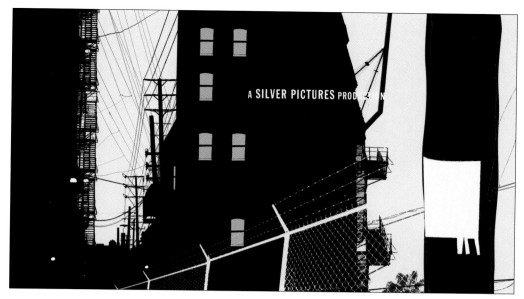

FILM TITLES

DESIGN
James Choi, Gary Mau,
Stephen Schuster, and Danny Yount
Malibu, California

CREATIVE DIRECTION
Danny Yount

DESIGN OFFICE
Prologue

CLIENT
Silver Pictures and Warner Bros.

PRINCIPAL TYPE
Franklin Gothic Extra Bold
Condensed

DESIGN
Matthias Ernstberger
New York, New York

CREATIVE DIRECTION
Stefan Sagmeister

LETTERING
Matthias Ernstberger

DESIGN OFFICE
Sagmeister Inc.

CLIENT
Seed Media Group

PRINCIPAL TYPE
Helvetica

DIMENSIONS
Various

seed media group.

12 West 21st Street, 7th Floor
New York, NY 10010

TEL +1 646 502 7050
FAX +1 646 502 7040

seedmediagroup.com
info@seedmediagroup.com

DESIGN
James Wai Mo Leung
Hong Kong, China

CREATIVE DIRECTION
James Wai Mo Leung

ART DIRECTION
James Wai Mo Leung

LETTERING
James Wai Mo Leung

DESIGN STUDIO
Genemix

CLIENT
Berth Ma and Helene Tam of
The Lenscape Studio

PRINCIPAL TYPE
Didot, Frutiger, and FF Meta

DIMENSIONS
Various

LENSCAPE
studio

3 March 2005

Mr. James Leung
Company Name
25th Floor
1 Des Voeux Road West
Hong Kong

Dear James,

This example shows the typing layout for The Lenscape Studio letterhead.

Set the left-hand margin to align on the left 25mm from the edge of the page. The Right-hand margin should also be set so it is 25mm.

The date, name and address should be typed in upper and lower case. The date should be 50mm from the top edge of the page. The name and address should be two line spaces below the date. The salutation is two line spaces below the last line of the typed address. Start the body of the letter two line spaces below the subject title or two line spaces below the salutation if there is no subject title. Use single line spacing throughout the letter. Use double spacing between paragraphs and do not indent paragraphs.

Use single spacing between words, and two spaces between the end of a sentence and the beginning of the next. Do not use right-hand justified margins but try to keep the right margin as even as possible.

Type the closure two line spaces after the end of the body of the letter. Type the name of the signatory five line spaces below the closure. Status or title may included immediately below the name if required.

Sincerely,

Bertha Ma

flat g, 9/f.
pak lee mansion
1 tin hau temple road
tin hau, hong kong

t +852 2528 2523
f +852 2528 5855

bertha ma
PHOTOGRAPHER

helena tam
COPYWRITER

LENSCAPE
studio

LENSCAPE
studio

flat g, 9/f.
pak lee mansion
1 tin hau temple road
tin hau, hong kong

flat g, 9/f.
pak lee mansion
1 tin hau temple road
tin hau, hong kong

t +852 2528 2523
f +852 2528 5855
e bertha@thelenscape.com.hk

t +852 2528 2523
f +852 2528 5855
e helena@thelenscape.com.hk

LENSCAPE
studio

flat g, 9/f.
pak lee mansion
1 tin hau temple road
tin hau, hong kong

LENSCAPE
studio

flat g, 9/f.
pak lee mansion
1 tin hau temple road
tin hau, hong kong

Mr. James Leung
Company Name
25th Floor
1 Des Voeux Road West
Hong Kong

DESIGN
Julia S. Kuon and Florian Pfeffer
Bremen, Germany

DESIGN OFFICE
jung und pfeffer: visuelle
kommunikation

CLIENT
: out output foundation

PRINCIPAL TYPE
Serifa BQ and Lutz Headline

DIMENSIONS
9.1 x 13 in.
(23 x 33 cm)

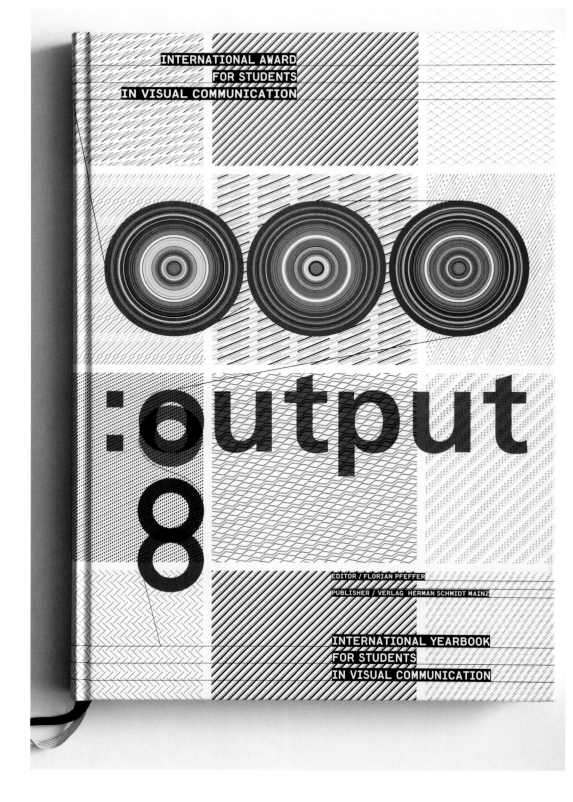

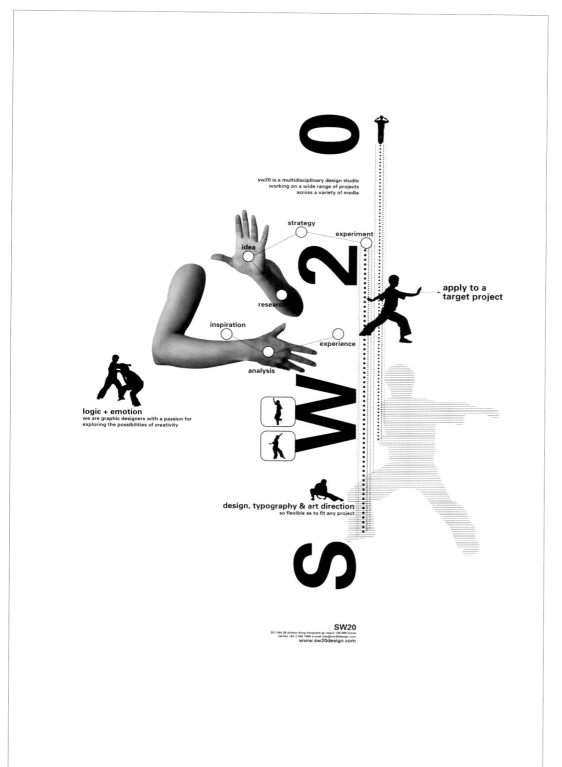

DESIGN
Choong Ho Lee
Seoul, Korea

ART DIRECTION
Choong Ho Lee

CREATIVE DIRECTION
Choong Ho Lee

DESIGN OFFICE
SW20

PRINCIPAL TYPE
Univers

DIMENSIONS
21.3 x 29.5 in.
(54 x 75 cm)

DESIGN
Emre Veryeri
New York, New York

ART DIRECTION
Garry Waller

CREATIVE DIRECTION
Jakob Trollbäck and Joe Wright

DESIGN OFFICE
Trollbäck + Company

CLIENT
Pop!Tech Conference

PRINCIPAL TYPE
Helvetica

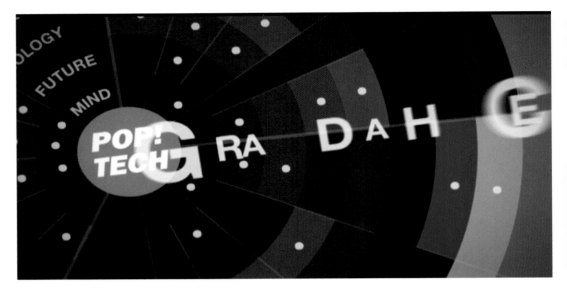

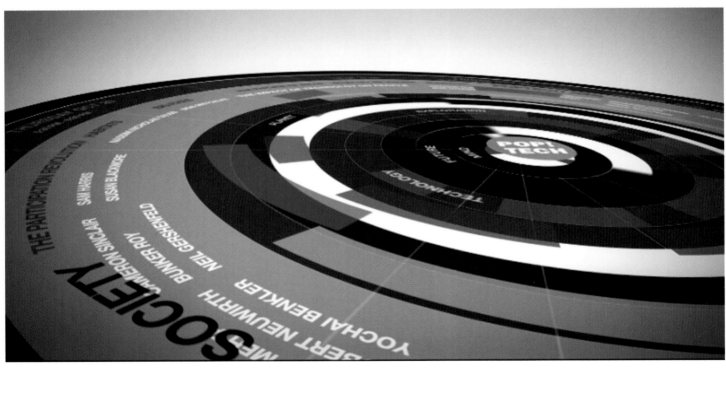

STUDENT PROJECT

DESIGN
Hana Sedelmayer
Hamburg, Germany

SCHOOL
Muthesius Academy of Fine Arts, Kiel

PROFESSOR
Klaus Detjen

PRINCIPAL TYPE
Proforma Medium and Auto 1 Black

DIMENSIONS
7.9 x 10.6 in.
(20 x 27 cm)

DESIGN

David Plunkert
Baltimore, Maryland

ILLUSTRATION

David Plunkert

STUDIO

Spur

CLIENT

Theatre Project

PRINCIPAL TYPE

Century Schoolbook

DIMENSIONS

14 x 23 in.
(35.6 x 58.4 cm)

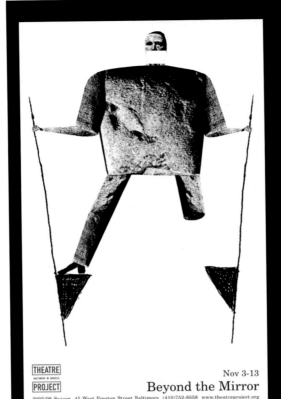

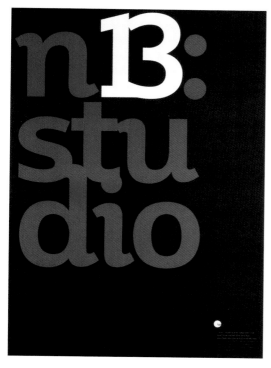
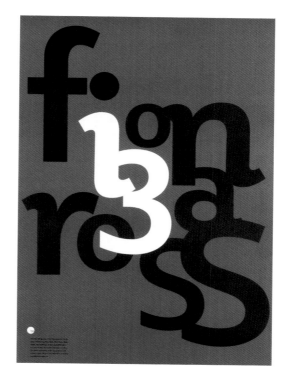
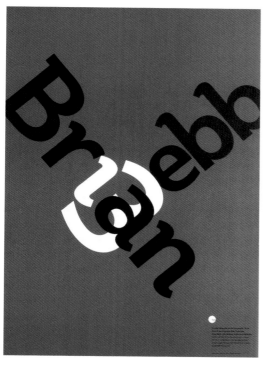
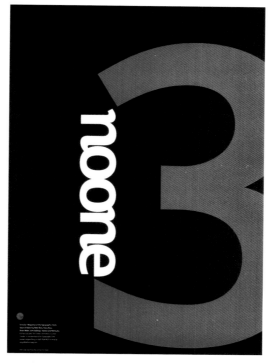

POSTERS

DESIGN
Domenic Lippa
London, England

ART DIRECTION
Domenic Lippa

CREATIVE DIRECTION
Domenic Lippa

TYPOGRAPHER
Domenic Lippa

DESIGN OFFICE
Lippa Pearce Design

CLIENT
The Typographic Circle

PRINCIPAL TYPE
Plume

DIMENSIONS
23.6 x 33.1 in.
(60 x 84 cm)

DESIGN
Guy Pask and Kerry Argus
Christchurch, New Zealand

ART DIRECTION
Guy Pask

CREATIVE DIRECTION
Guy Pask and Douglas Maclean

LETTERING
Guy Pask

STUDIO
Strategy Design & Advertising

CLIENT
Bell Hill Vineyards

PRINCIPAL TYPE
Futura and Indian typeface redrawn

DIMENSIONS
Various

DESIGN
Daniel Gneiding
Philadelphia, Pennsylvania

ART DIRECTION
Carol Keer

PRINTER
Medford Printing
Medford, New Jersey

CLIENT
Anthropologie

PRINCIPAL TYPE
Filosofia

DIMENSIONS
Various

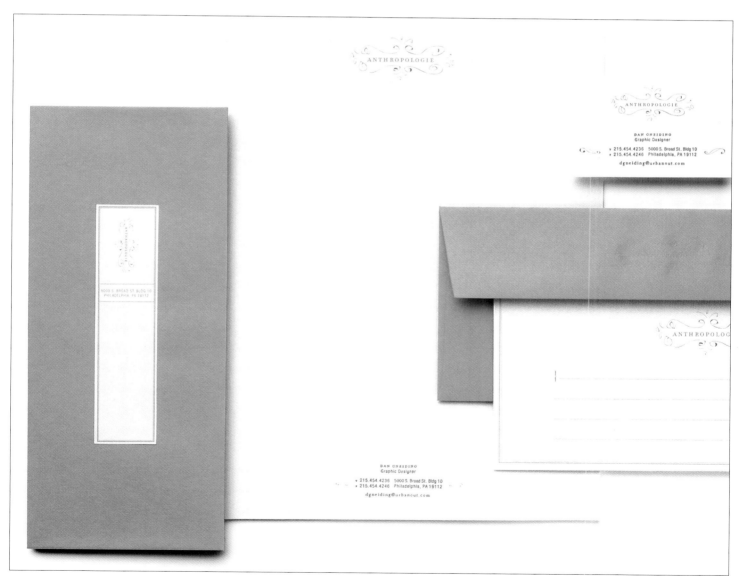

DESIGN
Kjell Ekhorn and Jon Forss
London, England

CREATIVE DIRECTION
Kjell Ekhorn and Jon Forss

STUDIO
Non-Format

CLIENT
The Royal Norwegian Embassy
London

PRINCIPAL TYPE
Custom

DIMENSIONS
33.1 x 23.2 in.
(84 x 59 cm)

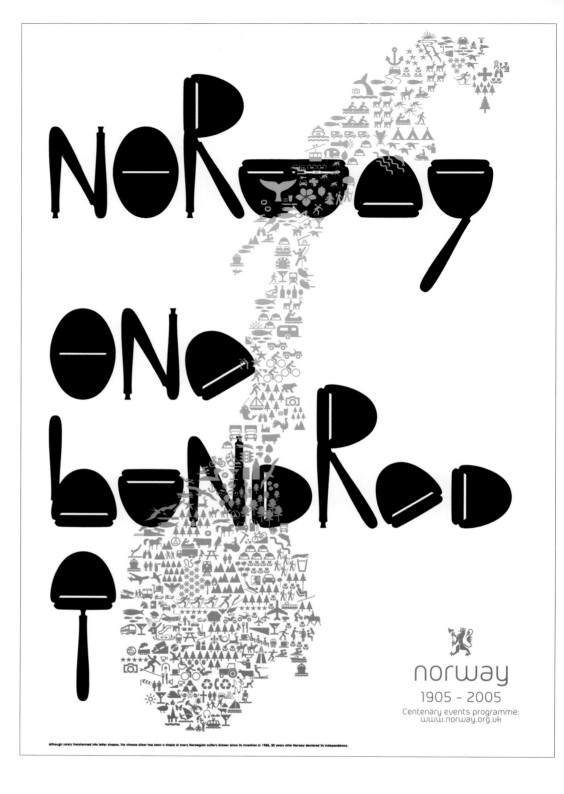

POSTER

ART DIRECTION
Ingo Maak
Wuppertal, Germany

CREATIVE DIRECTION
Christian Boros

AGENCY
Boros

CLIENT
Venice Biennale, German Pavilion

PRINCIPAL TYPE
Helvetica Neue

DIMENSIONS
23.4 x 33.1 in.
(59.4 x 84 cm)

DESIGN
Stefan Bargstedt, Philipp Dörrie,
and Betie Pankoke
Bremen, Germany

SUPPORTER
Professor Bernd Bexte

SCHOOL
Hochschule für Künste, Bremen

PRINCIPAL TYPE
FF Eureka and Lo-Res Teens

DIMENSIONS
5.8 x 7.7 in.
(14.8 x 19.5 cm)

CATALOG

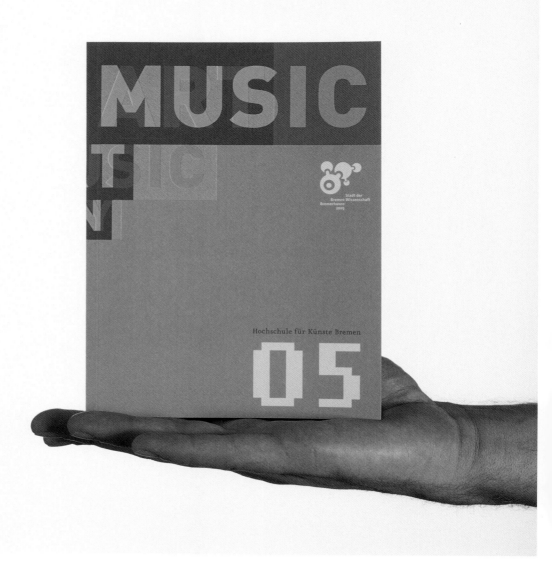

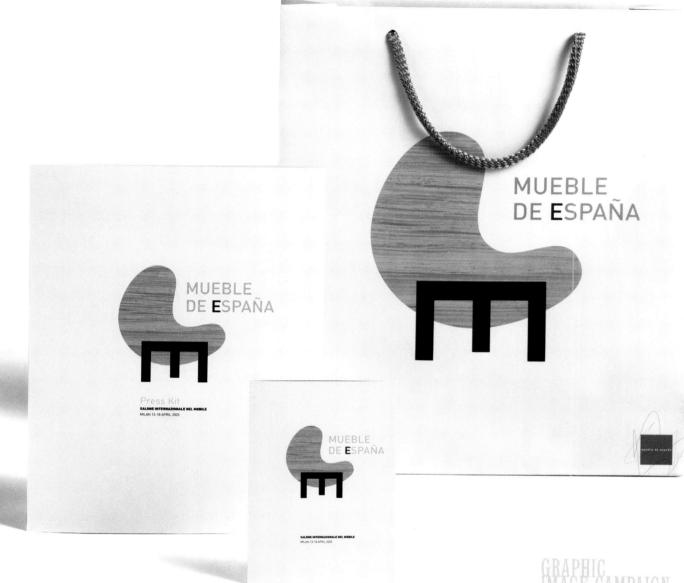

DESIGN
Ibán Ramón and Daniel Requeni
Valencia, Spain

ART DIRECTION
Ibán Ramón

CREATIVE DIRECTION
Ibán Ramón

STUDIO
Estudio Ibán Ramón

CLIENT
ICEX and Anieme

PRINCIPAL TYPE
FF DIN

DIMENSIONS
Various

STUDENT PROJECT

DESIGN
David Peacock
Seattle, Washington

SCHOOL
University of Washington

INSTRUCTOR
Annabelle Gould

PRINCIPAL TYPE
Stymie

DIMENSIONS
Various

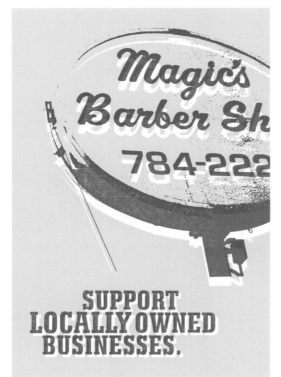

SUPPORT
LOCALLY OWNED
BUSINESSES.

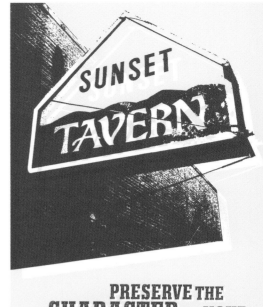

PRESERVE THE
CHARACTER OF YOUR
NEIGHBORHOOD.

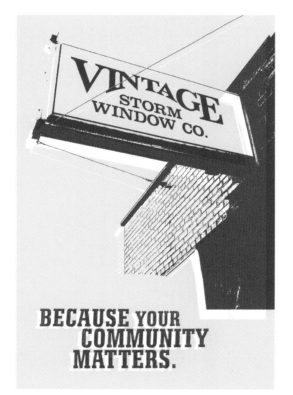

BECAUSE YOUR
COMMUNITY
MATTERS.

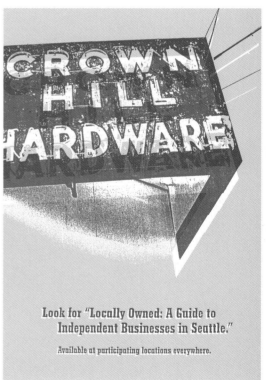

Look for "Locally Owned: A Guide to
Independent Businesses in Seattle."

Available at participating locations everywhere.

DESIGN
Brad Simon
New York, New York

ART DIRECTION
Brad Simon

CREATIVE DIRECTION
John Klotnia and Ron Louie

DESIGN OFFICE
Opto Design

PRINCIPAL TYPE
Akzidenz Grotesk and Le Corbusier

DIMENSIONS
4 x 5 in.
(10.2 x 12.7 cm)

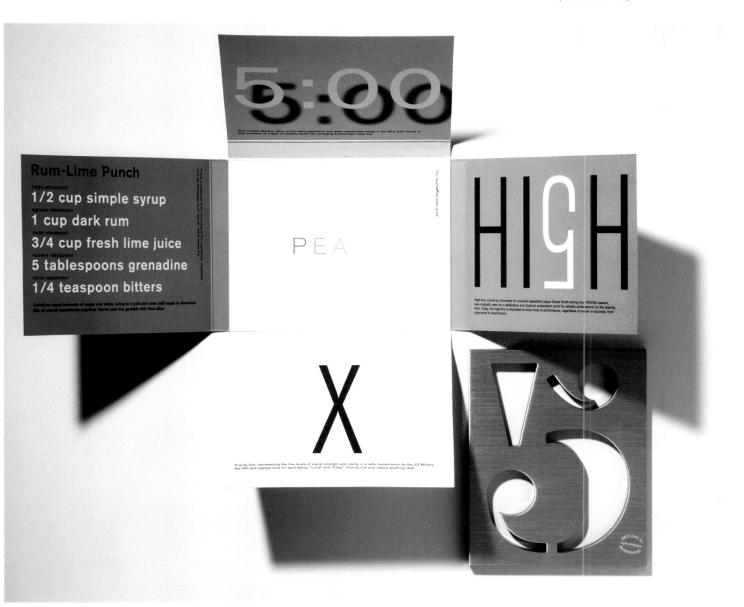

DESIGN
Anastasiya Arknipenko,
Rachel Bosley, Chase Campbell,
Eric Grzeskowiak, Jennifer Neese,
and Nick Vandeventer
West Lafayette, Indiana

SCHOOL
Purdue University

INSTRUCTOR
Dennis Y. Ichiyama

PRINCIPAL TYPEFACE
Baskerville, Bodoni Roman, Bodoni
Italic, Garamond, Times New
Roman, and Univers

DIMENSIONS
24 x 36 in.
(61 x 91.4 cm)

Anastasiya Arkhipenko

Rachel Bosley

Eric Grzeskowiak

Jennifer Neese

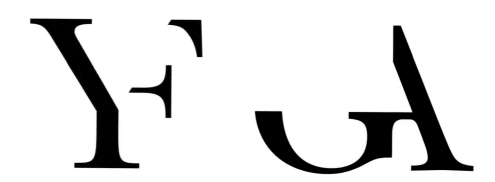

Chase Campbell

Nick Vandeventer

100

DESIGN
Takayoshi Fujimoto
Osaka, Japan

SCHOOL
Saito I.M.I. Graduate School

PROFESSOR
Akio Okumura

PRINCIPAL TYPE
Halfink

DIMENSIONS
86 x 40.6 in.
(218.4 x 103 cm)

ROOK

DESIGN
Martin Summ
Munich, Germany

LETTERING
Martin Summ

PRODUCTION
Katja Schmelz

AGENCY
KOCHAN & PARTNER GmbH

CLIENT
*designafairs, Munich, and
avedition, Ludwigsburg*

PRINCIPAL TYPE
FF Seria

DIMENSIONS
*4.9 x 7.5 in.
(12.5 x 19 cm)*

BOOK

DESIGN
Philipp von Rohden and Thees Dohrn
Berlin, Germany

ART DIRECTION
Philipp von Rohden and Thees Dohrn

CREATIVE DIRECTION
Philipp von Rohden and Thees Dohrn

DESIGN OFFICE
Zitromat

CLIENT
T-B A21

PRINCIPAL TYPE
Sabon and custom

DIMENSIONS
6.7 x 9.5 in.
(17 x 24 cm)

DESIGN
Clive Piercy and Carol Kono-Noble
Santa Monica, California

CREATIVE DIRECTION
Clive Piercy and Michael Hodgson

WRITER
Eric LaBrecque
Lafayette, California

DESIGN OFFICE
Ph.D

PRINCIPAL TYPE
Various

DIMENSIONS
3.75 x 5.5 in.
(9.5 x 14 cm)

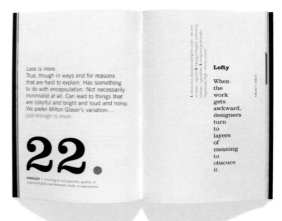

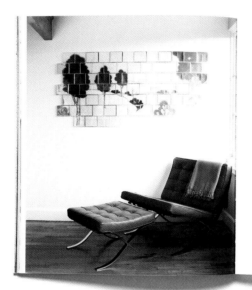

CD WALL MURAL

°02

RAW MATERIAL

Have you switched to the soft pack of CDs? Are all your empty jewel cases starting to block the way to the kitchen? Time to make something from that mess of plastic brittle. Remember, jewel cases are fabricated from Thermoset, which can't be melted down and turned into two-liter Coke bottles. It's our way or the highway to the dump for these fellers. But look at all they have to offer: protection against the elements; translucency; clean, modern lines. For all those reasons and more, use your empties to make a wall mural. It's yet another step in your march against passive domesticity.

DESIGN
Elizabeth Fitzgibbons, Eric Heiman, and Akiko Ito
San Francisco, California

ART DIRECTION
Eric Heiman

CREATIVE DIRECTION
Adam Brodsley and Eric Heiman

PHOTOGRAPHY
Jeffery Cross
Oakland, California

ILLUSTRATION
Kate Francis
Bermuda

DESIGN OFFICE
Volume, Inc.

CLIENT
ReadyMade

PRINCIPAL TYPE
FF DIN and Foundry Gridnik

DIMENSIONS
7.4 x 9 in.
(18.8 x 22.9 cm)

DESIGN
Giorgio Pesce and Roberto Muñiz
Lausanne, Switzerland

ART DIRECTION
Giorgio Pesce

CREATIVE DIRECTION
Giorgio Pesce

DESIGN OFFICE
Atelier Poisson

CLIENT
Musée Cantonal de Géologie,
Lausanne

PRINCIPAL TYPE
Gravur Condensed and Bembo

DIMENSIONS
35.2 x 50.4 in.
(89.5 x 128 cm)

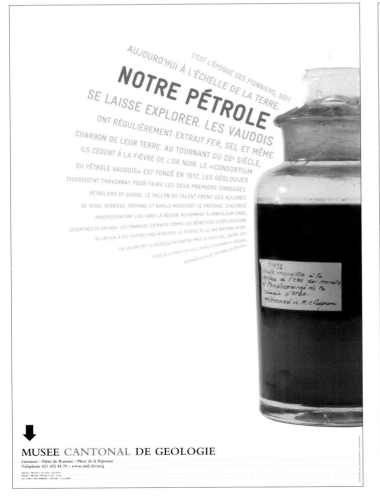

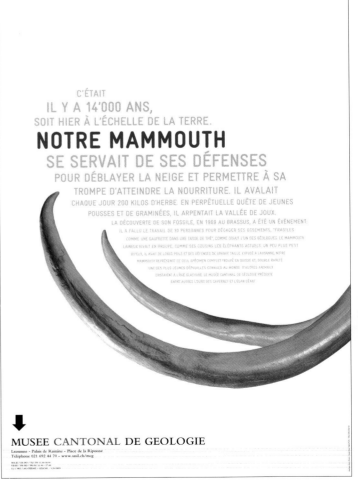

DESIGN
Oh Dong-Jun, Park Kum-Jun,
and You Na-Won
Seoul, Korea

ART DIRECTION
Park Kum-Jun

CREATIVE DIRECTION
Park Kum-Jun

LETTERING
Choi Han-Na

ILLUSTRATION
Park Kum-Jun

COORDINATORS
Kim Ji-Won, Jung Jong-In,
and Nam Seung-Youn

IMAGE REVISION
Kang Joong-Gyu

DESIGN OFFICE
601bisang

CLIENT
Visual Information Design
Association of Korea (VIDAK)

PRINCIPAL TYPE
Bembo, FF DIN Bold, FF DIN Light,
and FF DIN Regular

DIMENSIONS
8.9 x 10 in.
(22.5 x 25.5 cm)

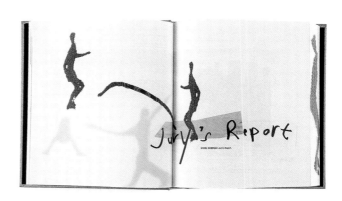

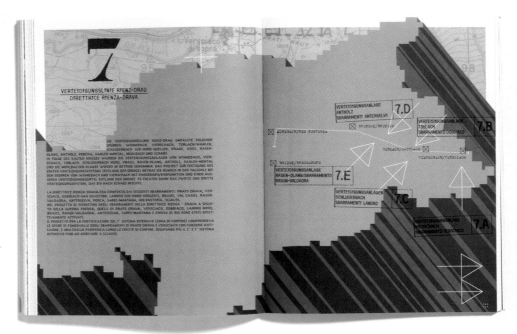

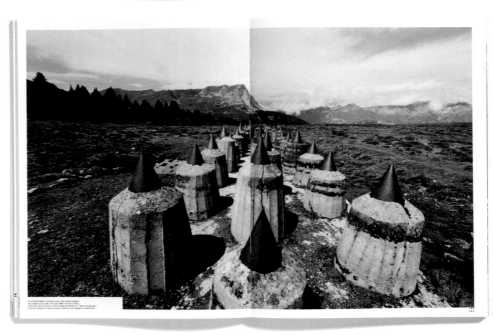

BOOK

DESIGN
Philipp Putzer
Bolzano, Italy

ART DIRECTION
Uli Prugger

CREATIVE DIRECTION
Alfonso Demetz

DESIGN OFFICE
Gruppe Gut Gestaltung

CLIENT
Provincia Autonoma di Bolzano

PRINCIPAL TYPE
Citizen, FF Flightcase, FF Meta, and FF Trixie Plain

DIMENSIONS
9.2 x 11.8 in.
(23.3 x 30 cm)

DESIGN
Carin Goldberg
Brooklyn, New York

ART DIRECTION
Carin Goldberg and Richard Wilde

CREATIVE DIRECTION
Carin Goldberg and Richard Wilde
Brooklyn, New York, and
New York, New York

PRODUCTION
Adam S. Wahler

DESIGN OFFICE
Carin Goldberg Design

CLIENT
School of Visual Arts

PRINCIPAL TYPE
Helvetica and Baskerville

DIMENSIONS
7.5 x 10.75 in.
(19.1 x 27.3 cm)

DESIGN
Noémie Darveau
Montreal, Canada

SCHOOL
École de Design, UQAM

INSRRUCTOR
Yann Mooney

PRINCIPAL TYPE
Univers Bold Condensed and custom

DIMENSIONS
27 x 39 in.
(68.6 x 99.1 cm)

DESIGN
Erin Mayes and DJ Stout
Austin, Texas

ART DIRECTION
DJ Stout

DESIGN OFFICE
Pentagram Design Inc.

CLIENT
*The Museum of Fine Arts,
Houston (MFAH)*

PRINCIPAL TYPE
ITC Conduit and Iowan

DIMENSIONS
*10.5 x 14 in.
(26.7 x 35.6 cm)*

DESIGN
Armin Lindauer
Mannheim, Germany

CLIENT
City of Darmstadt, Germany

PRINCIPAL TYPE
Thesis

DIMENSIONS
6 x 9 in.
(15 x 22.8 cm)

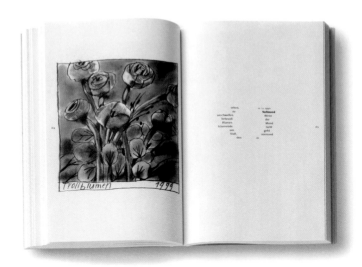

DESIGN
H. P. Becker
Wiesbaden, Germany

ART DIRECTION
H. P. Becker

PHOTOGRAPHY
Peter Poby

COPYWRITER
Cordula Becker

DESIGN OFFICE
New Cat Orange

PRINCIPAL TYPE
Bembo, Fette Fraktur,
and Helvetica Neue

DIMENSIONS
9.25 x 13.4 in.
(23.5 x 34 cm)

SO GEHT'S

MOTIV-IER DICH!

SCHLUSS MIT DEM MODEDIKTAT

Wie kommst du zu deinem ganz persönlichen Lieblings-Shirt? Ganz einfach: Besuch unseren Shop im Netz unter www.motiv-ator.de

Mach Schluss mit den müden Mode-Motiv-en! Stell dir zusammen, was dich motiv-iert und neidische Blicke garantiert! Such dir ein Motiv aus und entscheide dich für ein Shirt in der richtigen Größe. Im Angebot sind SlimFit für Jungs oder zweifarbige GirlieShirts. Stell dir einfach verschiedene Kombis per Mausklick zusammen und wähle dann deinen persönlichen Favoriten. Ab in den Warenkorb! Jetzt brauchst du die Bestellung nur noch abzuschicken. Natürlich kannst du auf dem gleichen Weg auch unsere Motiv-ator Taschen bestellen.

Nur wenige Tage später steht der Postbote mit einem Paket von uns vor deiner Tür.

Fast hätten wir das Beste vergessen. Wir haben uns eine Besonderheit für dich ganz persönlich ausgedacht: Dein T-Shirt wird in eine stylische Kartonage gepackt. Und nicht nur das – es steht auch dein Name drauf. Oder der Name deiner Freundin oder deines Freundes. Denn selbstverständlich kannst du unsere Motiv-ator Shirts auch an Freunde, Verwandte und Bekannte verschenken. Wie das funktioniert, erfährst du auf Seite 11.

Jedes Motiv-ator Shirt gibt's zum Einheitspreis von 37,50 Euro, inkl. Versand. **«**

MOTIV-ator

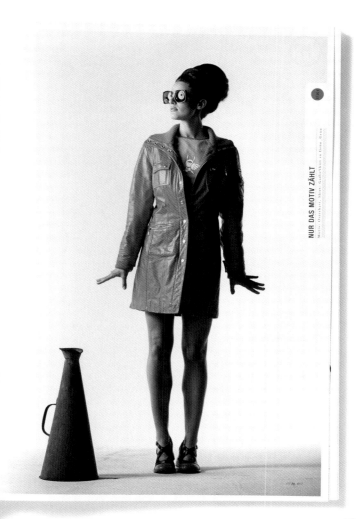

NUR DAS MOTIV ZÄHLT

DESIGN
Traian Stanescu
New York, New York

CREATIVE DIRECTION
Stefan Sagmeister

LETTERING
Stefan Sagmeister and
Traian Stanescu

PHOTOGRAPHY
Oliver Meckes and
Nicole Ottawa

DESIGN OFFICE
Sagmeister Inc.

CLIENT
Copy magazine

PRINCIPAL TYPE
Handlettering

DIMENSIONS
11.5 x 9 in.
(29.2 x 22.9 cm)

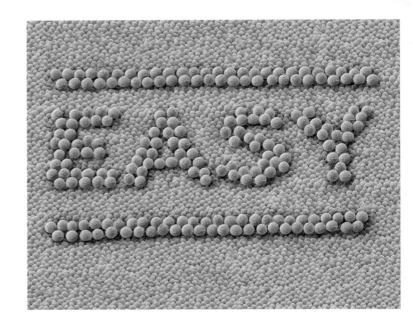

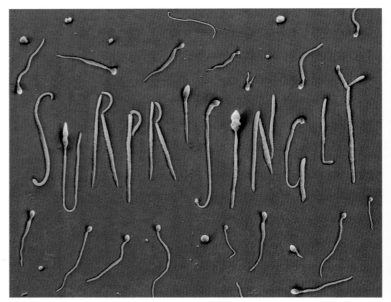

DESIGN
Paul Belford
London, England

ART DIRECTION
Paul Belford

CREATIVE DIRECTION
Paul Belford and Nigel Roberts

LETTERING
Paul Belford

AGENCY
AMV BBDO

CLIENT
The Economist

PRINCIPAL TYPE
Handlettering

DIMENSIONS
19.25 x 28.9 in.
(48.9 x 73.3 cm)

DESIGN
Jason Godfrey
London, England

CREATIVE DIRECTION
Jason Godfrey

DESIGN OFFICE
Godfrey Design

PRINCIPAL TYPE
Caslon and News Gothic

DIMENSIONS
23.4 x 33.1 in.
(59.4 x 84 cm)

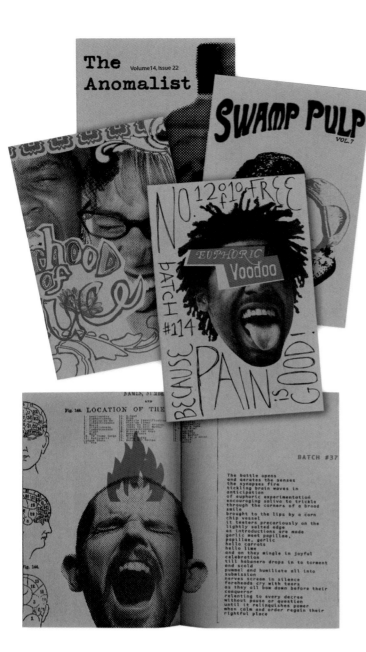

BROCHURE

DESIGN
*Kyle Anthony, Eric Haag,
and Kendra Inman*
Kansas City, Missouri

CREATIVE DIRECTION
Robin Knight

ILLUSTRATION
*Kyle Anthony, Eric Carver,
Eric Haag, and Kendra Inman*

COPYWRITERS
*Rick Dunn, James Holden,
and John Lightstone*

DESIGN OFFICE
Barkley Evergreen and Partners

CLIENT
Original Juan's

PRINCIPAL TYPE
*Courier, House Las Vegas Fabulous,
Myriad, Typeka, and handlettering*

DIMENSIONS
*5.5 x 8.5 in.
(14 x 21.6 cm)*

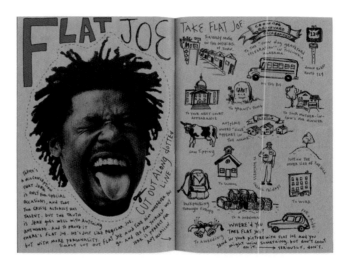

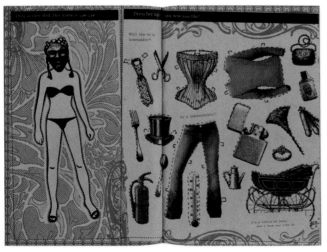

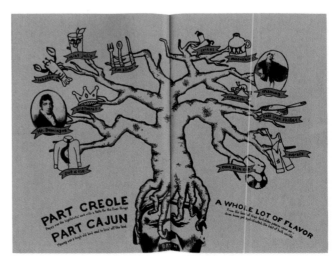

DESIGN
Richard The and Ariane Spiranni
Berlin, Germany

CREATIVE DIRECTION
Stefan Sagmeister
New York, New York

LETTERING
Richard The and Ariane Spiranni

PHOTOGRAPHY
Richard The and Ariane Spiranni

ILLUSTRATION
Richard The and Ariane Spiranni

DESIGN OFFICE
Sagmeister Inc.

CLIENT
Anni Kuan Design

PRINCIPAL TYPE
Handlettering

DIMENSIONS
16 x 23 in.
(40.6 x 58.4 cm)

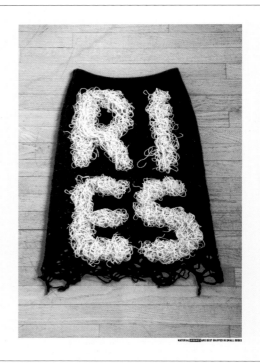

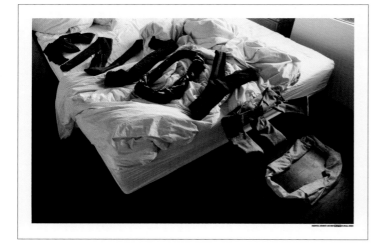
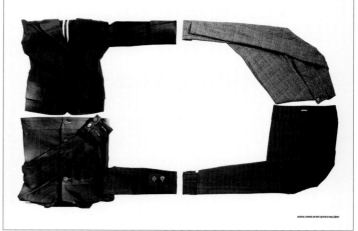

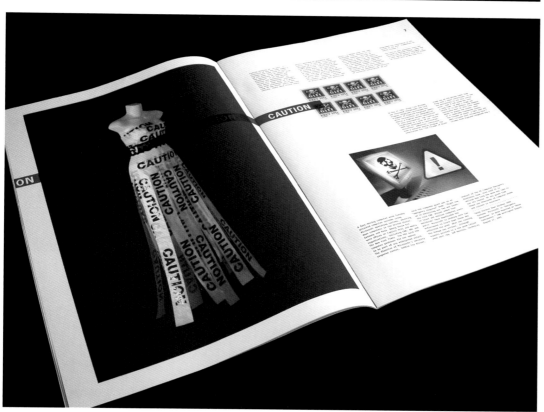

DESIGN
Geoff Halber
Falls Village, Connecticut

ART DIRECTION
William Drenttel and Jessica Helfand

CREATIVE DIRECTION
William Drenttel and Jessica Helfand

STUDIO
Winterhouse Studio

CLIENT
Winterhouse Institute

PRINCIPAL TYPE
Fedra Mono

DIMENSIONS
10.5 x 16 in.
(26.7 x 40.6 cm)

DESIGN
*Stephanie Zehender
and Kirsten Dietz*
Stuttgart, Germany

ART DIRECTION
Kirsten Dietz

CREATIVE DIRECTION
Jochen Rädeker

LETTERING
Stephanie Zehender

PHOTOGRAPHY
Armin Brosch
Munich, Germany

AGENCY
strichpunkt

CLIENT
Papierfabrik Scheufelen

PRINCIPAL TYPE
Univers and FF Scala

DIMENSIONS
*9.1 x 12.6 in.
(23 x 32 cm)*

INTELLIGENT DESIGN

CREATING AN EVOLVED RED VS BLUE STATE OF MIND

THE THIRST THEORY

BROCHURE

DESIGN
Robb Irrgang, John Pobojewski,
Rick Valicenti, and
Gina Vieceli-Garza
Barrington, Illinois

ART DIRECTION
Rick Valicenti

CREATIVE DIRECTION
Rick Valicenti

PHOTOGRAPHY
Gina Vieceli-Garza

ILLUSTRATION
Gina Vieceli-Garza

PROGRAMMER
Robb Irrang

STUDIO
Thirst

PRINCIPAL TYPE
Kroeger 05-53

DIMENSIONS
16 x 20 in.
(40.6 x 50.8 cm)

DESIGN
Chris Hoch, Beth Singer,
Howard Smith,
and Sucha Snidvongs
Arlington, Virginia

ART DIRECTION
Beth Singer

CREATIVE DIRECTION
Howard Smith

DESIGN OFFICE
Beth Singer Design, LLC

CLIENT
American Institute of Graphic Arts,
Washington, D.C.

PRINCIPAL TYPE
Interstate and FF Meta Plus

DIMENSIONS
25 x 22 in.
(63.5 x 55.9 cm)

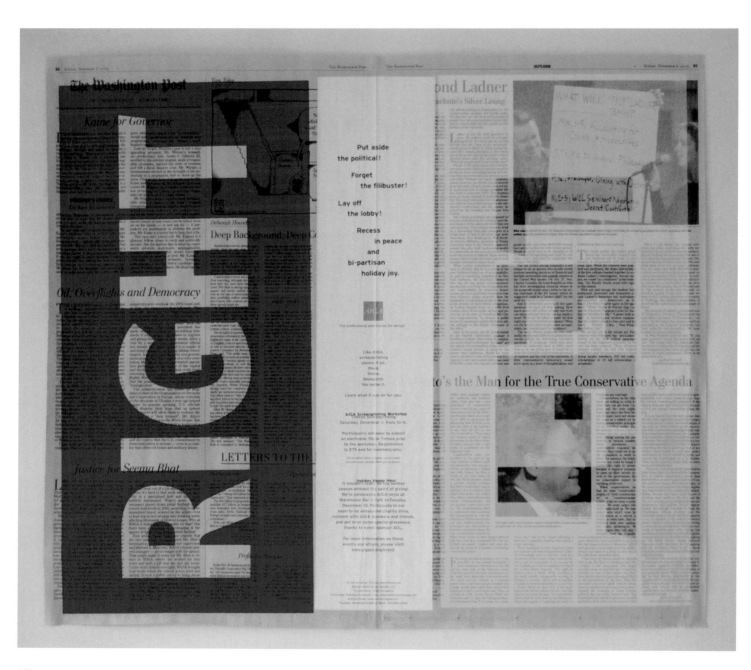

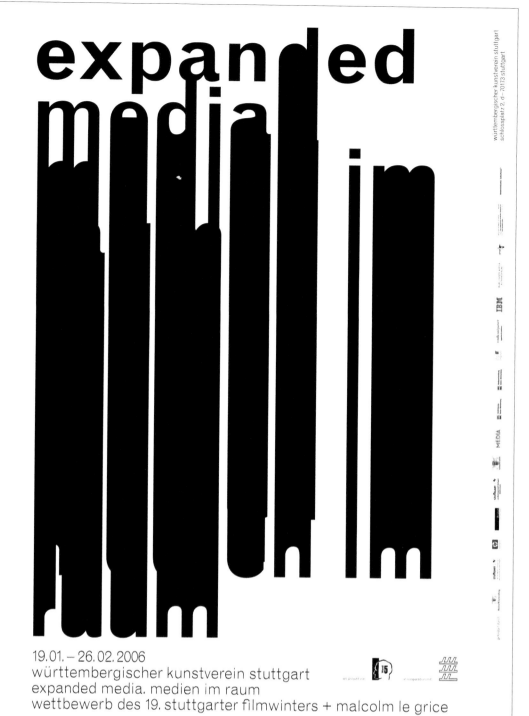

DESIGN
Sascha Lobe and Ina Bauer
Stuttgart, Germany

DESIGN OFFICE
L2M3 Kommunikationsdesign GmbH

CLIENT
Württembergischer Kunstverein
Stuttgart, Germany

PRINCIPAL TYPE
Monotype Grotesque

DIMENSIONS
23.4 x 33.1 in.
(59.4 x 84.1 cm)

DESIGN
Susanne Hörner
Stuttgart, Germany

ART DIRECTION
Kirsten Dietz

CREATIVE DIRECTION
Jochen Rädeker and Felix Widmaier

LETTERING
Susanne Hörner

AGENCY
strichpunkt

CLIENT
Art Directors Club Deutschland

PRINCIPAL TYPE
Various

DIMENSIONS
8.3 x 10.6 in.
(21 x 27 cm)

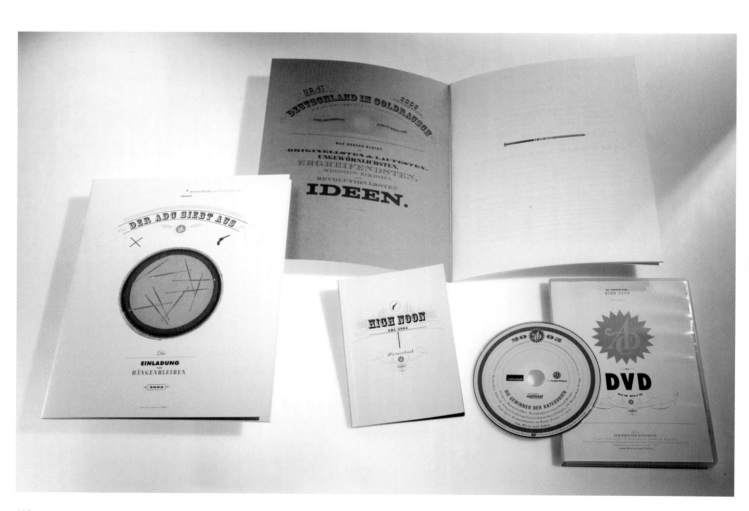

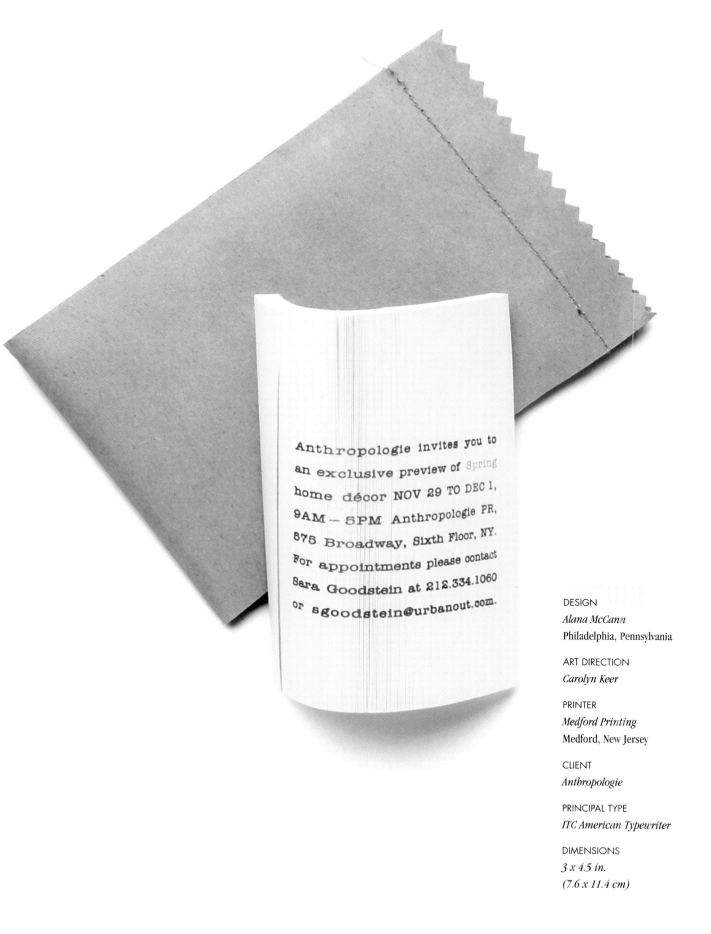

Anthropologie invites you to an exclusive preview of Spring home décor NOV 29 TO DEC 1, 9AM – 5PM Anthropologie PR, 575 Broadway, Sixth Floor, NY. For appointments please contact Sara Goodstein at 212.334.1060 or sgoodstein@urbanout.com.

DESIGN
Alana McCann
Philadelphia, Pennsylvania

ART DIRECTION
Carolyn Keer

PRINTER
Medford Printing
Medford, New Jersey

CLIENT
Anthropologie

PRINCIPAL TYPE
ITC American Typewriter

DIMENSIONS
3 x 4.5 in.
(7.6 x 11.4 cm)

DESIGN
Thomas Markl
Munich, Germany

ART DIRECTION
Thomas Markl

CREATIVE DIRECTION
Stefan Bogner

LETTERING
Oliver Koftalki and Thomas Markl

AGENCY
Factor Product GmbH

CLIENT
Great Stuff GmbH

PRINCIPAL TYPE
Rinzen Bits

DIMENSIONS
12.4 x 12.3 in.
(31.5 x 31.3 cm)

DESIGN
Susanne Hörner and Felix Widmaier
Stuttgart, Germany

ART DIRECTION
Kirsten Dietz

CREATIVE DIRECTION
Kirsten Dietz and Jochen Rädeker

AGENCY
strichpunkt

CLIENT
Papierfabrik Scheufelen

PRINCIPAL TYPE
FF Scala

DIMENSIONS
24.4 x 31.5 in.
(62 x 80 cm)

DESIGN
Koen Geurts, Marenthe Otten,
and Floris Schrama
The Hague, The Netherlands

ART DIRECTION
Koen Geurts and Marenthe Otten

DESIGN OFFICE
Studio 't Brandt Weer

PRINCIPAL TYPE
AT Riot, Tarzana Narrow,
and handmade type

DIMENSIONS
7.7 x 10.2 in.
(19.5 x 26 cm)

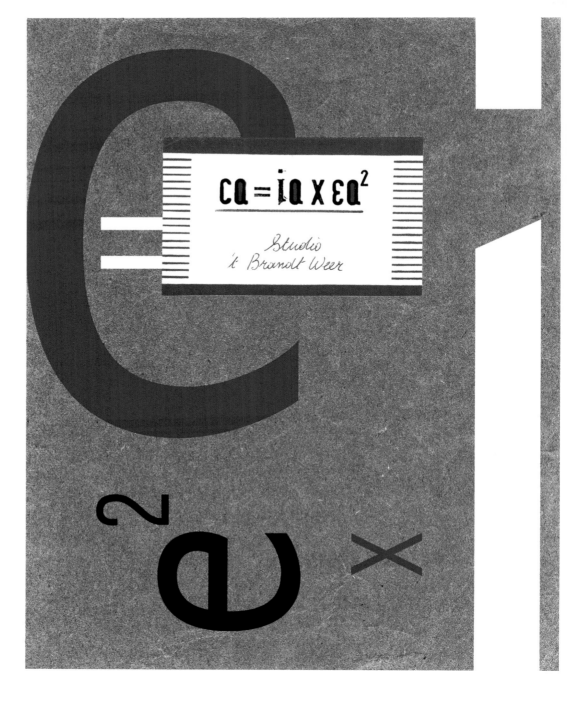

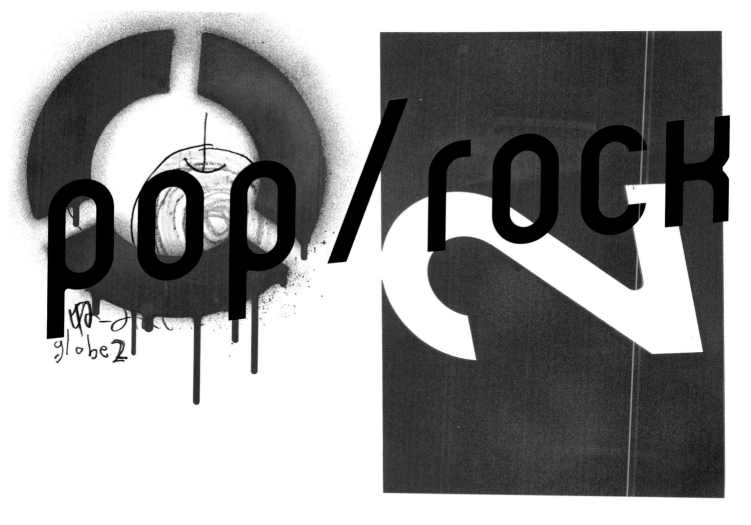

POSTER

DESIGN
Katsunori Aoki
Tokyo, Japan

ART DIRECTION
Katsunori Aoki

CREATIVE DIRECTION
Katsunori Aoki

ILLUSTRATION
Shuzo Hayashi

DESIGN OFFICE
Butterfly • Stroke Inc.

CLIENT
AVEX ENTERTAINMENT INC.

PRINCIPAL TYPE
Afloat

DIMENSIONS
75.1 x 53.2 in.
(190.8 x 135 cm)

DESIGN
*Lonny Israel, Alan Sinclair,
and Brad Thomas*
San Francisco, California

LETTERING
Brad Thomas

ARCHITECT
*Kye Archuleta, Michael Duncan,
and Patricia Yeh*

DESIGN OFFICE
Skidmore, Owings & Merrill LLP

CLIENT
*Chongqing Financial Street Real
Estate, Ltd.*

PRINCIPAL TYPE
Handlettering

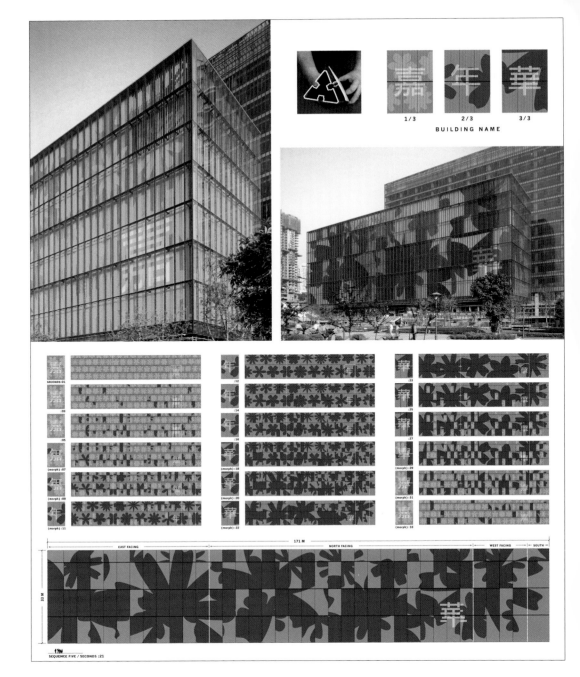

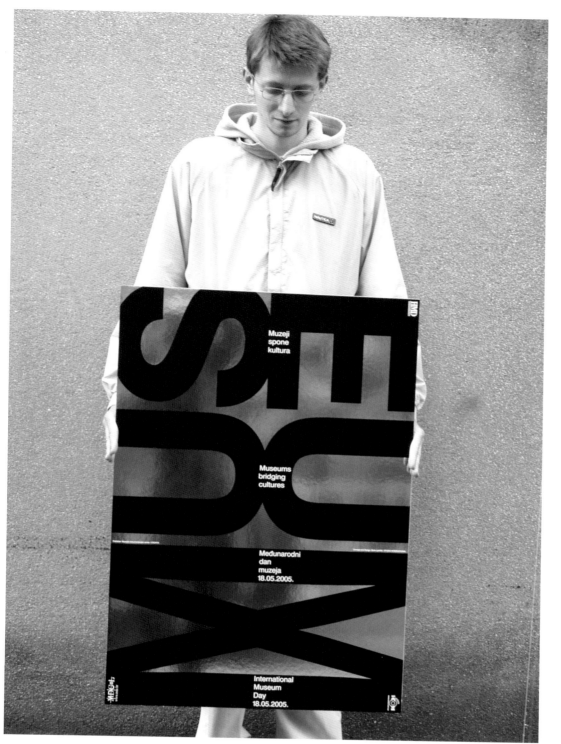

DESIGN
Boris Ljubicic
Zagreb, Croatia

ART DIRECTION
Boris Ljubicic

CREATIVE DIRECTION
Boris Ljubicic

STUDIO
Studio International

CLIENT
Museum Documentation Centre,
Croatia

PRINCIPAL TYPE
Helvetica Medium

DIMENSIONS
26.8 x 38.6 in.
(68 x 98 cm)

DESIGN
Richard Kegler and Colin Kahn
Buffalo, New York

ART DIRECTION
Richard Kegler

CREATIVE DIRECTION
Richard Kegler

PRINTER AND PACKAGE FORMAT
Bruce Licher
Sedona, Arizona

STUDIO
P22

CLIENT
P22 Records

PRINCIPAL TYPE
LTC Caslon family

DIMENSIONS
5.5 x 5 in.
(14 x 12.7 cm)

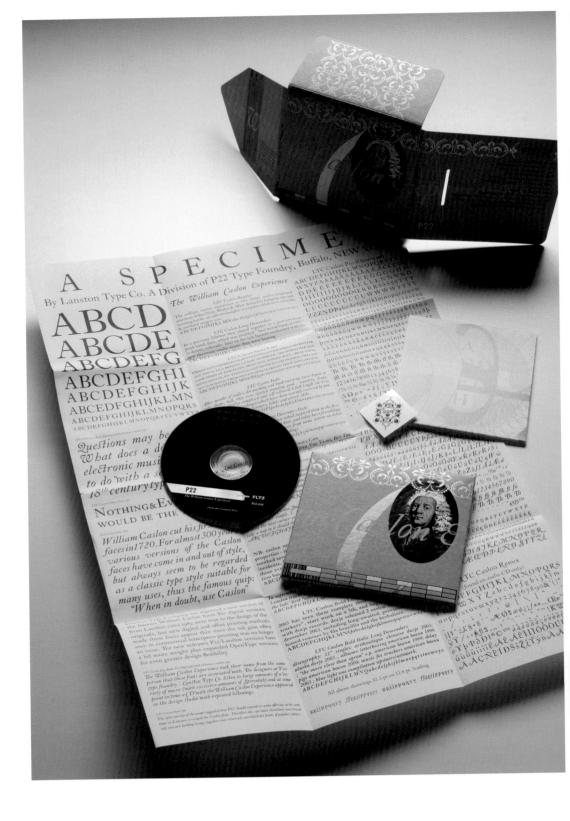

DESIGN
Maja Bagic
Zagreb, Croatia

ART DIRECTION
Maja Bagic

AGENCY
Bruketa&Zinic

CLIENT
Adris Group

PRINCIPAL TYPE
Didot

DIMENSIONS
13.4 x 9.25 in.
(34 x 23.5 cm)

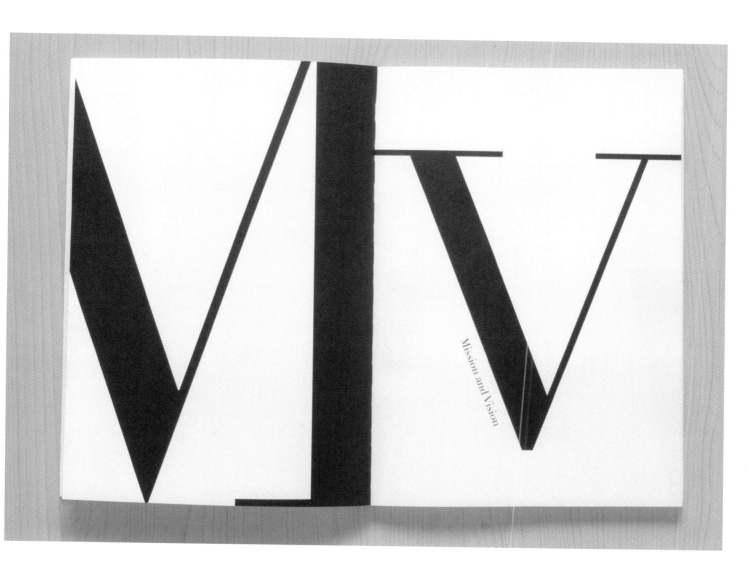

DESIGN
Kelly Atkins, Nancy Caal,
and Brad Simon
New York, New York

ART DIRECTION
John Klotnia and Brad Simon

CREATIVE DIRECTION
John Klotnia

DESIGN OFFICE
Opto Design

CLIENT
Alexandria Real Estate Equities, Inc.

PRINCIPAL TYPE
Trade Gothic and Bembo

DIMENSIONS
6 x 9 in.
(15.2 x 22.9 cm)

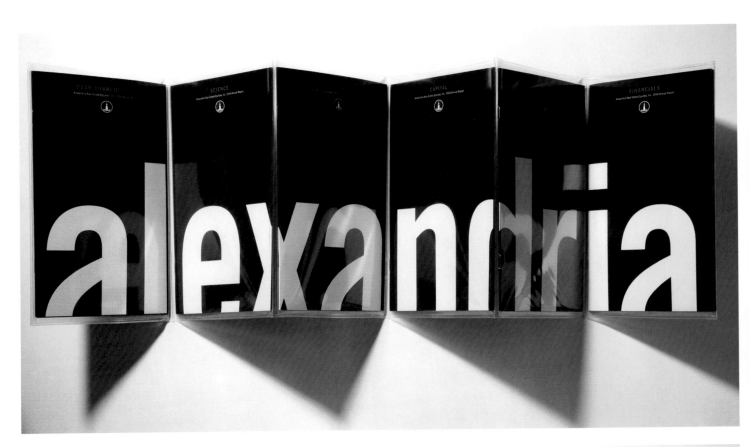

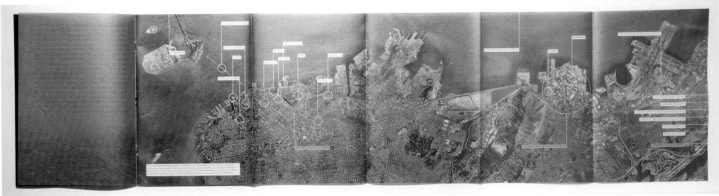

FOOD

ANNUAL REPORT

DESIGN
Davor Bruketa and Nikola Zinic
Zagreb, Croatia

ART DIRECTION
Davor Bruketa and Nikola Zinic

CREATIVE DIRECTION
Davor Bruketa and Nikola Zinic

PHOTOGRAPHY
Marin Topic and Domagoj Kunic

AGENCY
Bruketa&Zinic

CLIENT
Podravka d.d.

PRINCIPAL TYPE
DIN, Minion, and Milton

DIMENSIONS
8.9 x 10.5 in.
(22.5 x 26.7 cm)

DESIGN
Iran Narges
San Francisco, California

SCHOOL
California College of the Arts

INSTRUCTOR
Emily McVarish

PRINCIPAL TYPE
ITC Fenice

DIMENSIONS
8 x 10 in.
(20.3 x 25.4 cm)

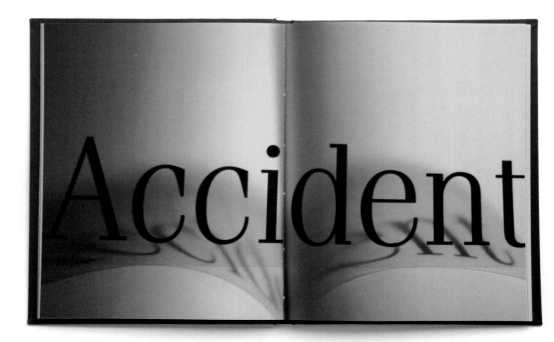

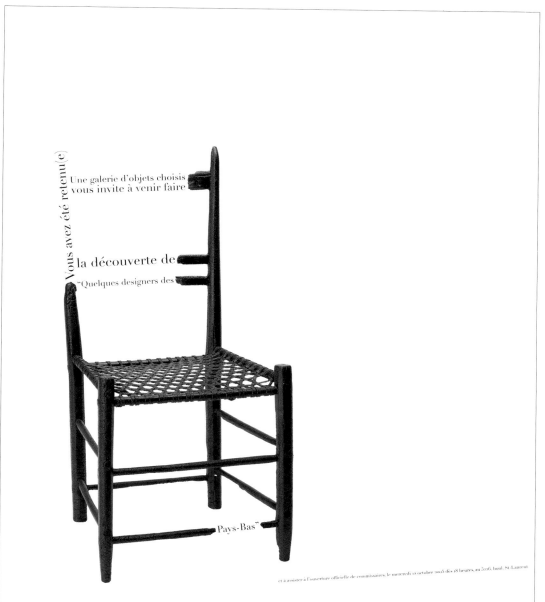

Vous avez été retenu(e)

Une galerie d'objets choisis
vous invite à venir faire

la découverte de

"Quelques designers des

Pays-Bas"

et à assister à l'ouverture officielle de commissaires, le mercredi 12 octobre 2005 dès 18 heures, au 5226, boul. St-Laurent

DESIGN
David Guarnieri
Montreal, Canada

ART DIRECTION
David Guarnieri and Rene Clement

CREATIVE DIRECTION
Louis Gagnon

DESIGN OFFICE
Paprika

CLIENT
Commissaires

PRINCIPAL TYPE
Didot

DIMENSIONS
32 x 40 in.
(81.3 x 101.6 cm)

STUDENT PROJECT

DESIGN
Kate Rascoe
San Francisco, California

SCHOOL
California College of the Arts

INSTRUCTOR
Emily McVarish

PRINCIPAL TYPE
Freeband 521, Helvetica Neue,
Orator, and wood type ornaments

DIMENSIONS
14 x 8 in.
(35.6 x 20.3 cm)

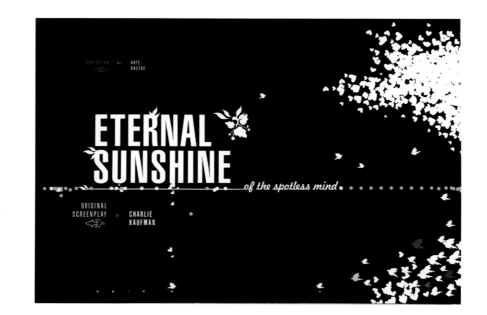

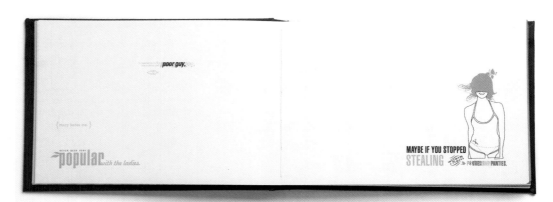

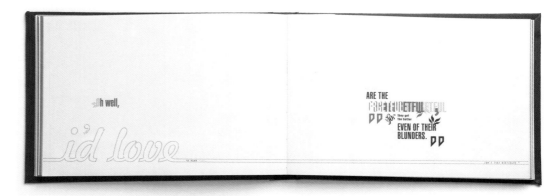

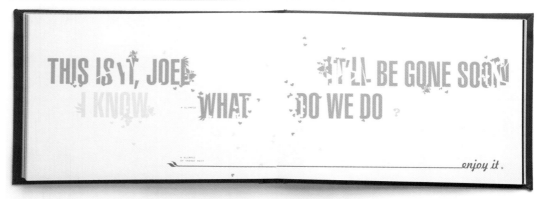

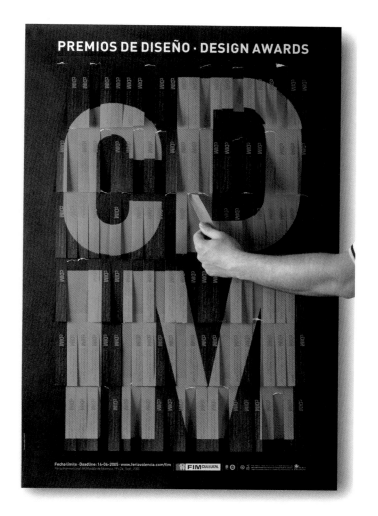

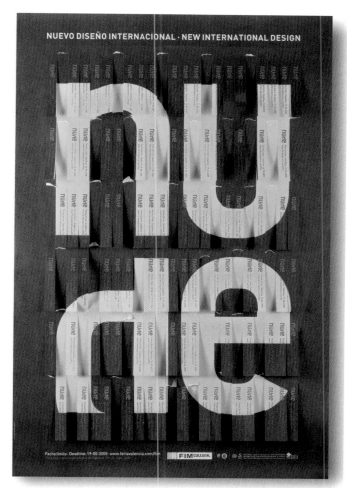

DESIGN
Pepe Gimeno and Dídac Ballester
Valencia, Spain

DESIGN STUDIO
Pepe Gimeno Proyecto Grafico

CLIENT
Feria Internacional del Mueble de Valencia

PRINCIPAL TYPE
FF DIN

DIMENSIONS
27.6 x 39.4 in.
(70 x 100 cm)

DESIGN
Klaus Hesse
Erkrath, Germany

DESIGN OFFICE
Hesse Design

CLIENT
HfG Offenbach

PRINCIPAL TYPE
Corporate S

DIMENSIONS
27.6 x 39.4 in.
(70 x 100 cm)

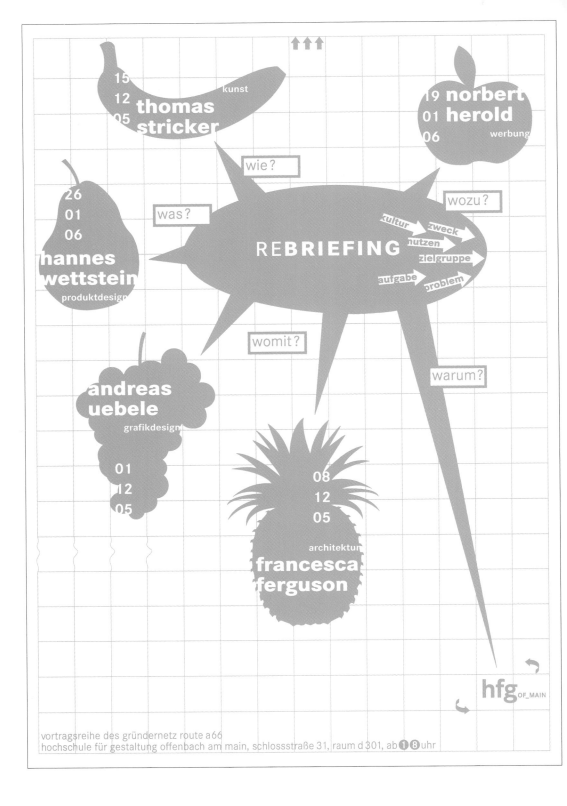

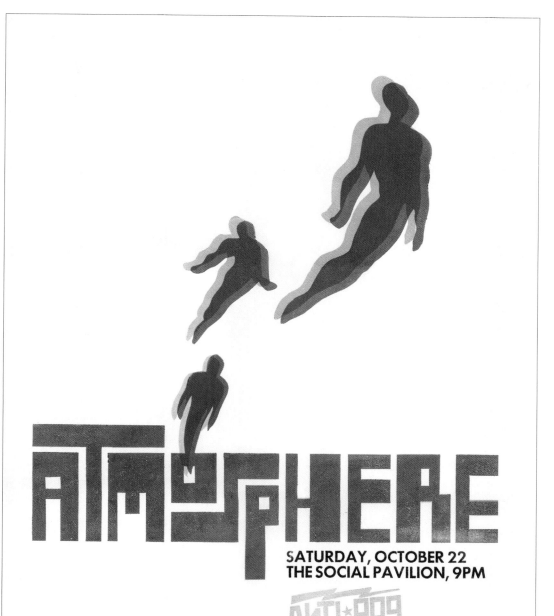

DESIGN
Dirk Fowler
Lubbock, Texas

STUDIO
f2 design

CLIENT
Anti-Pop Festival

PRINCIPAL TYPE
Handcut and Twentieth Century

DIMENSIONS
18 x 24 in.
(45.7 x 61 cm)

DESIGN
Pazu Lee Ka Ling
Shenzhen, China

ART DIRECTION
Pazu Lee Ka Ling

LETTERING
Pazu Lee Ka Ling

CLIENT
*Shenzhen Graphic Design
Association*

PRINCIPAL TYPE
Custom and handlettering

DIMENSIONS
*27.6 x 39.4 in.
(70 x 100 cm)*

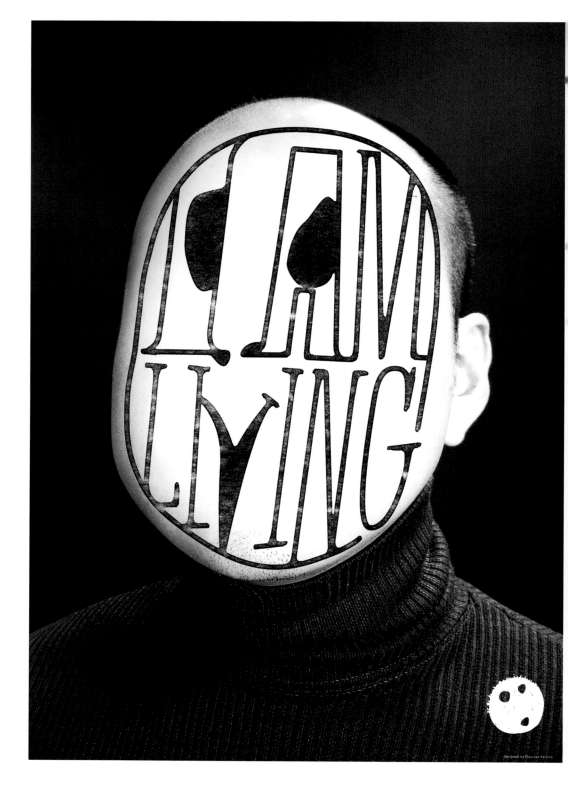

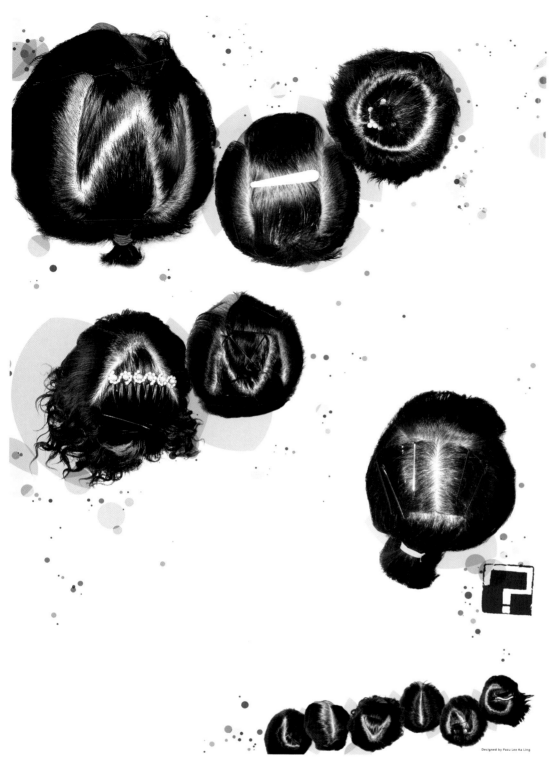

Designed by Pazu Lee Ka Ling

DESIGN
Pazu Lee Ka Ling
Shenzhen, China

ART DIRECTION
Pazu Lee Ka Ling

CLIENT
Shenzhen Graphic Design
Association

PRINCIPAL TYPE
Custom

DIMENSIONS
27.6 x 39.4 in.
(70 x 100 cm)

DESIGN
Niklaus Troxler
Willisau, Switzerland

LETTERING
Niklaus Troxler

DESIGN OFFICE
Niklaus Troxler Design

CLIENT
Jazz in Willisau

PRINCIPAL TYPE
Custom

DIMENSIONS
35.6 x 50.4 in.
(90.5 x 128 cm)

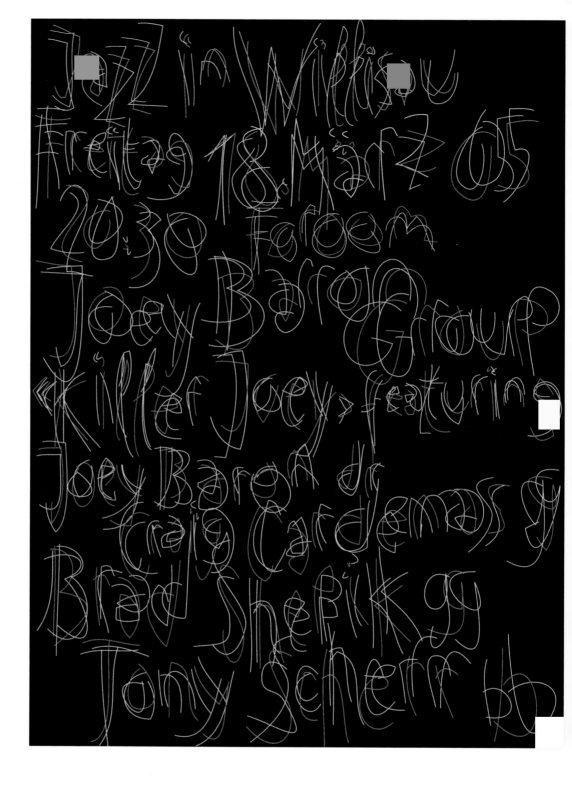

DESIGN
Domenic Lippa and Paul Skerm
London, England

ART DIRECTION
Domenic Lippa

CREATIVE DIRECTION
Domenic Lippa

TYPOGRAPHER
Domenic Lippa

DESIGN OFFICE
Lippa Pearce Design

CLIENT
Heal & Son

PRINCIPAL TYPE
Helvetica Heavy (85), Helvetica Light (45), and Helvetica Roman (55)

DIMENSIONS
Various

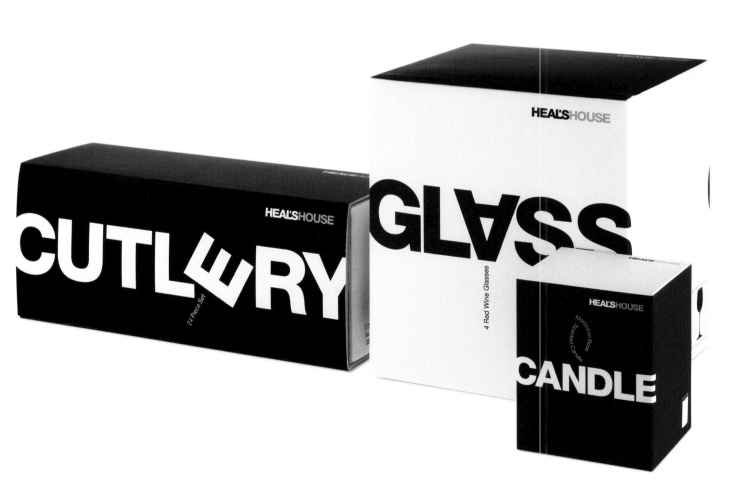

DESIGN
Stephen Doyle
New York, New York

CREATIVE DIRECTION
Stephen Doyle

DESIGN OFFICE
Doyle Partners

CLIENT
Stora Enso

PRINCIPAL TYPE
Custom

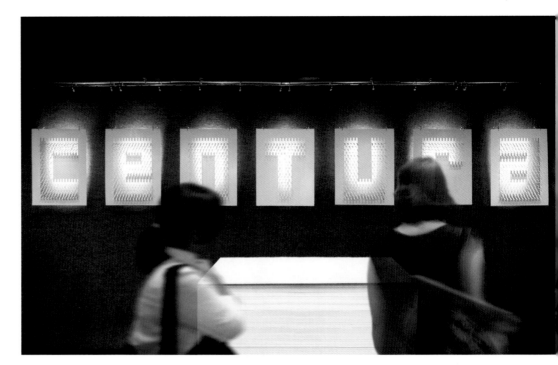

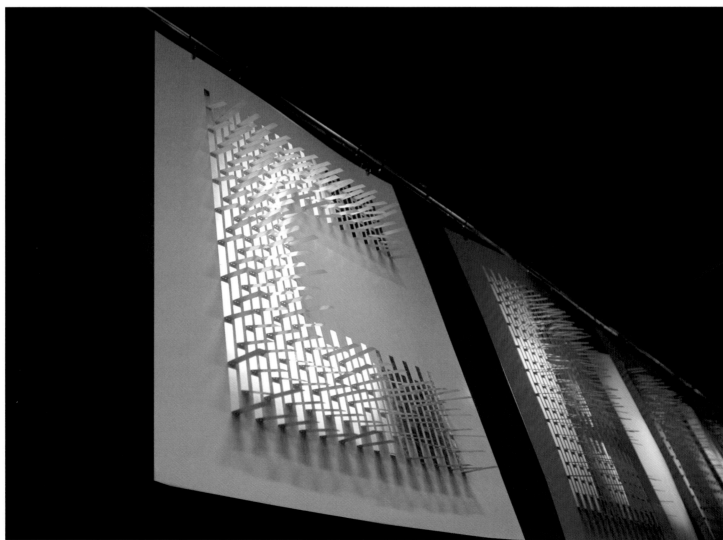

DESIGN
Eric Cai Shi Wei
Beijing, China

ART DIRECTION
Eric Cai Shi Wei

CREATIVE DIRECTION
Eric Cai Shi Wei

DESIGN OFFICE
Eric Cai Design Co.

PRINCIPAL TYPE
Times New Roman

DIMENSIONS
25.6 x 35.4 in.
(65 x 90 cm)

DESIGN
Ken Sakurai
Minneapolis, Minnesota

CREATIVE DIRECTION
Dan Olson

COPYWRITER
Lisa Pemrick

DESIGN OFFICE
Duffy & Partners

CLIENT
Thymes

PRINCIPAL TYPE
Bryant and Bulldog

DIMENSIONS
Various

DESIGN
Amanda Lawrence
New Canaan, Connecticut

CREATIVE DIRECTION
Amanda Lawrence and Dave Lyon
New Canann and
Norwalk, Connecticut

LETTERING
Ian Brignell
Toronto, Canada

DESIGN OFFICE
White Dot Inc.

CLIENT
Bath and Body Works

PRINCIPAL TYPE
*AT Sackers Antique Solid
and Trade Gothic*

DIMENSIONS
Various

DESIGN
Clive Piercy and Carol Kono-Noble
Santa Monica, California

CREATIVE DIRECTION
Clive Piercy and Michael Hodgson

LETTERING
Clive Piercy and Carol Kono-Noble

DESIGN OFFICE
Ph.D

CLIENT
Nook Bistro

PRINCIPAL TYPE
News Gothic and handlettering

DIMENSIONS
Various

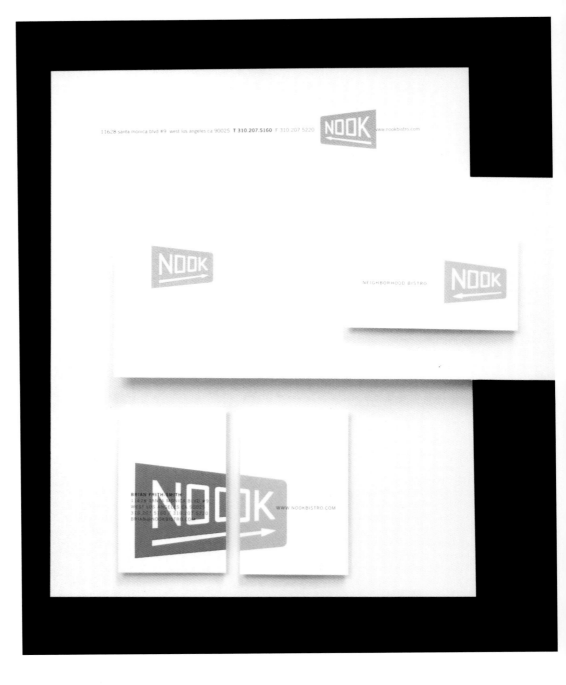

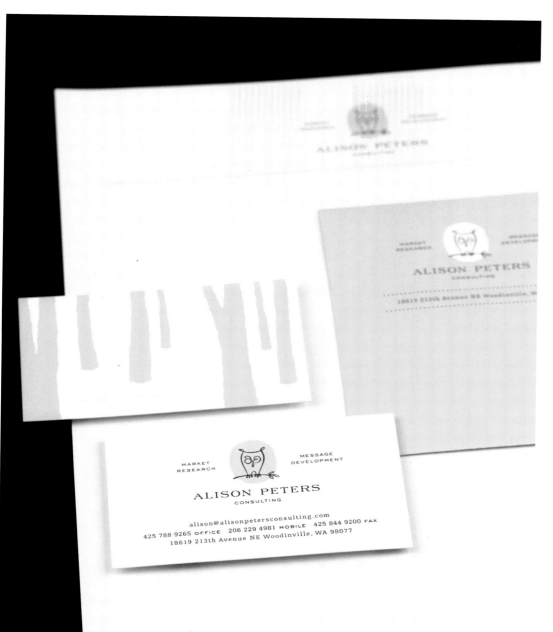

DESIGN
Pat Snavely
Seattle, Washington

DESIGN OFFICE
Partly Sunny

CLIENT
Alison Peters Consulting

PRINCIPAL TYPE
Egyptienne, Engravers Roman, and AT Sackers Gothic

DIMENSIONS
Various

PACKAGING

DESIGN
Giorgio Davanzo
Seattle, Washington

DESIGN OFFICE
Giorgio Davanzo Design

CLIENT
Facelli Winery

PRINCIPAL TYPE
Clarendon and wood type

DIMENSIONS
7.75 x 2.25 in.
(19.7 x 5.7 cm)

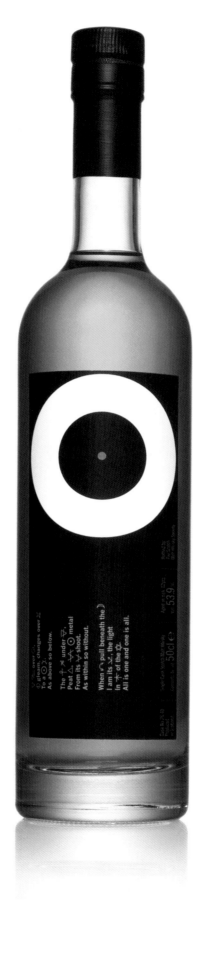

PACKAGING

DESIGN
Harry Pearce
London, England

ART DIRECTION
Harry Pearce

CREATIVE DIRECTION
Harry Pearce

TYPOGRAPHER
Harry Pearce

WRITER
John Simmons

DESIGN OFFICE
Lippa Pearce Design

CLIENT
*"26" and The Scotch Malt
Whiskey Society*

PRINCIPAL TYPE
*News Gothic Bold and News Gothic
Extra Condensed*

Dimensions
*2.4 x 5.5 in.
(6 x 14 cm)*

DESIGN
Martin Summ and
Claudia Bannwarth
Munich, Germany

PRODUCTION
Katja Schmelz

CLIENT
Claudia Bannwarth

PRINCIPAL TYPE
Locator

DIMENSIONS
Various

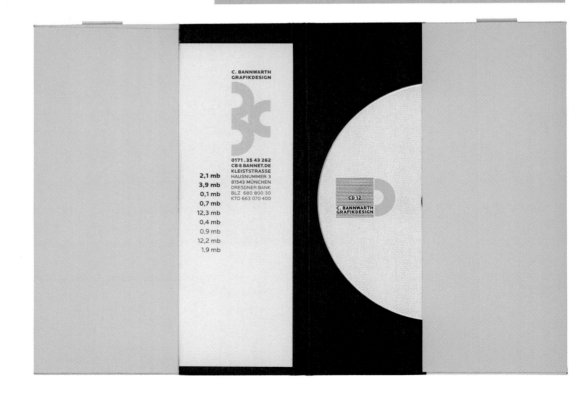

DESIGN
Richard Boynton
Minneapolis, Minnesota

ART DIRECTION
Richard Boynton and Scott Thares

CREATIVE DIRECTION
Richard Boynton and Scott Thares

LETTERING
Richard Boynton

DESIGN OFFICE
Wink

CLIENT
Copycats

PRINCIPAL TYPE
*Futura, Monterey, and
Trade Gothic Extended*

DIMENSIONS
Various

712 ONTARIO AVENUE WEST MINNEAPOLIS, MN 55403 PHONE (612) 371-8008 FAX (612) 371-8011 TOLL FREE (888) 698-8008

HI-FI MEDIA

JOSHUA WERT

JOSHUA.WERT@COPYCATSMEDIA.COM

712 ONTARIO AVENUE WEST MINNEAPOLIS, MN 55403

PHONE (612) 371-8008 FAX (612) 371-8011

TOLL FREE (888) 698-8008 *COPYCATSMEDIA.COM*

COPYCATSMEDIA.COM

DESIGN
*Marie-Élaine Benoît
and Laurence Pasteels*
Montreal, Canada

CREATIVE DIRECTION
HéI'ene Godin

LETTERING
Graphiques M&H

PHOTOGRAPHY
Raoul Manuel Schnell

ILLUSTRATION
Jo Tyler and Gérard Dubois
Boston, Massachusetts,
and Montreal, Canada

PRODUCER
Peter Pigeon

WRITERS
*Marìeve Guertin-Blanchette
and Jonathan Rosman*

AGENCY
Diesel

CLIENT
Les Fromages Saputo

PRINCIPAL TYPE
Nathalie Gamache

DIMENSIONS
Various

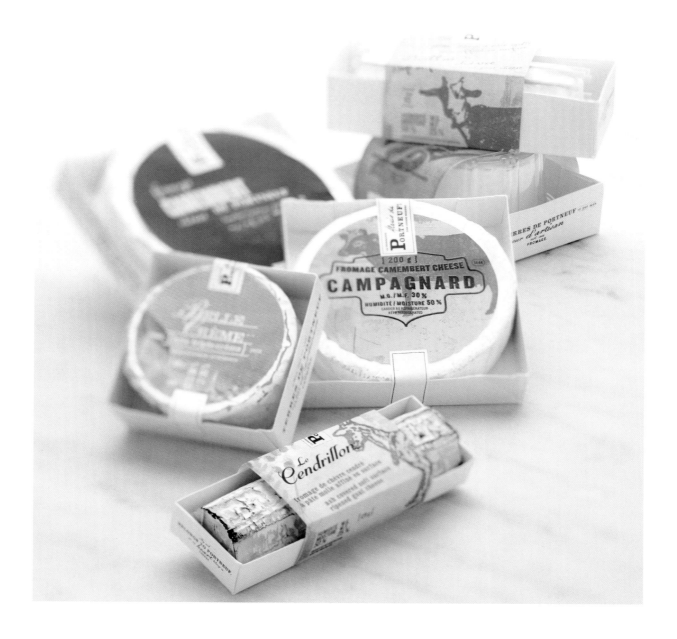

DESIGN
Thomas Markl and Stephanie Hugel
Munich, Germany

ART DIRECTION
Thomas Markl and Stefan Bogner

CREATIVE DIRECTION
Stefan Bogner

LETTERING
Thomas Markl and Stephanie Hugel

AGENCY
Factor Product GmbH

CLIENT
Kosmo Records

PRINCIPAL TYPE
*ITC Edwardian Script, Trade Gothic
Condensed, and handlettering*

DIMENSIONS
*23.4 x 33.1 in.
(59.4 x 84.1 cm)*

DESIGN
Scott Thares and Richard Boynton
Minneapolis, Minnesota

CREATIVE DIRECTION
Richard Boynton and Scott Thares

DESIGN OFFICE
Wink

CLIENT
Girard Management

PRINCIPAL TYPE
Clarendon, HTF Gotham,
and Monoline Script

DIMENSIONS
Various

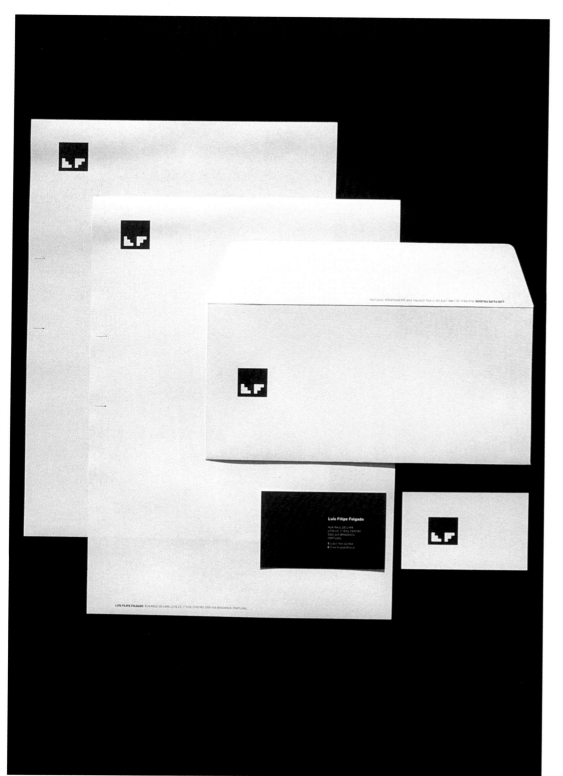

DESIGN
Vitor Quelhas
Maia, Portugal

CLIENT
Luis Filipe Folgado

PRINCIPAL TYPE
LF and FF DIN

DIMENSIONS
14.2 x 17.9 in.
(36 x 45.5 cm)

DESIGN
Guy Pask and Kerry Argus
Christchurch, New Zealand

ART DIRECTION
Guy Pask

CREATIVE DIRECTION
Guy Pask and Douglas Maclean

LETTERING
Guy Pask

STUDIO
Strategy Design & Advertising

CLIENT
Bell Hill Vineyard

PRINCIPAL TYPE
Futura and Indian typeface redrawn

DIMENSIONS
Various

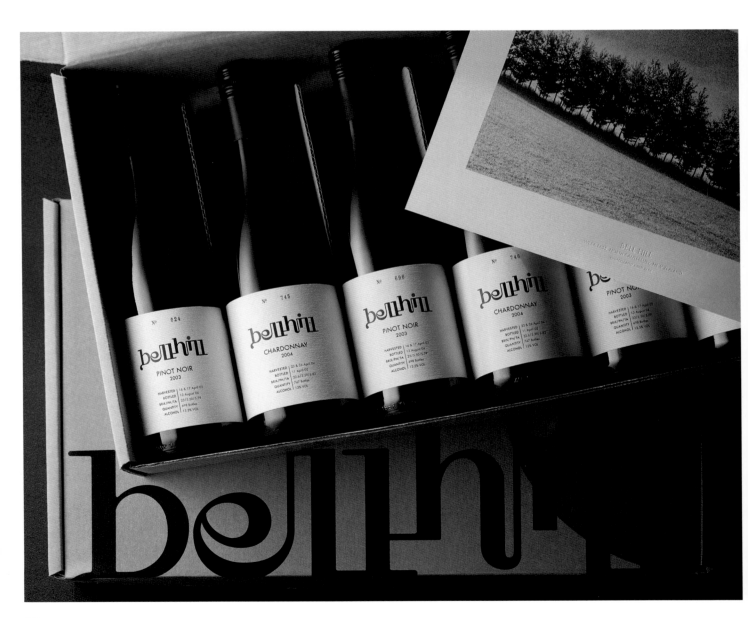

DESIGN
Larry Anderson, Elmer dela Cruz,
Jay Hilburn, and Bruce Stigler
Seattle, Washington

ART DIRECTION
Bruce Stigler

CREATIVE DIRECTION
Jack Anderson

DESIGN STUDIO
Hornall Anderson Design Works

CLIENT
Widmer Brothers Brewery

PRINCIPAL TYPE
Helvetica and FF Trixie

DIMENSIONS
Various

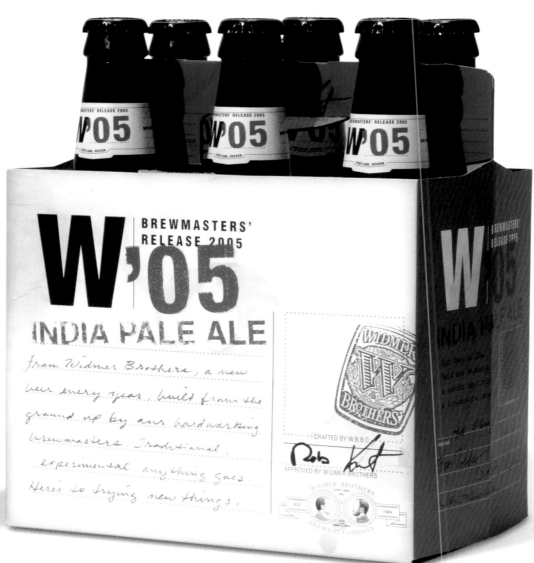

Len Cheeseman and Jason Bowden
Newmarket, New Zealand

ART DIRECTION
Len Cheeseman and Chris Bleackley

CREATIVE DIRECTION
Nick Worthington

LETTERING
Jason Bowden

COPYWRITER
John Plimmer

AGENCY
Publicis Mojo

CLIENT
Remix Magazine

PRINCIPAL TYPE
FF The Serif

DIMENSIONS
16.5 x 23.4 in.
(42 x 59.4 cm)

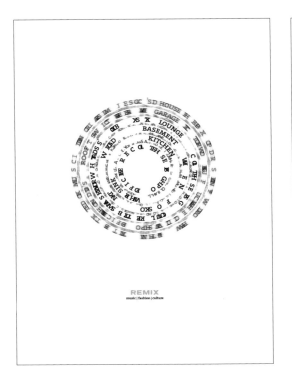

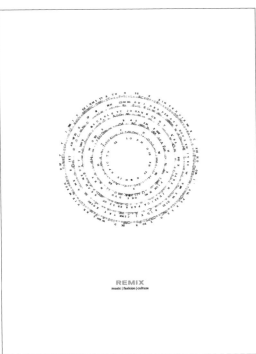

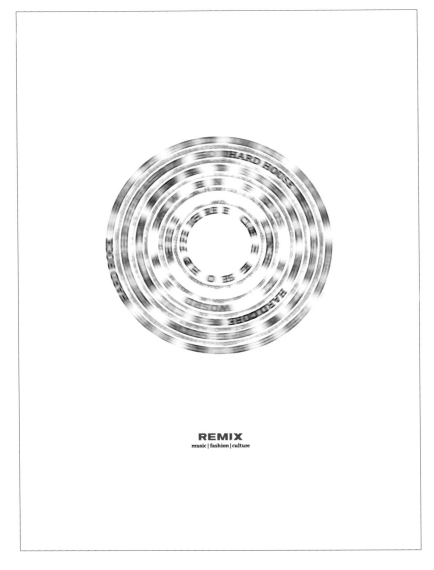

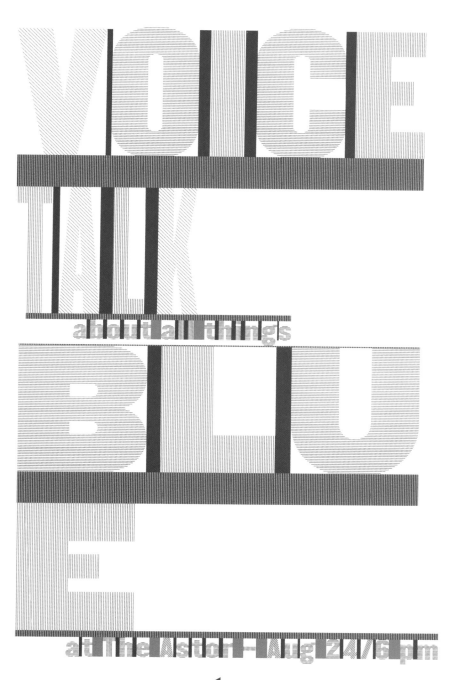

DESIGN
Scott Carslake
Adelaide, Australia

ART DIRECTION
Scott Carslake

CREATIVE DIRECTION
Scott Carslake

LETTERING
Scott Carslake

DESIGN OFFICE
Voice

CLIENT
TAFE SA

PRINCIPAL TYPE
HTF Champion Gothic and FF Unit

DIMENSIONS
16.5 x 23.4 in.
(42 x 59.4 cm)

DESIGN
Eszter Clark
San Francisco, California

ART DIRECTION
Joel Templin and Gaby Brink

CREATIVE DIRECTION
Joel Templin and Gaby Brink

DESIGN OFFICE
Templin Brink Design

CLIENT
Michael Austin Wines

PRINCIPAL TYPE
FF Trixie

DIMENSIONS
2.9 x 3.9 in.
(7.4 x 9.9 cm)

STUDENT PROJECT

DESIGN
Dimitrios Stefanidis
New York, New York

SCHOOL
Pratt Institute

INSTRUCTOR
Chava Ben Amos

PRINCIPAL TYPE
*Matrix CF and Akzidenz
Grotesk Condensed*

DIMENSIONS
*2.25 x 8.5 in.
(5.7 x 21.6 cm)*

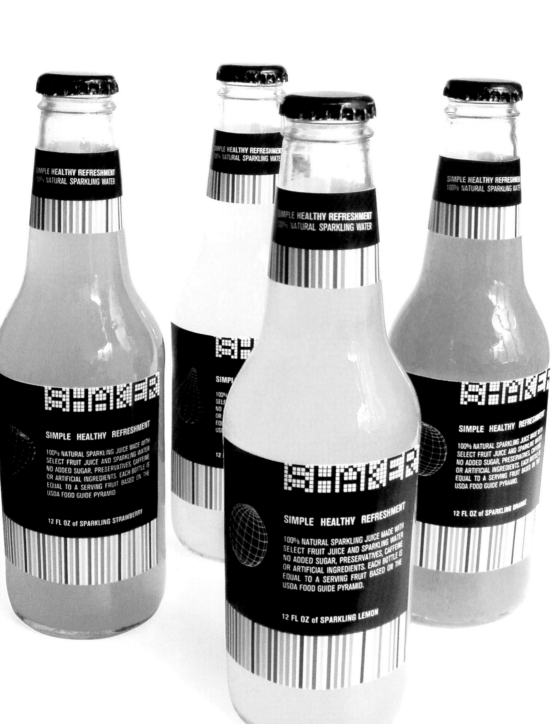

DESIGN
Ace Angara, Rafael Esquer,
Allison Ruiz, and Olivia Ting
New York, New York

ART DIRECTION
Rafael Esquer

CREATIVE DIRECTION
Rafael Esquer

PRINTER
Pazazz
Montreal, Canada

DESIGN OFFICE
Alfalfa

CLIENT
John Connelly Presents

PRINCIPAL TYPE
Adine Kimberg and ITC Conduit

DIMENSIONS
6.75 x 9.25 in.
(17.2 x 23.5 cm)

DESIGN
Oded Ezer
Givatayim, Israel

ART DIRECTION
Oded Ezer

CREATIVE DIRECTION
Oded Ezer

LETTERING
Oded Ezer

STUDIO
Oded Ezer Typography

PRINCIPAL TYPE
Frankrühlya

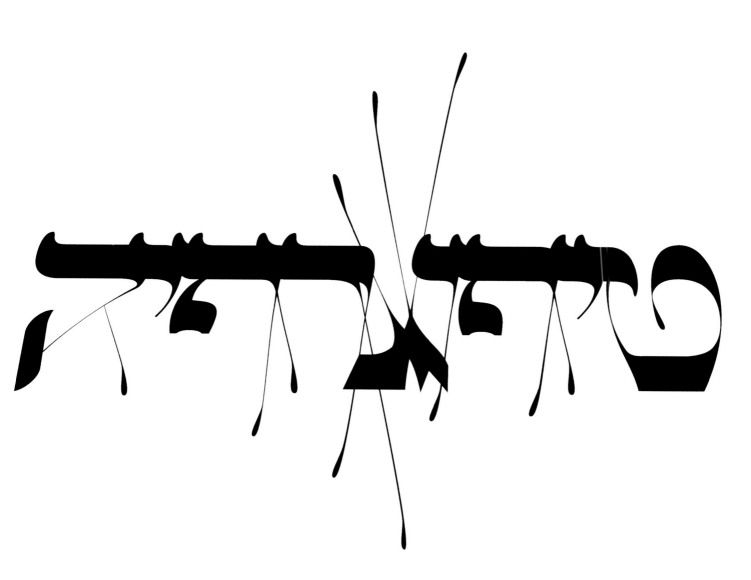

DESIGN
Rosa Pupillo, Alex Stertzig,
and Marcus Wichmann
Stuttgart, Germany

ART DIRECTION
Susanne Wacker and
Wolfram Schäffer

CREATIVE DIRECTION
Susanne Wacker and
Wolfram Schäffer

DESIGN OFFICE
design hoch drei GmbH & Co. KG

PRINCIPAL TYPE
Akzidenz Grotesk, Corporate S, DIN,
Eurostile, Gill Sans, and Stencil

DIMENSIONS
12.6 x 16.5 in.
(32 x 42 cm)

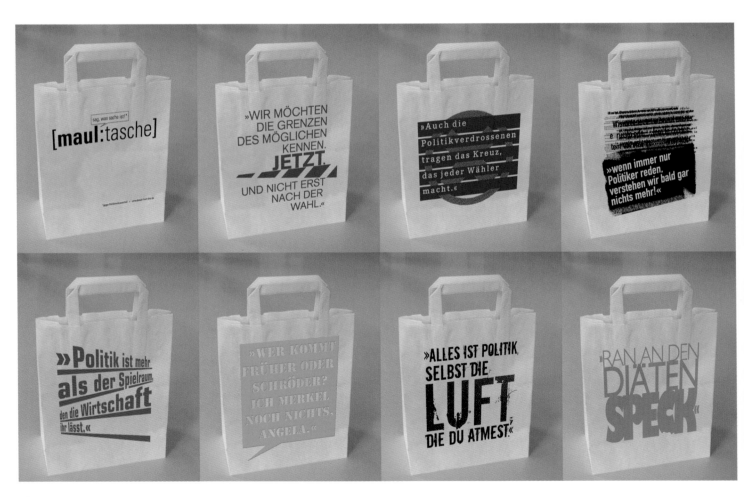

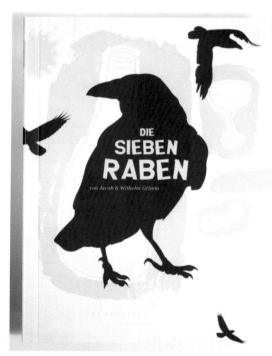

BOOK

DESIGN
Anders Bergesen, Kirsten Dietz,
and Ankia Marquardsen
Stuttgart, Germany

ART DIRECTION
Kirsten Dietz

CREATIVE DIRECTION
Kirsten Dietz and Jochen Rädeker

AGENCY
strichpunkt

CLIENT
Staatstheater Stuttgart, Schauspiel
Stuttgart

PRINCIPAL TYPE
Compatil

DIMENSIONS
4.7 x 6.3 in.
(12 x 16 cm)

DESIGN
Marie-Élaine Benoît, Jonathan Nicol,
and Laurence Pasteels
Montreal, Canada

CREATIVE DIRECTION
Hélène Godin

LETTERING
Graphiques M&H

PHOTOGRAPHY
Raoul Manuel Schnell

WRITERS
Mariève Guertin-Blanchette and
Jonathan Rosman

PRODUCER
Marie-Pierre Lemieux

AGENCY
Diesel

CLIENT
Les Fromages Saputo

PRINCIPAL TYPE
Nathalie Gamache

DIMENSIONS
11.5 x 15 in.
(29.2 x 38.1 cm)

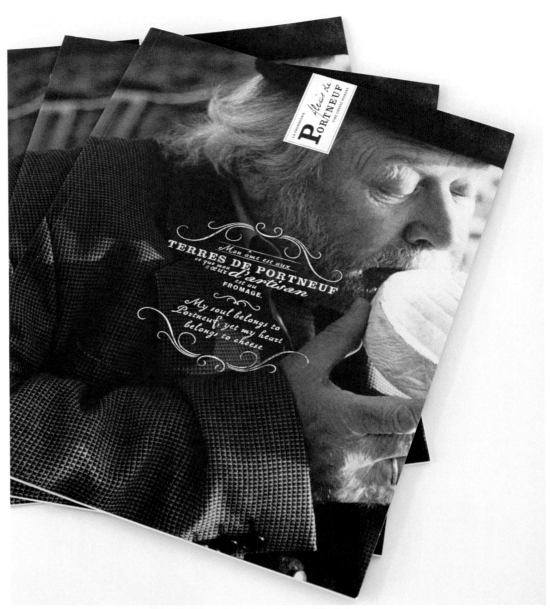

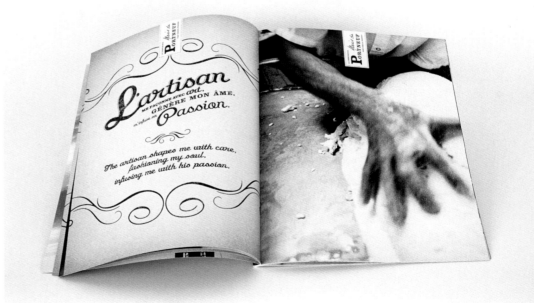

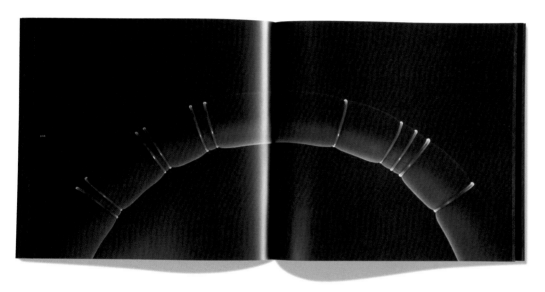

DESIGN
Tim Murphy
Melbourne, Australia

CREATIVE DIRECTION
Garry Emery

DESIGN STUDIO
emerystudio

CLIENT
Workshop 3000 and Susan Cohn

PRINCIPAL TYPE
FF DIN

DIMENSIONS
8.3 x 8.3 in.
(21 x 21 cm)

DESIGN
Micahel Bierut and Tracey Cameron
New York, New York

ART DIRECTION
Michael Bierut

PHOTOGRAPHY
Peter Mauss/ESTO

FABRICATION
VGS

CONSULTANTS
Suben/Dougherty

DESIGN OFFICE
Pentagram Design Inc.

CLIENT
Robert F. Wagner Graduate School of
Public Service, New York University

PRINCIPAL TYPE
FF Meta Bold and FF Meta Normal

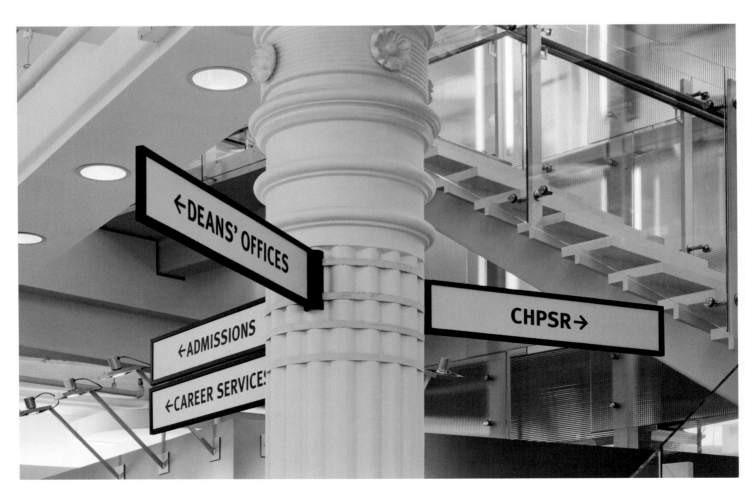

DESIGN
*Len Cheeseman
and Mikhail Gherman*
Newmarket, New Zealand

ART DIRECTION
*Len Cheeseman and
Mikhail Gherman*

CREATIVE DIRECTION
Nick Worthington

LETTERING
Mark van der Hoeven

COPYWRITER
Nick Worthington

AGENCY
Publicis Mojo

CLIENT
Rodney Wayne

PRINCIPAL TYPE
HTF Champion Welterweight

DIMENSIONS
*16.5 x 11.7 in.
(42 x 29.7 cm)*

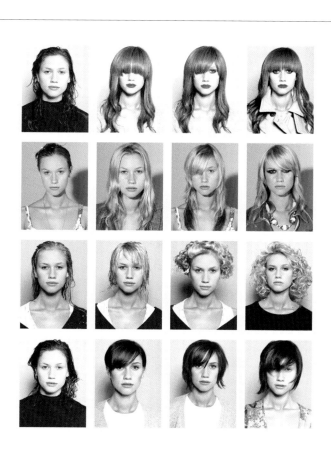

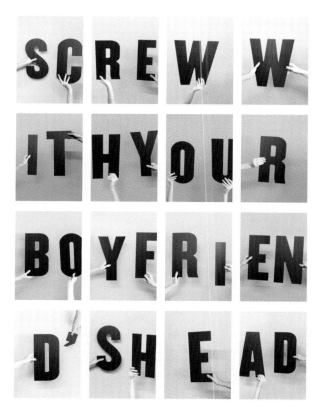

DESIGN
Giorgio Baravalle
Millbrook, New York

ART DIRECTION
Giorgio Baravalle

CREATIVE DIRECTION
Giorgio Baravalle

PHOTOGRAPHY
Antonin Kratochvil
New York, New York

DESIGN OFFICE
de.MO

PRINCIPAL TYPE
Ruse

DIMENSIONS
14.25 x 9.5 in.
(36.2 x 24.1 cm)

DESIGN
Paul Belford, Steve Davies,
and Nils Leonard
London, England

ART DIRECTION
Paul Belford

CREATIVE DIRECTION
Paul Belford and Nigel Roberts

AGENCY
AMV BBDO

CLIENT
Newspaper Marketing Agency

PRINCIPAL TYPE
Courier, Sun Futura,
and Times Roman

DIMENSIONS
19.25 x 28.9 in.
(48.9 x 73.3 cm)

STUDENT PROJECT

DESIGN
Dirk Wachowiak
Stuttgart, Germany

SCHOOL
Yale University School of Art

INSTRUCTORS
Barbara Glauber and David Israel

PRINCIPAL TYPE
Lambrecht, Moire Style,
and Pressure Style

DIMENSIONS
11.4 x 11.8 in.
(29 x 30 cm)

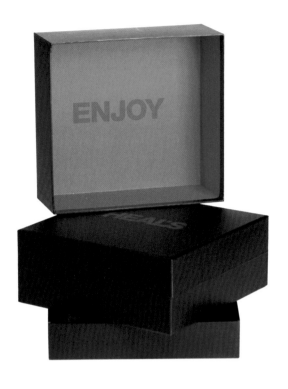

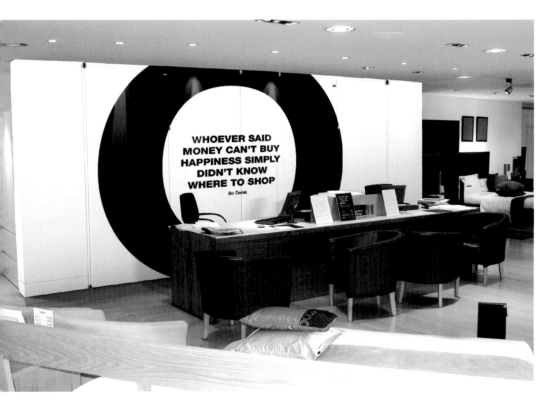

DESIGN
Domenic Lippa and Paul Skerm
London, England

ART DIRECTION
Domenic Lippa

CREATIVE DIRECTION
Domenic Lippa

TYPOGRAPHER
Domenic Lippa

DESIGN OFFICE
Lippa Pearce Design

CLIENT
Heal & Son

PRINCIPAL TYPE
Helvetica Heavy (85), Helvetica Light (45), and Helvetica Roman (55)

DIMENSIONS
Various

BOOK

DESIGN
Thomas Neeser and Thomas Müller
Basel, Switzerland

ART DIRECTION
Thomas Neeser and Thomas Müller

CREATIVE DIRECTION
Thomas Neeser and Thomas Müller

LETTERING
Thomas Neeser and Thomas Müller

STUDIO
Neeser & Müller

CLIENT
Verein Neue Musik Rümlingen and Christoph Merian Verlag

PRINCIPAL TYPE
Hornet MonoMassiv and Hornet DuoMassiv

DIMENSIONS
11.2 x 11.8 in.
(28.5 x 30 cm)

Lydia Jeschke, Daniel Ott, Lukas Ott [Hg.]

GEBALLTE GEGENVART

EXPERIMENT ..NEUE MUSIK RÜMLINGEN

mit 140 Minuten Musik
→ auf 2 CDs

Christoph Merian Verlag

Mitglied werden
Becoming a member

DESIGN
Büro Uebele Visuelle Kommunikation
Stuttgart, Germany

ART DIRECTION
Claudia Burtscher

CREATIVE DIRECTION
Andreas Uebele

CLIENT
*Society for the Advancement of
Architecture, Engineering and Design
(AED)*

PRINCIPAL TYPE
Akzidenz Grotesk Bold

DIMENSIONS
Various

DESIGN
Harry Pearce
London, England

ART DIRECTION
Harry Pearce

CREATIVE DIRECTION
Harry Pearce

TYPOGRAPHER
Harry Pearce

AUTHOR OF QUOTE
Spike Milligan

DESIGN OFFICE
Lippa Pearce Design

PRINCIPAL TYPE
Rockwell Bold Condensed

DIMENSIONS
23.6 x 33.1 in.
(60 x 84 cm)

I'm
walking
backwards
for christmas
spike
milligan

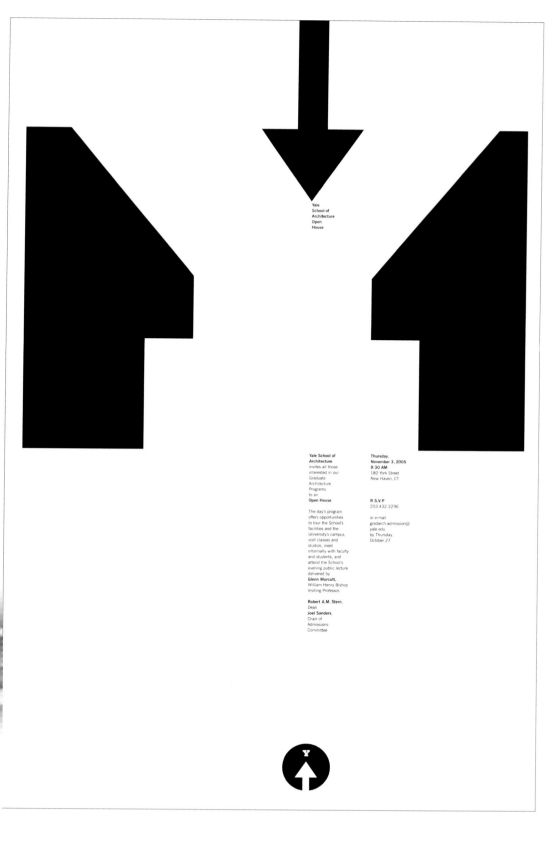

Yale
School of
Architecture
Open
House

Yale School of
Architecture
invites all those
interested in our
Graduate
Architecture
Programs
to an
Open House

The day's program
offers opportunities
to tour the School's
facilities and the
University's campus,
visit classes and
studios, meet
informally with faculty
and students, and
attend the School's
evening public lecture
delivered by
Glenn Murcutt,
William Henry Bishop
Visiting Professor.

Robert A.M. Stern,
Dean
Joel Sanders,
Chair of
Admissions
Committee

Thursday,
November 3, 2005
9:30 AM
180 York Street
New Haven, CT

R.S.V.P.
203.432.2296

or e-mail
gradarch.admission@
yale.edu
by Thursday,
October 27

DESIGN
Elizabeth Cory Holzman
New York, New York

ART DIRECTION
Michael Bierut

DESIGN OFFICE
Pentagram Design Inc.

CLIENT
Yale School of Architecture

PRINCIPAL TYPE
News Gothic and HTF Ziggurat

DIMENSIONS
22 x 34 in.
(55.9 x 86.4 cm)

ART DIRECTION
Jens Stein
Berlin, Germany

CREATIVE DIRECTION
Matthias Schmidt
and Constantin Kaloff

LETTERING
Annegret Richter, Jens Stein,
and Julia Witsche

PHOTOGRAPHY
Heribert Schindler

COPYWRITER
Philipp Woehler

AGENCY
Scholz & Friends

CLIENT
Holsten-Brauerei AG

PRINCIPAL TYPE
Handlettering

DIMENSIONS
16.5 x 11.7 in.
(42 x 29.7 cm)

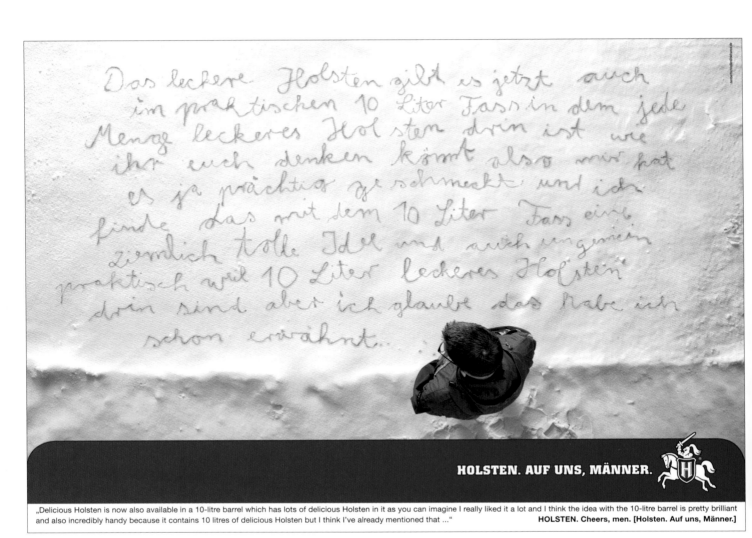

HOLSTEN. AUF UNS, MÄNNER.

„Delicious Holsten is now also available in a 10-litre barrel which has lots of delicious Holsten in it as you can imagine I really liked it a lot and I think the idea with the 10-litre barrel is pretty brilliant and also incredibly handy because it contains 10 litres of delicious Holsten but I think I've already mentioned that ..." **HOLSTEN. Cheers, men. [Holsten. Auf uns, Männer.]**

182

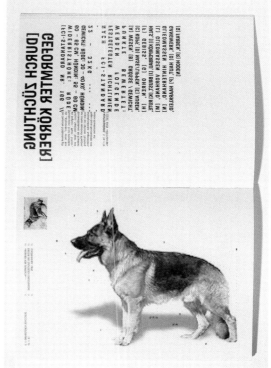

DESIGN
Kerstin Wolf
Mannheim, Germany

SCHOOL
Fachhochschule Mainz,
University of Applied Sciences

PROFESSOR
Ulysses Voelker

PRINCIPAL TYPE
Trade Gothic Bold and FF Info Office

DIMENSIONS
7.5 x 9.7 in.
(19 x 24.7 cm)

DESIGN
Julia Trudeau
Montreal, Canada

SCHOOL
École de Design, UQAM

INSTRUCTOR
Judith Poirier

PRINCIPAL TYPE
Univers 47

DIMENSIONS
7 x 11 in.
(17.8 x 27.9 cm)

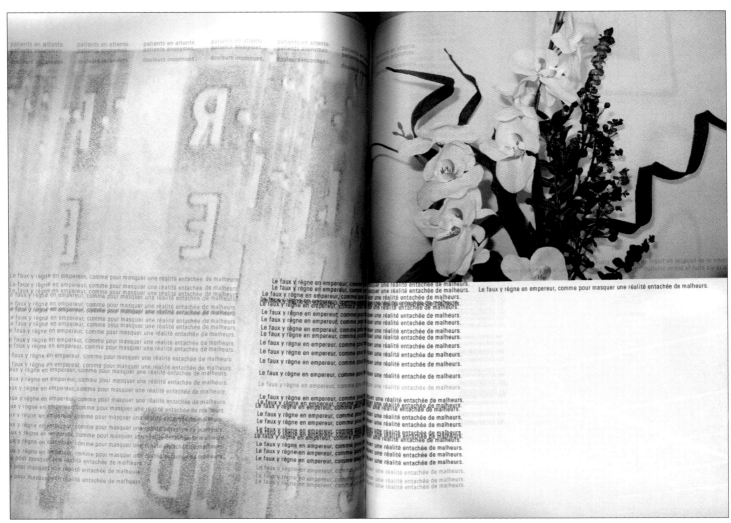

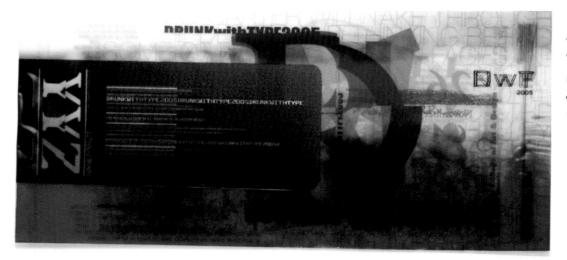

DESIGN
Jeehwan Yeo
New York, New York

SCHOOL
School of Visual Arts

INSTRUCTOR
Mike Joyce

PRINCIPAL TYPE
*Auriol, Big Caslon, Georgia,
and Adobe Jenson Pro*

DIMENSIONS
*8 x 3.5 in.
(20.3 x 8.9 cm)*

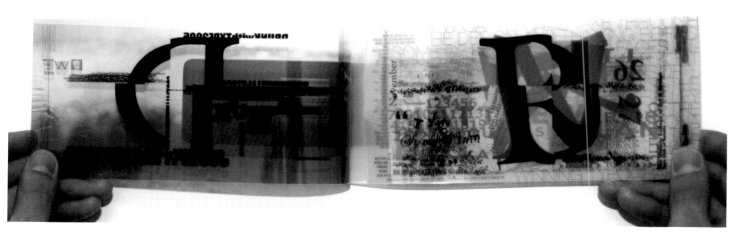

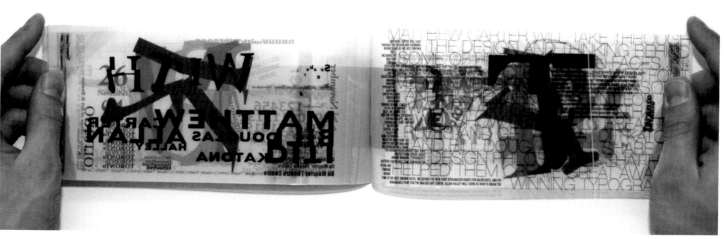

STUDENT PROJECT

DESIGN
Byron Regej
New York, New York

SCHOOL
School of Visual Arts

INSTRUCTOR
Robert Best

PRINCIPAL TYPE
Acclamation and Electra

DIMENSIONS
7.75 x 10 in.
(19.7 x 25.4 cm)

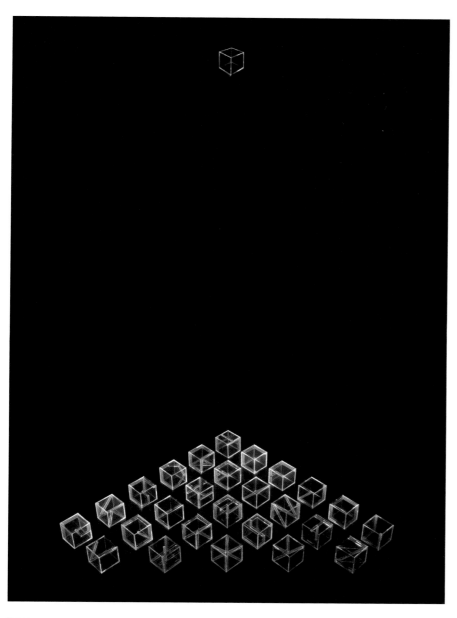

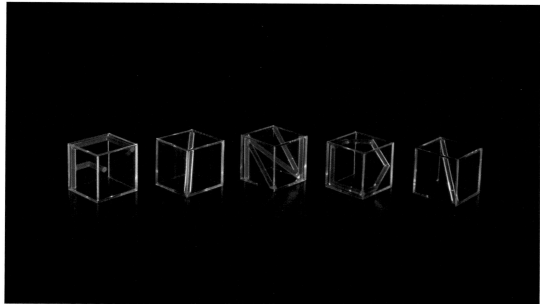

DESIGN
Mariko Yokogi
Osaka, Japan

SCHOOL
Saito I.M.I. Graduate School

PROFESSOR
Akio Okumura

PRINCIPAL TYPE
Helvetica and custom

DIMENSIONS
28.7 x 40.6 in.
(72.8 x 103 cm)

STUDENT PROJECT

DESIGN
Randy J. Hunt
New York, New York

SCHOOL
School of Visual Arts, MFA Design

INSTRUCTOR
Gail Anderson

PRINCIPAL TYPE
Foundry Gridnik

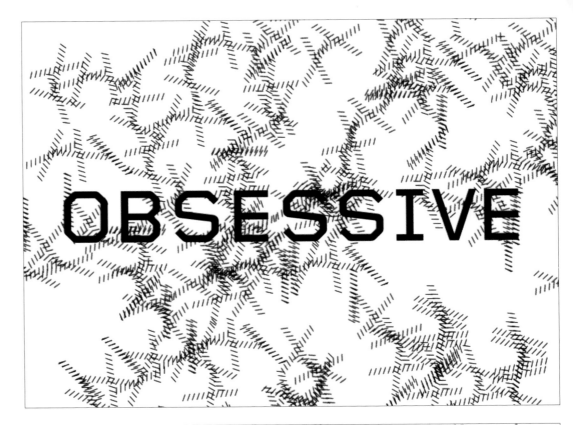

188

WEB SITE

DESIGN
Hong Ko
Hong Kong, China

ART DIRECTION
Hong Ko

CREATIVE DIRECTION
Hong Ko

DESIGN OFFICE
www.kosiuhong.com

PRINCIPAL TYPE
Custom

189

DESIGN
Agung Wimboprasetyo
Valencia, California

SCHOOL
California Institute of the Arts

INSTRUCTORS
Shelley Stepp and Jae-Hyouk Sung

PRINCIPAL TYPE
Custom

DIMENSIONS
20 x 30 in.
(50.8 x 76.2 cm)

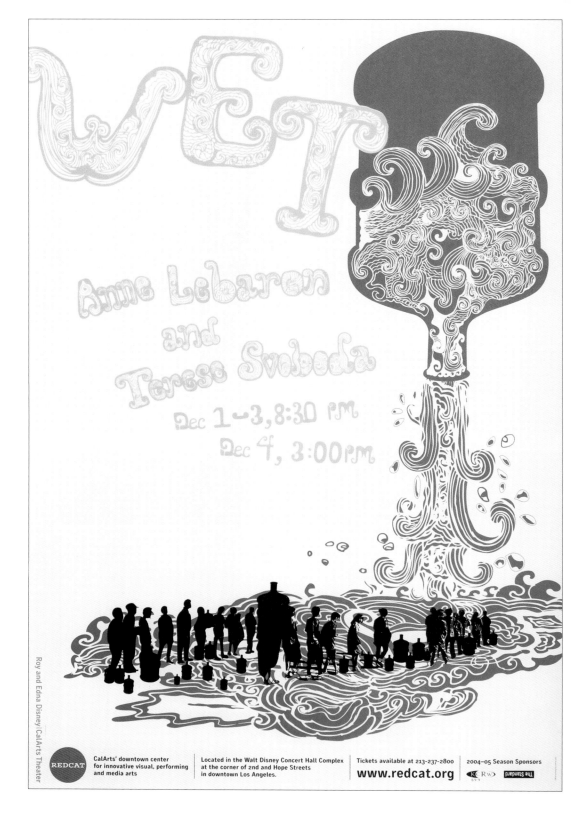

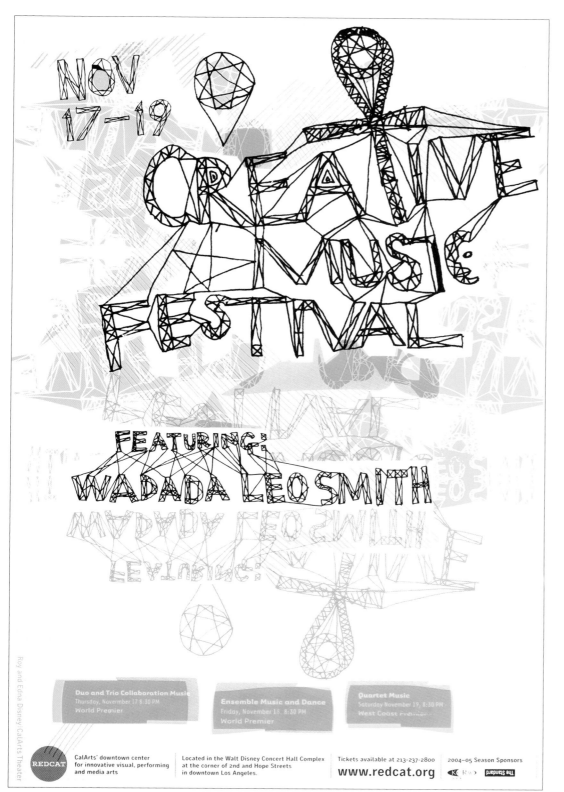

STUDENT PROJECT

DESIGN
Colin Graham and Justin O'Brien
Valencia, California

SCHOOL
California Institute of the Arts

INSTRUCTORS
Shelley Stepp and Jae-Hyouk Sung

PRINCIPAL TYPE
Custom

DIMENSIONS
20 x 30 in.
(50.8 x 76.2 cm)

STUDENT PROJECT

DESIGN
Colin Graham
Valencia, California

SCHOOL
California Institute of the Arts

INSTRUCTORS
Shelley Stepp and Jae-Hyouk Sung

PRINCIPAL TYPE
Custom

DIMENSIONS
20 x 30 in.
(50.8 x 76.2 cm)

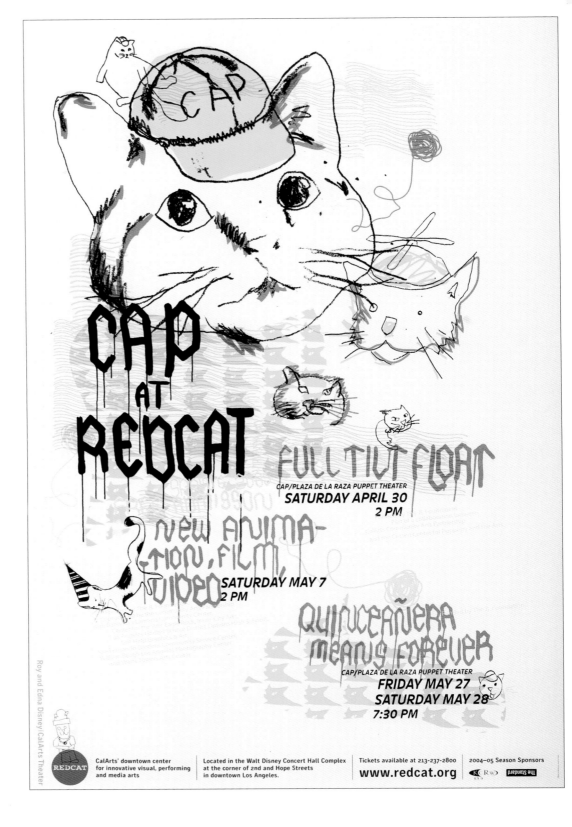

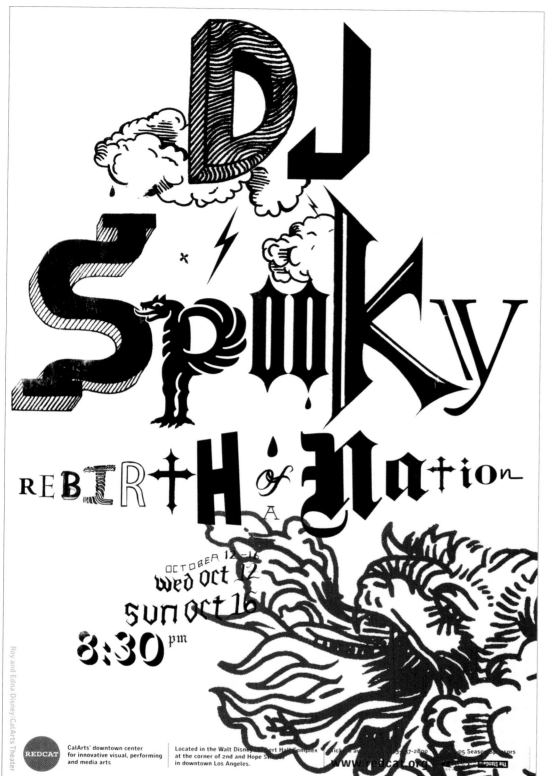

DESIGN
Jason Mendez
Valencia, California

SCHOOL
California Institute of the Arts

INSTRUCTORS
Shelley Stepp and Jae-Hyouk Sung

PRINCIPAL TYPE
Custom

DIMENSIONS
20 x 30 in.
(50.8 x 76.2 cm)

DESIGN
Anne-Marie Clermont
Montreal, Canada

SCHOOL
École de Design, UQAM

INSTRUCTOR
Yann Mooney

PRINCIPAL TYPE
Custom

DIMENSIONS
27 x 39 in.
(68.6 x 99.1 cm)

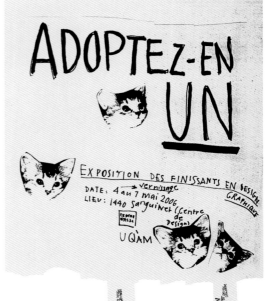

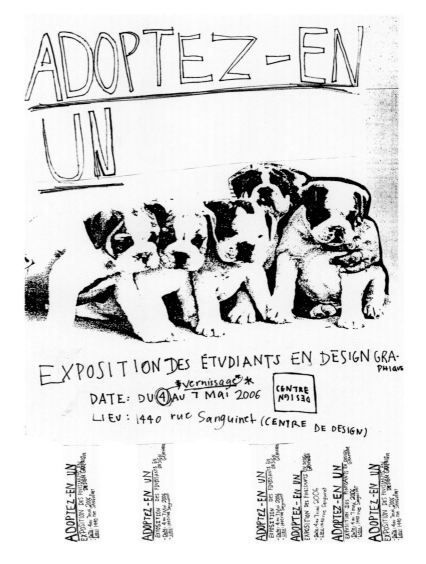

WEB SITE
DESIGN
*Christoph Bebermeier
and David Krause*
Berlin, Germany

CREATIVE DIRECTION
*Christoph Bebermeier
and David Krause*

DESIGN OFFICE
BÜRO WEISS

CLIENT
Jan Pauls

PRINCIPAL TYPE
Helvetica Condensed Bold

DESIGN
Andy Outis
New York, New York

SCHOOL
School of Visual Arts

INSTRUCTOR
Stephen Doyle

PRINCIPAL TYPE
News Gothic

STUDENT PROJECT

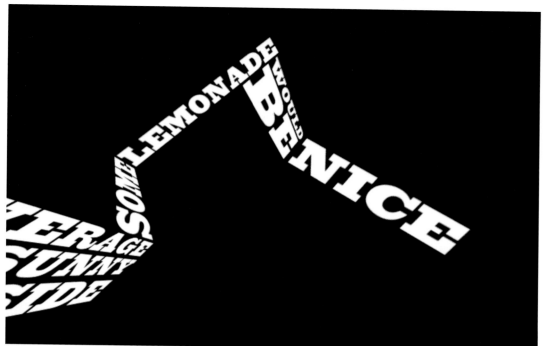

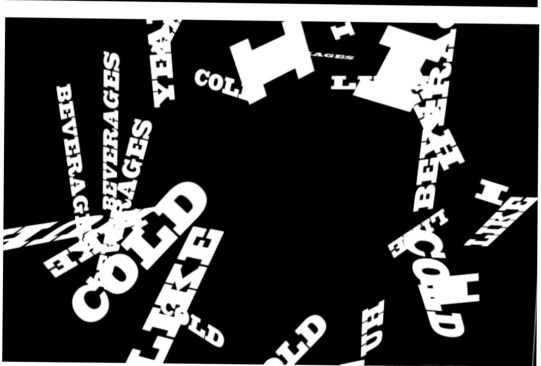

STUDENT PROJECT

DESIGN
Ryan Feerer
New York, New York

SCHOOL
School of Visual Arts, MFA Design

INSTRUCTOR
Gail Anderson

PRINCIPAL TYPE
*Antique, Batak Condensed,
and Bokka*

DESIGN
Maris Bellack
New York, New York

SCHOOL
School of Visual Arts

INSTRUCTOR
Paula Scher

PRINCIPAL TYPE
Trade Gothic

DIMENSIONS
Various

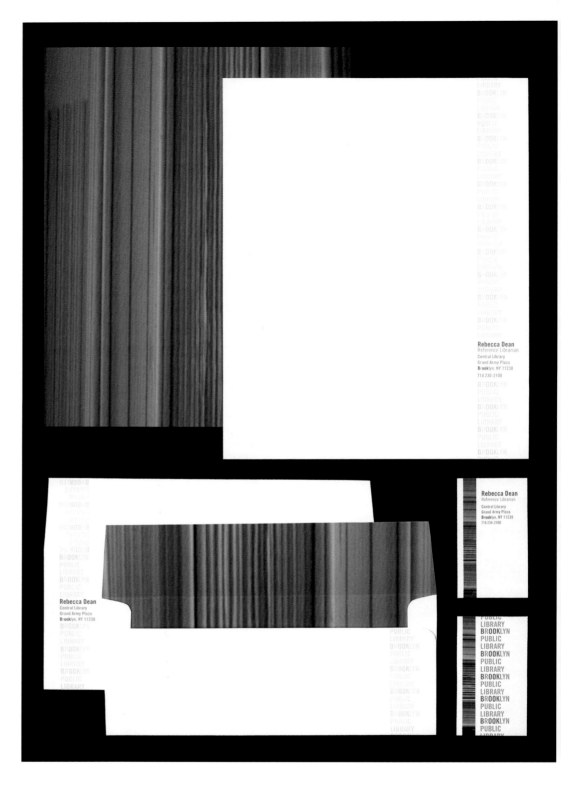

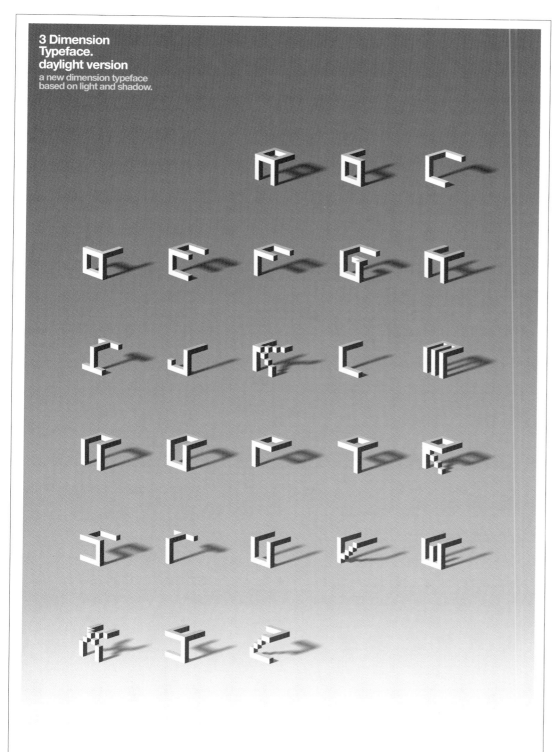

3 Dimension Typeface. daylight version
a new dimension typeface based on light and shadow.

DESIGN
Yoni Kim
New York, New York

SCHOOL
School of Visual Arts

INSTRUCTOR
Kim Maley

PRINCIPAL TYPE
Helvetica Neue and custom

DIMENSIONS
28 x 36 in.
(71.1 x 91.4 cm)

199

DESIGN
Niels Schrader
Amsterdam, The Netherlands

MUSIC
Sister Love

PROCESSING
Jelle Herold

CLIENT
Stichting Pleinmuseum, Amsterdam

PRINCIPAL TYPE
FFF Mono 01

DESIGN
*Sean Dougherty, Dennis Go, Kevin
Robinson, and Danny Ruiz*
New York, New York

LETTERING
Sean Dougherty

STUDIO
Brand New School

CLIENT
Country Music Television (CMT)

PRINCIPAL TYPE
Various and handlettering

BOOK

DESIGN
Mariana Contegni and
Vanessa Eckstein
Mexico City, Mexico

CREATIVE DIRECTION
Vanessa Eckstein

DESIGN OFFICE
Bløk Design

CLIENT
Museo Marco

PRINCIPAL TYPE
Blender and Helvetica Neue

DIMENSIONS
5.75 x 8.25 in.
(14.6 x 21 cm)

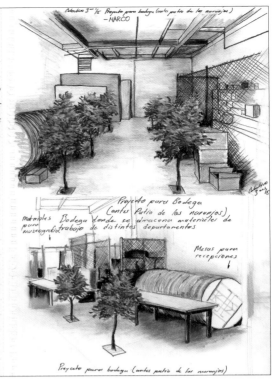

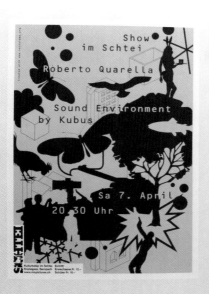

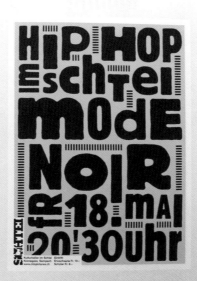

DESIGN
Erich Brechbühl
Lucerne, Switzerland

DESIGN OFFICE
Mixer

PRINCIPAL TYPE
Akzidenz Grotesk

DIMENSIONS
5.8 x 7.5 in.
(14.8 x 19 cm)

DESIGN
Adam Figielski, Helmut Himmler,
and Ina Thedens
Frankfurt, Germany

ART DIRECTION
Helmut Himmler and Till
Schaffarczyk

CREATIVE DIRECTION
Helmut Himmler and Lars Huvart

LETTERING
Adam Figielski, Helmut Himmler,
and Ina Thedens

AGENCY
Ogilvy & Mather
Frankfurt

CLIENT
MYFonts.com

PRINCIPAL TYPE
Armada Condensed, ITC Aspirin,
Bureau Grotesque, and Radiant

DIMENSIONS
46.8 x 66.1 in.
(118.8 x 168 cm)

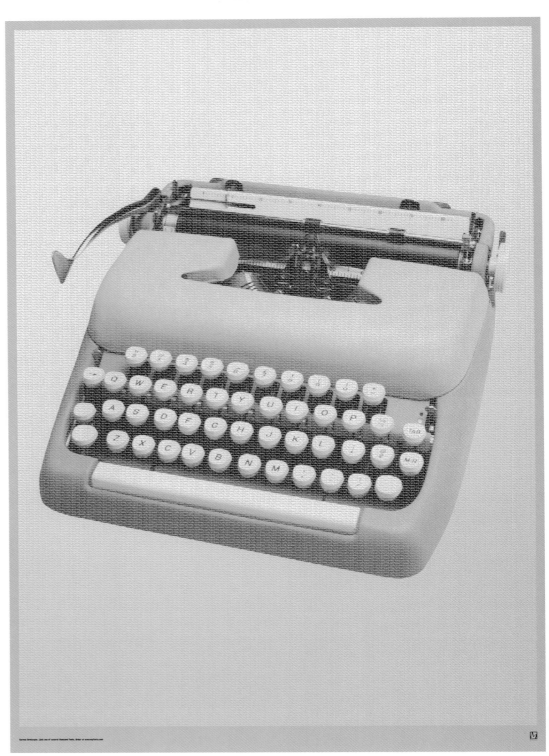

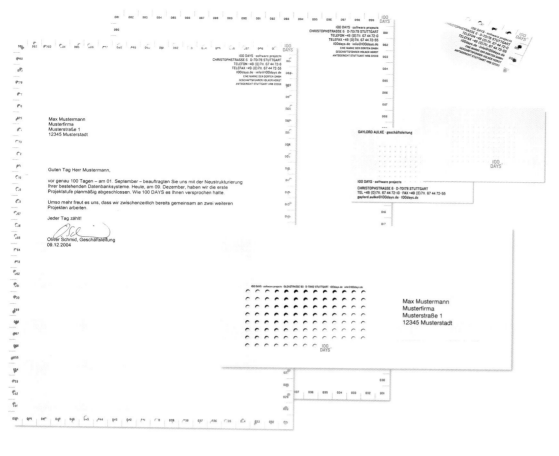

DESIGN
Joerg Bauer
Stuttgart, Germany

ART DIRECTION
Joerg Bauer

CREATIVE DIRECTION
Joerg Bauer and Christian Schwarm

DESIGN OFFICE
Dorten Bauer

CLIENT
100 Days

PRINCIPAL TYPE
HTF Knockout

DIMENSIONS
Various

Dream

Eternal

Groovy

Imagine

POSTER

DESIGN
Kan Akita
Tokyo, Japan

ART DIRECTION
Kan Akita

DESIGN OFFICE
Akita Design Kan Inc.

PRINCIPAL TYPE
Avant Garde Bold

DIMENSIONS
57.3 x 40.6 in.
(145.6 x 103 cm)

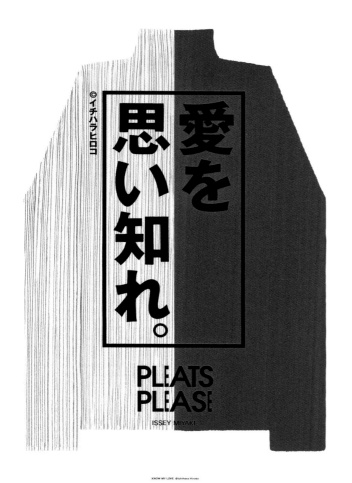

KNOW MY LOVE. ©Ichihara Hiroko

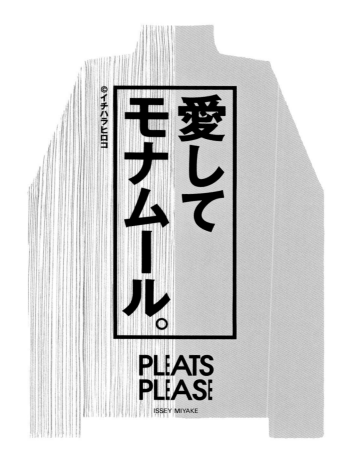

LOVE ME, MON AMOUR. ©Ichihara Hiroko

DESIGN
Kan Akita
Tokyo, Japan

ART DIRECTION
Kan Akita

CREATIVE DIRECTION
Midori Kitamura

PHOTOGRAPHY
Yasuaki Yoshinaga

ARTIST
Hiroko Ichihara

DESIGN OFFICE
Akita Design Kan Inc.

CLIENT
Issey Miyake Inc.

PRINCIPAL TYPE
Custom

DIMENSIONS
*40.6 x 28.7 in.
(103 x 72.8 cm)*

BOOK

DESIGN
Mariana Contegni and
Vanessa Eckstein
Mexico City, Mexico

CREATIVE DIRECTION
Vanessa Eckstein

DESIGN OFFICE
Bløk Design

CLIENT
ING

PRINCIPAL TYPE
Tsar Mono Round and Franklin
Gothic

DIMENSIONS
10.4 x 10.4 in.
(26.5 x 26.5 cm)

154 155

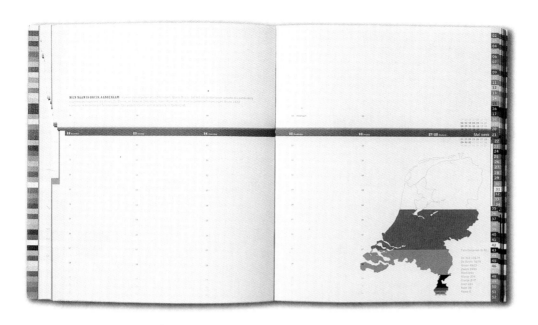

CALENDAR

DESIGN
Barlock
The Hague, The Netherlands

ART DIRECTION
*Hél'ene Bergmans, Käthi Dübi,
and Saskia Wierinck*

CREATIVE DIRECTION
*Hél'ene Bergmans, Käthi Dübi,
and Saskia Wierinck*

ILLUSTRATION
Fréderiek Westerweel

DESIGN OFFICE
Ando bv

PRINCIPAL TYPE
Rosewood and Bell Gothic

DIMENSIONS
*7.9 x 9.7 in.
(20 x 24.5 cm)*

DESIGN
Michael Vanderbyl
San Francisco, California

ART DIRECTION
Michael Vanderbyl

CREATIVE DIRECTION
Michael Vanderbyl

DESIGN OFFICE
Vanderbyl Design

CLIENT
Wildass Vineyards

PRINCIPAL TYPE
Ironwood

DIMENSIONS
3 x 4.7 in.
(7.6 x 11.9 cm)

NOTECARDS

DESIGN
Sallie Reynolds Allen, Dennis Garcia,
Tracy Meiners, Robert Palmer, and
Justin Skeesuck
San Diego, California

ART DIRECTION
Dennis Garcia

LETTERING
Tracy Meiners and
Sallie Reynolds Allen

PRINTER
DeFrance Printing

DESIGN OFFICE
Miriello Grafico

CLIENT
DeFrance Printing, Fox River Paper,
and Miriello Grafico

PRINCIPAL TYPE
Berthold Akzidenz Grotesk, Filosofia,
Sabon, Univers, and handlettering

DIMENSIONS
4.5 x 5.5 in.
(11.4 x 14 cm)

211

DESIGN
Michael Vanderbyl and Ellen Gould
San Francisco, California

ART DIRECTION
Michael Vanderbyl

CREATIVE DIRECTION
Michael Vanderbyl

DESIGN OFFICE
Vanderbyl Design

CLIENT
Mohawk Fine Papers, Inc.

PRINCIPAL TYPE
Clarendon and Artscript

DIMENSIONS
11 x 17 in.
(27.9 x 43.2 cm)

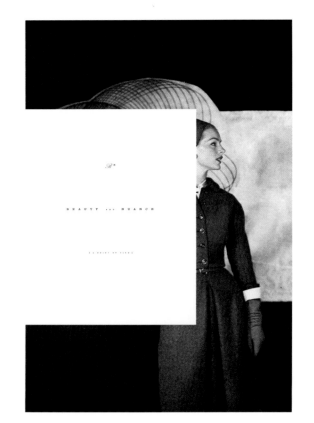

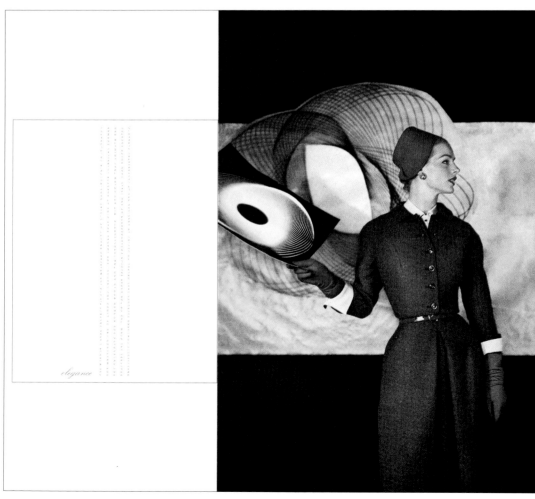

悼念 波尔·雷德 Mourning for Mr. Paul Rand 1914-1996 (US)

DESIGN
Eric Cai Shi Wei
Beijing, China

ART DIRECTION
Eric Cai Shi Wei

CREATIVE DIRECTION
Eric Cai Shi Wei

DESIGN OFFICE
Eric Cai Design Co.

PRINCIPAL TYPE
Times New Roman

DIMENSIONS
25.6 x 35.4 in.
(65 x 90 cm)

DESIGN
*Karin Bryant, Aine Coughlan,
and Nathan Durrant*
San Francisco, California

CREATIVE DIRECTION
Jennifer Jerde

LETTERING
Nathan Durrant

ILLUSTRATION
Polly Becker
Boston, Massachusetts

DESIGN OFFICE
Elixir Design

CLIENT
Buck & Rose Road Trip Productions

PRINCIPAL TYPE
*ITC Galliard, Italienne (hand-
rendered), and Plantagenet*

DIMENSIONS
Various

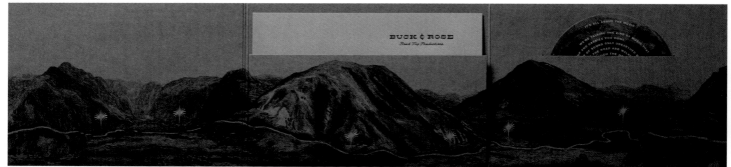

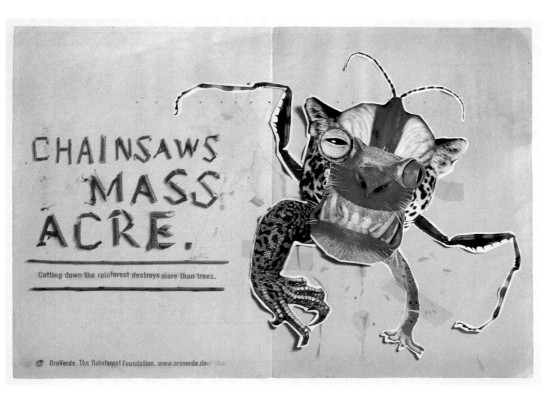

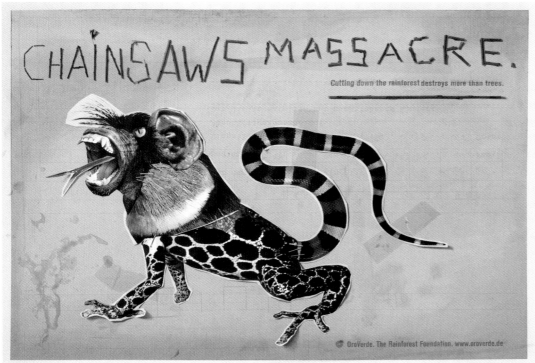

DESIGN
Till Schaffarczyk
Frankfurt, Germany

ART DIRECTION
Till Schaffarczyk

CREATIVE DIRECTION
Helmut Himmler and Lars Huvart

LETTERING
Till Schaffarczyk

COPYWRITER
Ales Polcar

AGENCY
Ogilvy & Mather
Frankfurt

CLIENT
OroVerde Rainforest Foundation
Germany

PRINCIPAL TYPE
Handlettering

DIMENSIONS
33.1 x 23.4 in.
(84 x 59.4 cm)

DESIGN
Sarah Nelson, Paul Sieka,
and Sharon Werner
Minneapolis, Minnesota

CREATIVE DIRECTION
Sharon Werner

DESIGN OFFICE
Werner Design Werks, Inc.

CLIENT
Contractors Property Developers
Company

PRINCIPAL TYPE
Old Typewriter and ITC Franklin
Gothic

DIMENSIONS
Various

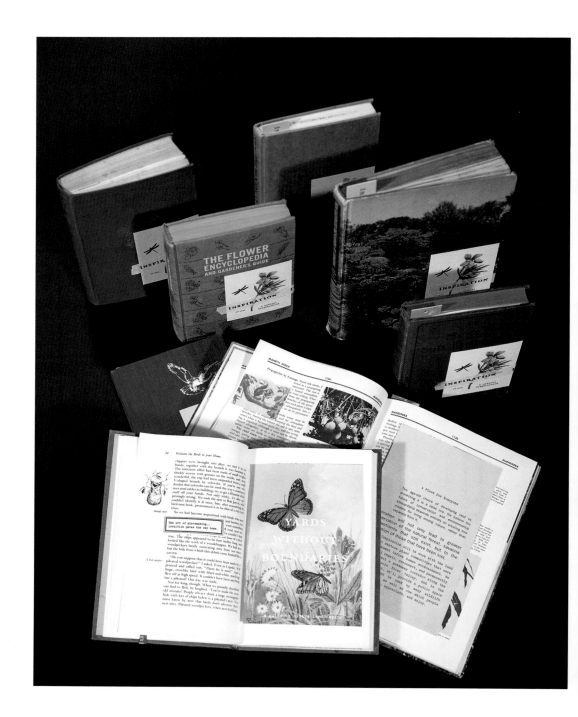

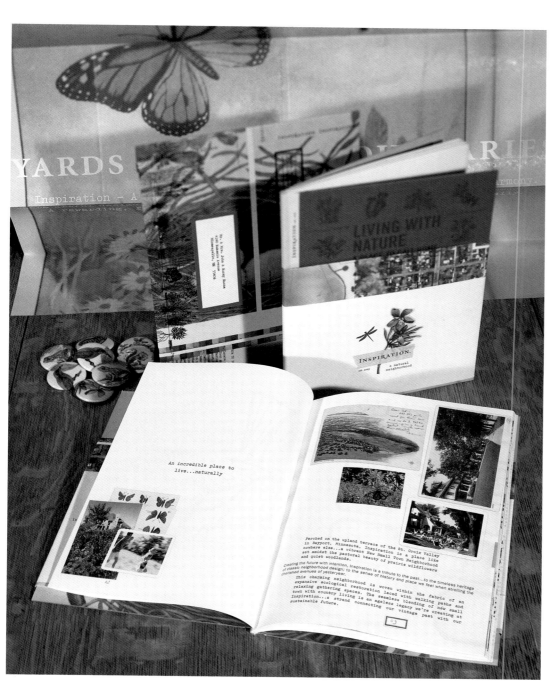

DESIGN
Sharon Werner and Sarah Nelson
Minneapolis, Minnesota

CREATIVE DIRECTION
Sharon Werner

STUDIO
Werner Design Werks, Inc.

CLIENT
*Contractor Property Development
Company*

PRINCIPAL TYPE
*Old Typewriter and ITC Franklin
Gothic*

DIMENSIONS
Various

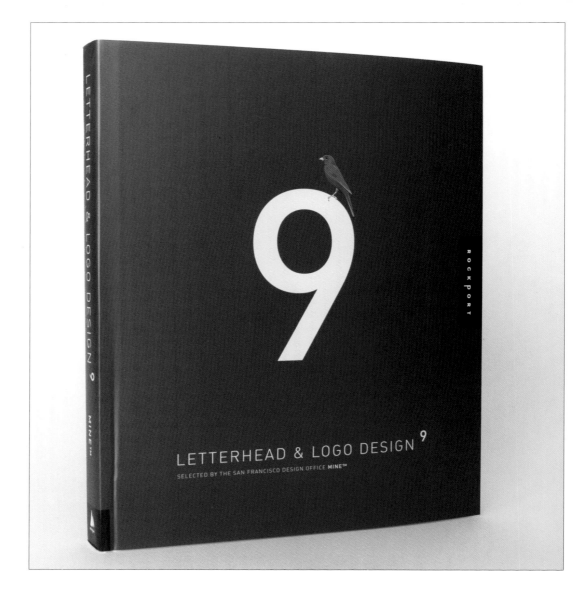

BOOK COVER

DESIGN
Christopher Simmons
San Francisco, California

CREATIVE DIRECTION
Christopher Simmons

DESIGN OFFICE
MINE™

CLIENT
Rockport Publishers

PRINCIPAL TYPE
FF DIN

DIMENSIONS
9 x 12 in.
(22.9 x 30.5 cm)

218

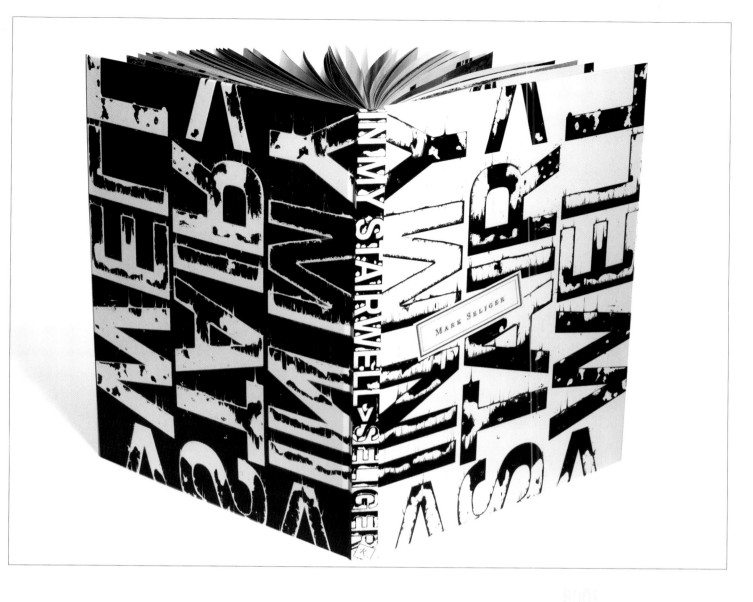

DESIGN
Fred Woodward and Ken DeLago
New York, New York

PHOTOGRAPHY
Mark Seliger

CLIENT
Rizzoli

PRINCIPAL TYPE
Titling Gothic

DIMENSIONS
12 x 15.25 in.
(30.5 x 38.7 cm)

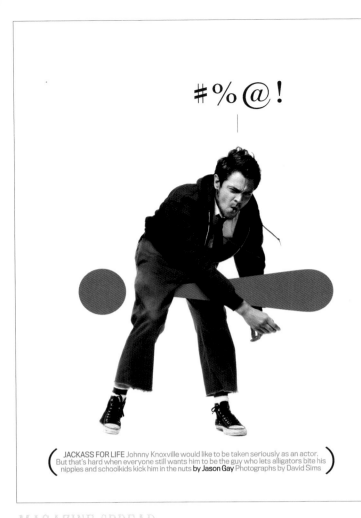

#%@!

AUGUST.05.GQ.105

MAGAZINE SPREAD

DESIGN
Ken DeLago
New York, New York

DESIGN DIRECTION
Fred Woodward

PUBLICATION
GQ

PRINCIPAL TYPE
Miller

DIMENSIONS
15.6 x 11 in.
(39.6 x 27.9 cm)

+A ¼ n Gr ⅗ n- ...span Tak ⅗... a Bath

●●● Illustration by NOLI NOVAK

For the past eighteen years, the Oz-like ALAN GREENSPAN has used his position as chairman of the Federal Reserve to push, behind the scenes, for strict budgetary discipline. Now, in his final year in office, he has watched the Bush administration destroy the budget surplus and drive the deficit to record highs. So the mysterious chairman must decide: Will he continue to fight for his economic principles, even if it means fighting his own party?
by WIL S. HYLTON

MAGAZINE SPREAD

DESIGN
Ken DeLago
New York, New York

DESIGN DIRECTION
Fred Woodward

PUBLICATION
GQ

PRINCIPAL TYPE
Farnham

DIMENSIONS
15.6 x 11 in.
(39.6 x 27.9 cm)

Michael Vanderbyl and
Amanda Linder
San Francisco, California

ART DIRECTION
Michael Vanderbyl

CREATIVE DIRECTION
Michael Vanderbyl

PHOTOGRAPHY
Jim Hedrich of Hedrich Blessing
Chicago, Illinois

COPYWRITER
Penny Benda

DESIGN OFFICE
Vanderbyl Design

CLIENT
Teknion

PRINCIPAL TYPE
Adobe Garamond Expert, Adobe
Garamond Regular, and FF Meta Plus
Book

DIMENSIONS
7 x 9 in.
(17.8 x 22.9 cm)

[optimism]

altos

Altos® is a full-height, architec-
tural wall system designed to
create interior spaces of varied
dimensions and planning
requirements for today and
tomorrow. Interchangeable
fascias combine to meet
aesthetic and functional require-
ments in the executive office,
boardroom, team and manage-
rial spaces. Altos also integrates
seamlessly with existing office
furniture and systems.

½
The number of doomsday
predictions that have come true:

M A L L O N É E & A S S O C I A T E S

F O O D S T R A T E G I E S

DESIGN
Michael Vanderbyl and Ellen Gould
San Francisco, California

ART DIRECTION
Michael Vanderbyl

CREATIVE DIRECTION
Michael Vanderbyl

DESIGN OFFICE
Vanderbyl Design

CLIENT
Mallonée & Associates

PRINCIPAL TYPE
Filosofia

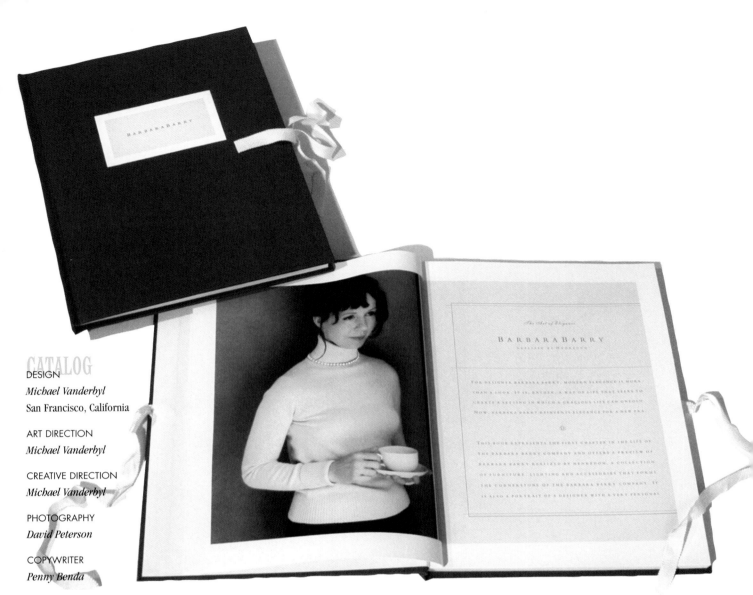

CATALOG

DESIGN
Michael Vanderbyl
San Francisco, California

ART DIRECTION
Michael Vanderbyl

CREATIVE DIRECTION
Michael Vanderbyl

PHOTOGRAPHY
David Peterson

COPYWRITER
Penny Benda

Design Office
Vanderbyl Design

CLIENT
Henredon

PRINCIPAL TYPE
Bembo and Shelley Allegro Script

DIMENSIONS
7.25 x 9.25 in.
(18.4 x 23.5 cm)

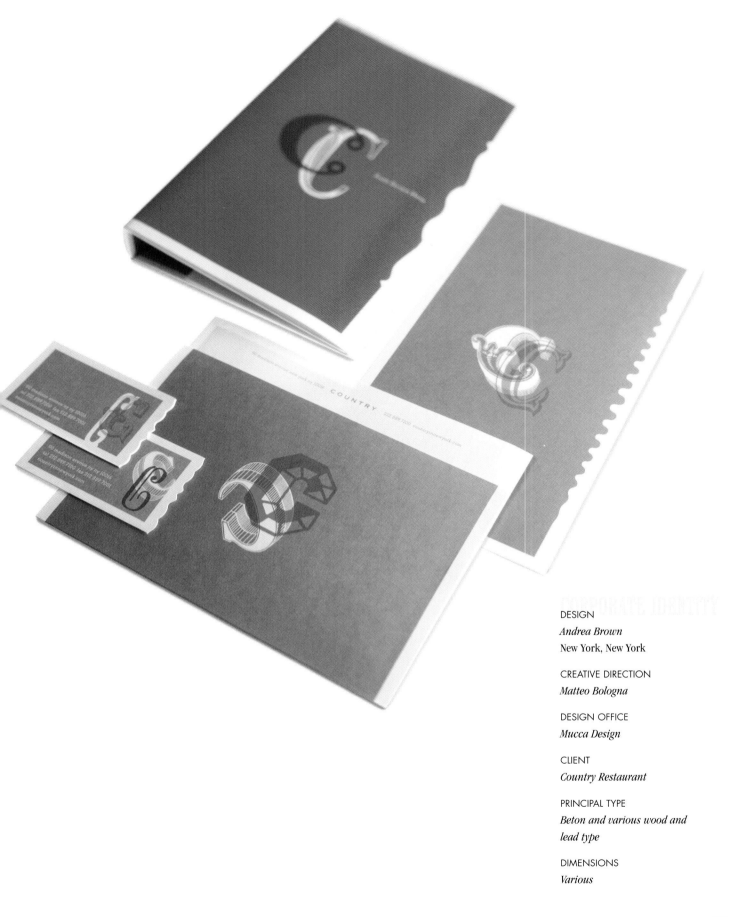

DESIGN
Andrea Brown
New York, New York

CREATIVE DIRECTION
Matteo Bologna

DESIGN OFFICE
Mucca Design

CLIENT
Country Restaurant

PRINCIPAL TYPE
*Beton and various wood and
lead type*

DIMENSIONS
Various

DESIGN
Ken-Tsai Lee and Yao-Feng Chou
Taipei, Taiwan

ART DIRECTION
Ken-Tsai Lee

CREATIVE DIRECTION
Ken-Tsai Lee

STUDIO
Ken-Tsai Lee Design Studio

CLIENT
Fonso Interprise Co., Ltd.

PRINCIPAL TYPE
Custom

DIMENSIONS
15.8 x 24.4 in.
(40 x 62 cm)

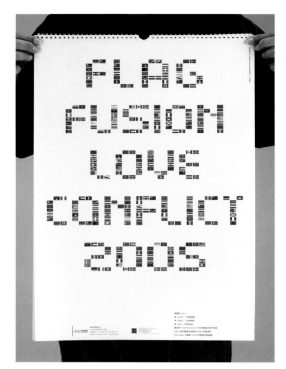
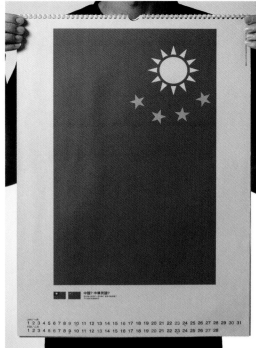
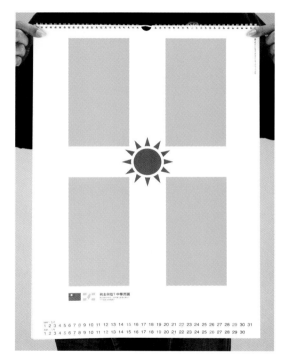
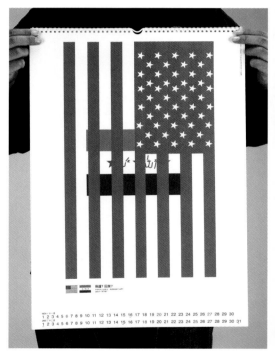

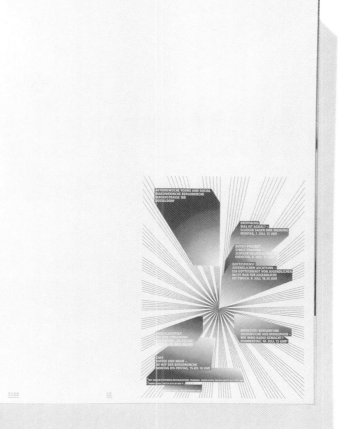

BOOK

DESIGN
Caro Hansen, Fons Hickmann,
Sabine Kornbrust, Franziska Morlok,
Verena Petrasch, and Annik Troxler
Berlin, Germany

ART DIRECTION
Fons Hickmann

CREATIVE DIRECTION
Fons Hickmann

PUBLISHER
Die Gestalten Verlag (dgv)

DESIGN STUDIO
Fons Hickmann m23

CLIENT
www.touch-me-there.com

PRINCIPAL TYPE
for_boys_only

DIMENSIONS
9.5 x 11 in.
(24 x 28 cm)

DESIGN
Michael Jakab
San Francisco, California

ART DIRECTION
Michael Jakab

CREATIVE DIRECTION
Michael Jakab

AGENCY
Collective

CLIENT
Yale School of Art

PRINCIPAL TYPE
Booble, Monolab, and Prestige Elite

DIMENSIONS
6 x 10 in.
(15.2 x 25.4 cm)

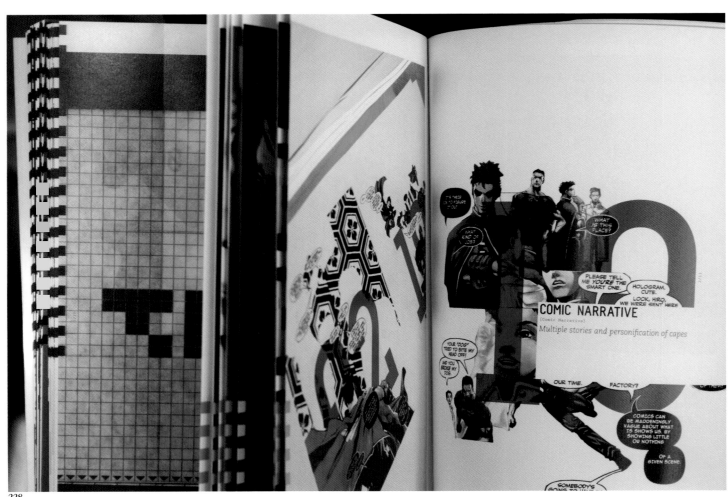

DESIGN
Masayoshi Kodaira and Emi Ikami
Tokyo, Japan

ART DIRECTION
Masayoshi Kodaira

PHOTOGRAPHY
Mikiya Takimoto

STUDIO
FLAME, Inc.

CLIENT
PIE BOOKS

PRINCIPAL TYPE
Custom based on Helvetica

DIMENSIONS
10.1 x 14.3 in.
(25.7 x 36.4 cm)

DESIGN
Mark Denton
London, England

CREATIVE DIRECTION
Mark Denton

LETTERING
Alison Carmichael

DESIGN OFFICE
Mark Denton Design

CLIENT
Alison Carmichael

PRINCIPAL TYPE
Handlettering

DIMENSIONS
16.5 x 23.4 in.
(42 x 59.4 cm)

WORDS LOOK MUCH NICER WHEN THEY'RE HAND LETTERED

ALISON CARMICHAEL Lettering Artist phone/fax +44 (0)20 8789 3509 mobile +44 (0)775 398 6699 www.alisoncarmichael.com

DESIGN
Kozue Takechi
Tokyo, Japan

ART DIRECTION
Kozue Takechi

LETTERING
Futaba

ILLUSTRATION
Futaba

CLIENT
chutte

PRINCIPAL TYPE
Handlettering

DIMENSIONS
20.3 x 28.7 in.
(51.5 x 72.8 cm)

STUDENT PROJECT

DESIGN
Mike Krol
New York, New York

SCHOOL
School of Visual Arts

INSTRUCTOR
Mike Joyce

PRINCIPAL TYPE
Helvetica Round

DIMENSIONS
Various

DESIGN
Richard Belanger
Montreal, Canada

ART DIRECTION
Louis Gagnon

CREATIVE DIRECTION
Louis Gagnon

DESIGN OFFICE
Paprika

PRINCIPAL TYPE
*Helvetica Neue, Helvetica Neue Bold,
and Helvetica Neue Roman*

DIMENSIONS
Various

233

DESIGN
David Guarnieri
Montreal, Canada

ART DIRECTION
Louis Gagnon and David Guarnieri

CREATIVE DIRECTION
Louis Gagnon

DESIGN OFFICE
Paprika

CLIENT
Commissaires

PRINCIPAL TYPE
*Helvetica Neue, Helvetica Neue Bold,
and Helvetica Neue Roman*

DIMENSIONS
Various

INVITATION

DESIGN
Masayoshi Kodaira and
Namiko Otsuka
Tokyo, Japan

ART DIRECTION
Masayoshi Kodaira

STUDIO
FLAME, Inc.

CLIENT
Magnum, Inc.

PRINCIPAL TYPE
Helvetica and handlettering

DIMENSIONS
15.75 x 15.75 in.
(40 x 40 cm)

DESIGN
David Guarnieri
Montreal, Canada

SCHOOL
École de Design, UQAM

INSTRUCTOR
Judith Poirier

PRINCIPAL TYPE
FF DIN, Edwardian Script,
and Mrs. Eaves

DIMENSIONS
Various

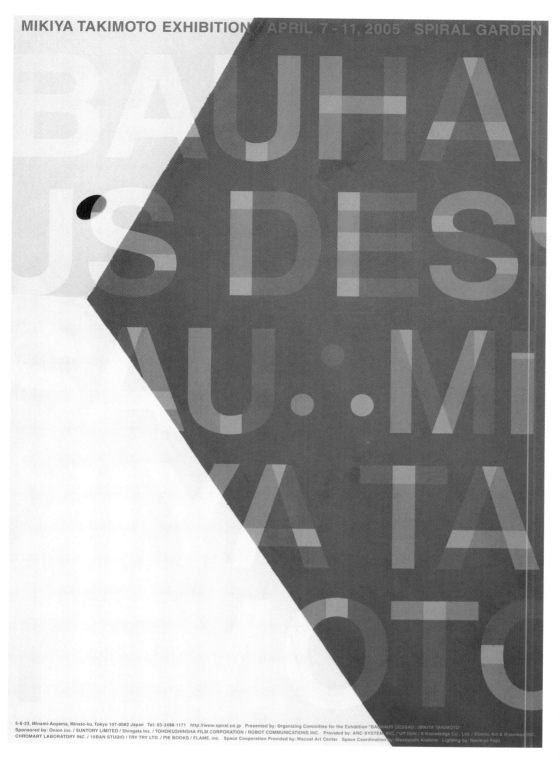

5-6-23, Minami-Aoyama, Minato-ku, Tokyo 107-0062 Japan Tel: 03-3498-1171 http://www.spiral.co.jp Presented by: Organizing Committee for the Exhibition "BAUHAUS DESSAU: MIKIYA TAKIMOTO"
Sponsored by: Onion inc. / SUNTORY LIMITED / Shingata Inc. / TOHOKUSHINSHA FILM CORPORATION / ROBOT COMMUNICATIONS INC. Provided by: ARC-SYSTEM INC. / UP field / X-Knowledge Co., Ltd. / Kinetic Art & Business INC.
CHROMART LABORATORY INC. / 10BAN STUDIO / TRY-TRY LTD. / PIE BOOKS / FLAME, inc. Space Cooperation Provided by: Wacoal Art Center Space Coordination by: Masayoshi Kodaira Lighting by: Norikiyo Fujii

POSTER
AND INVITATION

DESIGN
Masayoshi Kodaira
Tokyo, Japan

ART DIRECTION
Masayoshi Kodaira

CREATIVE DIRECTION
Masayoshi Kodaira

PHOTOGRAPHY
Mikiya Takimoto

STUDIO
FLAME, Inc.

CLIENT
Organizing Committee for the Exhibition "Bauhaus Dessau: Mikiya Takimoto"

PRINCIPAL TYPE
Custom based on Helvetica

DIMENSIONS
Various

DESIGN
Mike Krol
New York, New York

SCHOOL
School of Visual Arts

INSTRUCTOR
Mike Joyce

PRINCIPAL TYPE
Disneyland and Futura

DIMENSIONS
8 x 11 in.
(20.3 x 27.9 cm)

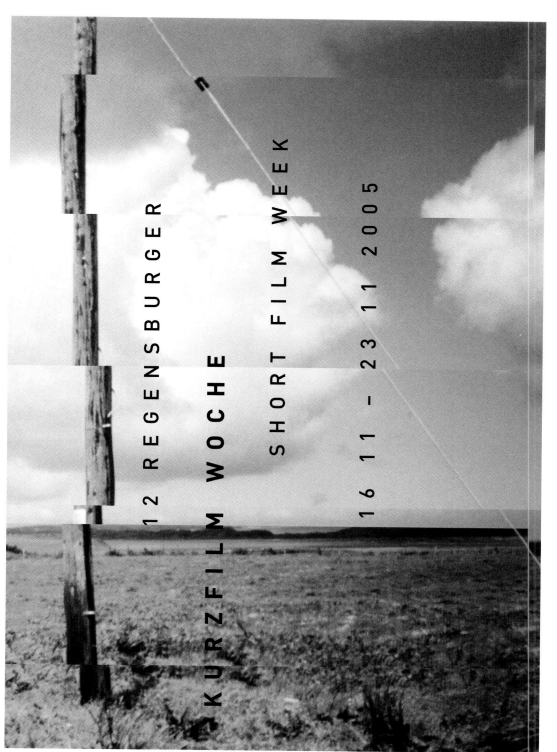

12 REGENSBURGER KURZFILMWOCHE SHORT FILM WEEK 16 11 – 23 11 2005

DESIGN
Nina Neusitzer and Nicolas Markwald
Frankfurt, Germany

ART DIRECTION
Nina Neusitzer and Nicolas Markwald

DESIGN OFFICE
Markwald und Neusitzer

CLIENT
Arbeitskreis Film Regensburg e.V.

PRINCIPAL TYPE
FF DIN

DIMENSIONS
23.4 x 33.1 in.
(59.4 x 84 cm)

DESIGN
Matthias Ernstberger and
Richard The
New York, New York

LETTERING
Matthias Ernstberger

CREATIVE DIRECTION
Stefan Sagmeister

DESIGN OFFICE
Sagmeister Inc.

CLIENT
Experimenta, Lisbon, Portugal,
and Superbock

PRINCIPAL TYPE
Handlettering

DIMENSIONS
169.3 x 63.5 ft
(8 x 3 m)

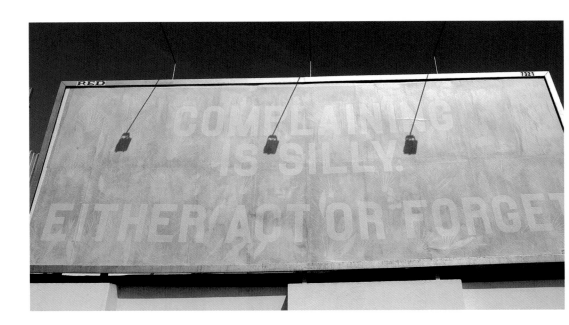

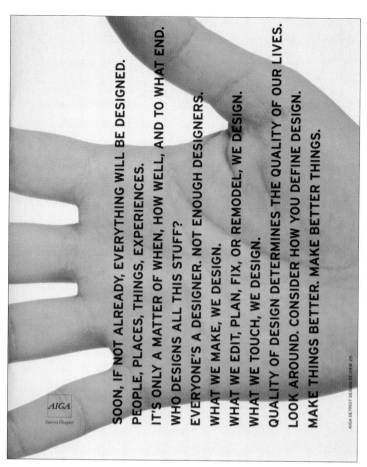

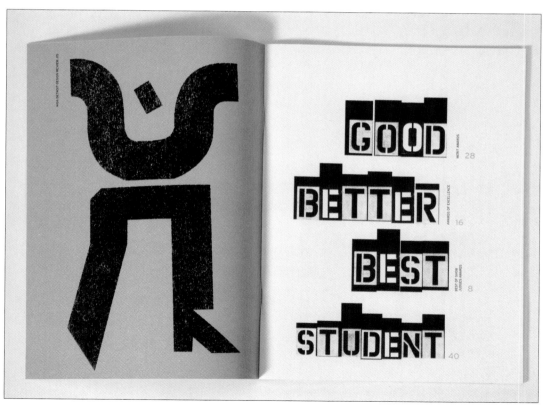

DESIGN
Brian Hauch and Jason Murray
Grand Rapids, Michigan

ART DIRECTION
Brian Hauch

CREATIVE DIRECTION
Kevin Budelmann

ILLUSTRATION
Kevin Budelmann and Jason Murray

STUDIO
BBK Studio

CLIENT
American Institute of Graphic Arts
Detroit

PRINCIPAL TYPE
Interstate

DIMENSIONS
11 x 14.5 in.
(27.9 x 36.8 cm)

CORPORATE IDENTITY

DESIGN
Martin Schoberer
Hamburg, Germany

CREATIVE DIRECTION
Wolfgang von Geramb

DESIGN OFFICE
Robinizer

CLIENT
Walter Pfisterer Fotografie

PRINCIPAL TYPE
Egyptienne F

DIMENSIONS
Various

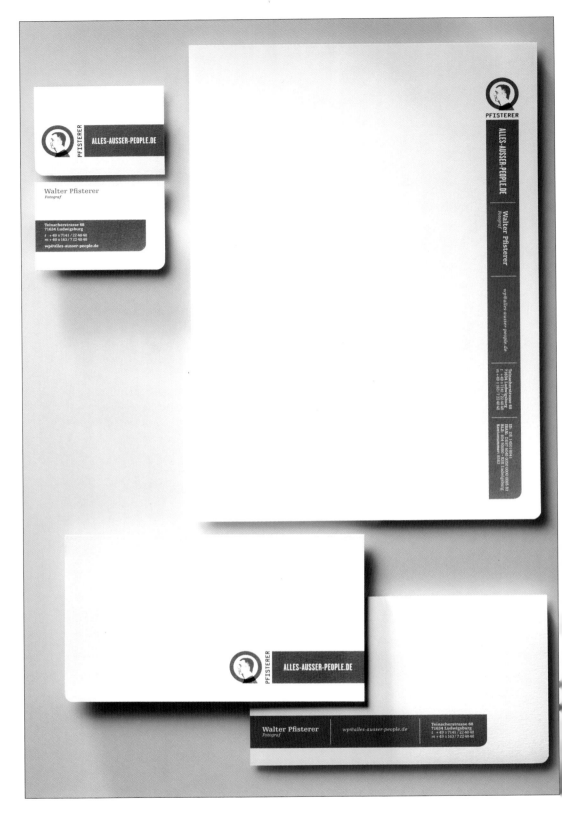

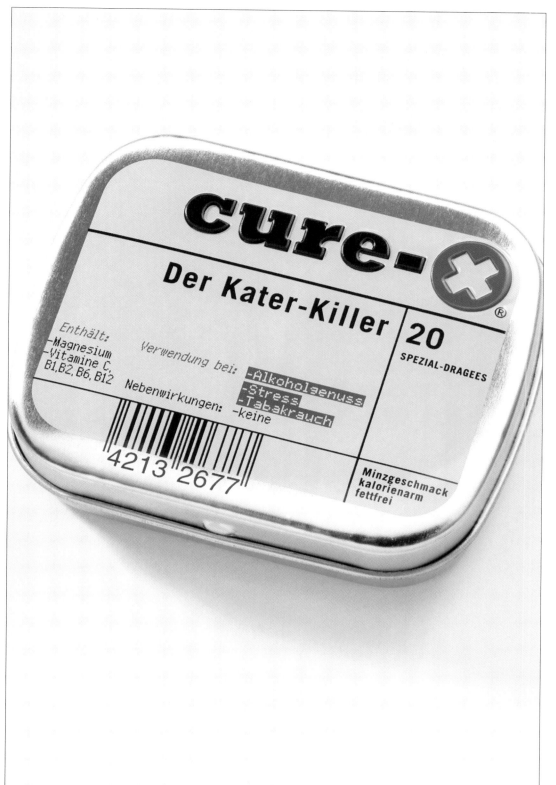

DESIGN
Klaus Trommer
Essen, Germany

ART DIRECTION
Klaus Trommer

CREATIVE DIRECTION
Klaus Trommer

LETTERING
Klaus Trommer

DESIGN AGENCY
HOME^Agentur für Kommunikation

CLIENT
Cure-X GmbH

PRINCIPAL TYPE
Call One, Call Six, and Trade Gothic

DIMENSIONS
2.4 x 2 x .6 in.
(6.2 x 5 x 1.6 cm)

DESIGN
Lee O'Brien and Andy Trantham
Winston-Salem, North Carolina

ART DIRECTION
Lee O'Brien and Andy Trantham

AGENCY
Elephant In The Room

CLIENT
Glass Half Full

PRINCIPAL TYPE
Vendetta and HTF Knockout

DIMENSIONS
10 x 3.5 in.
(25.4 x 8.9 cm)

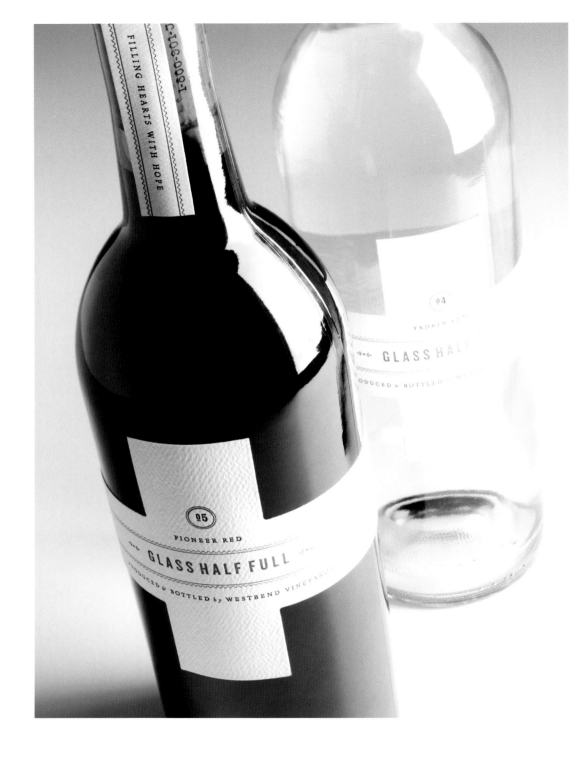

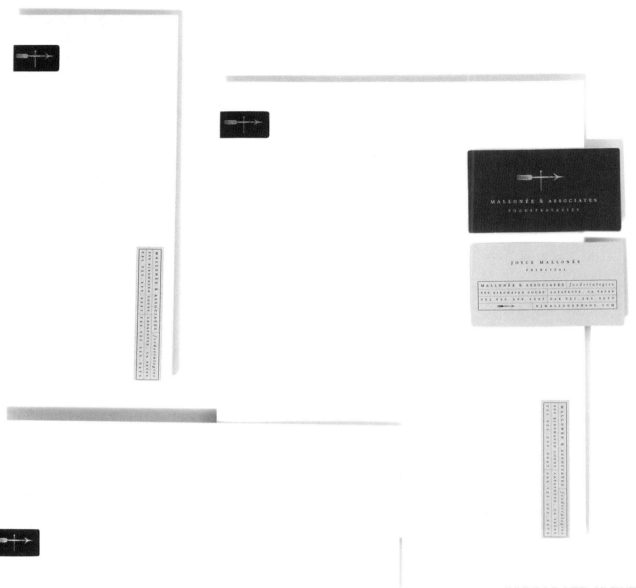

DESIGN
Michael Vanderbyl and Ellen Gould
San Francisco, California

ART DIRECTION
Michael Vanderbyl

CREATIVE DIRECTION
Michael Vanderbyl

DESIGN OFFICE
Vanderbyl Design

CLIENT
Mallonée & Associates

PRINCIPAL TYPE
Filosofia

DIMENSIONS
Various

245

TDC² 2006

Ilene Strizver

Ilene Strizver, founder of The Type Studio, is a noted typographic educator, consultant, designer, and writer. She specializes in all aspect of visual communication—from the aesthetic to the technical. Ilene has written and lectured extensively on type and typographic design to both students and professionals in the field. She conducts her widely acclaimed Gourmet Typography workshops internationally.

From 1977 to 2000 Ilene was director of typeface development for International Typeface Corporation (ITC) where she developed more than 300 text and display typefaces with such respected and world-renowned type designers as Jim Bell, Tim Donaldson, Jim Parkinson, Erik Spiekermann, Sumner Stone, and the late Phill Grimshaw. She "cut her typographic teeth" by working on Upper and Lowercase (U&lc) *and other type projects with such legendary icons as Ed Benguiat, Aaron Burns, and Herb Lubalin.*

Ilene's clients have included Adobe, bethere.com, BJ's Wholesale, Galápagos Design Group, Haband, International Typeface Corporation, Johnson & Johnson, Linotype, Monotype Imaging Corporation, Nassau Guardian, and RGD Ontario. Ilene has written for Dynamic Graphics, HOW, *and* STEP Inside, *as well as authoring the popular column, fy(t)I (For Your Typographic Information), which can be found on www.fonts.com and www.itcfonts.com. Her current book, the 2nd edition of* Type Rules! The Designer's Guide to Professional Typography, *has received numerous accolades from the type and design community.*

Typeface design has come a long way in the digital age both technically and conceptually. Only 25 years ago, type-faces were painstakingly drawn by hand. Every stroke of every character of every weight was individually drawn, taking many months and sometimes years before they were completed. At this point it was delivered to a foundry to be digitized by a highly skilled person operating high-end equipment. It was only at this late stage in the design's development that the designer could truly see what the typeface looked like in text.

Light years have passed since then. The digital age has brought with it software which allows virtually anyone to design a typeface, often at breakneck speed. This "democratization of type design" has literally changed the face of type design.

As a former two-term Type Directors Club board member, former judge, and most recently TDC² 2006 chairperson, I've had the privilege of seeing hundreds of typeface submissions over the years. The nature of the entries has definitely changed over time. When the competition began ten years ago, type design software was still relatively new, and the entries reflected this. A higher percentage of display designs were submitted to the competition then, probably because these required less time and tradition skills (or so many believed). These earlier designs were often conceptual and experimental in nature—heavy on concept and often weak on execution. They often showed great creativity but poor practicality as a useable typeface.

This year's type design entries showed a lot more maturity. The entries consisted of a higher percentage of text than display in comparison to earlier years. The entries in general showed a high degree of skill and attention to detail. In fact, so much emphasis was paid to exquisite execution that creativity and innovation were often lost in the shuffle.

I believe this is the natural course of type design evolution in the digital age. The pendulum swings in both directions before it settles in a place of balance in the center. I look forward to the coming years when type design will also find its center and be a harmonious blend of concept and execution.

ITC VINTAGE

ABCDEFGHIJKLMNOPQRSTUVWXYZ
ABCDEFGHIJKLMNOPQRSTUVWXYZ0123456789
0123456789ÇØÆOEçøæoefifl
&$¢£¥?ƒ%‰@
(){}[]""''-–—«‹›»?¿!¡.,:; †‡§¶*

ITC VINTAGE

ABCDEFGHIJKLMNOPQRSTUVWXYZ
ABCDEFGHIJKLMNOPQRSTUVWXYZ0123456789
0123456789ÇØÆOEçøæoefifl
&$¢£¥?ƒ%‰@
(){}[]""''-–—«‹›»?¿!¡.,:; †‡§¶*

ITC Vintage, designed by Ilene Strizver and Holly Goldsmith.

TDC² 2006 JUDGES

Yvonne Diedrich

Yvonne Diedrich was born in Vienna and raised bilingually in a family rooted partially in Slovakia, France, Germany, and England. She started working as a freelance designer and letter artist in 1994, though she had planned originally to become a painter.

The label ydt fonts was founded in 2000 by Yvonne Diedrich as an independent foundry for the design and implementation of exclusive typefaces and corporate images. The main focus of the foundry is on family type systems and corporate fonts, with the aim of developing new typographic moldings. Thus her work attempts to utilize typography as an artistic medium to create a differential context as typographic demands are diversifying.

Yvonne has designed typefaces for ITC International Typeface Corporation, Letraset Ltd., and custom clients. Her work has been published in *U&lc*, the TDC Annual, and *Type Rules!*, among others. Her text family ITC Dyadis was released in 1998. This project gave Yvonne the opportunity to work together with Ilene Strizver. In 2000 Letraset released the binary-based text family Eplica. The series won an award from the Type Directors Club and was the primary text used by Gail Anderson for TDC Annual *Typography 22*. Diego Vainesman chose Eplica as the primary typeface for the TDC newsletter *Letterspace*.

Currently Yvonne Diedrich is working on the launch of her new text family YDT Advena, which will be released by ydt fonts in 2006. For more about Yvonne visit www.ydt-fonts.com.

Advena Sans

NEOHUMANIST *TYPE*
unifying acuity & blurring
SMOOTH TRANSITION
letterform *reflexive finish*
DIFFERENT TYPE MATTER
ADVENA SANS issued by ydt fonts.com

HfyQ27

ABCDEFGHIJKLMNOPQ
RSTUVWXYZabcdefghi
jklmnopqrstuvwxyz
1234567890*ABCDEFG
HIJKLMNOPQRSTUVWX
YZabcdefghijklmnopq
rstuvwxyz1234567890*

Advena Sans

HfyQ27

Eplica

Distinctively DISTINCTIVE
Distinctively DISTINCTIVE
Distinctively DISTINCTIVE

HQ27il

Distinctively DISTINCTIVE
Distinctively DISTINCTIVE
Distinctively DISTINCTIVE

HQ27il

ff ty ff ty ff ty
ff ty ff ty ff ty

Mark Jamra

Mark Jamra is a type designer, typographic designer, and associate professor at Maine College of Art in Portland, Maine. He has designed and produced typefaces for over 20 years and is the founder of TypeCulture, a digital type foundry and academic resource. He also designs books, creates short documentary films, and is a partner in Alice Design Communication, a collective of communication designers and specialists in Portland. His typeface designs include Alphatier, Brynmorgen Greek, Expo Sans, Expo Sans Dotscreen, Expo Sans Inline, ITC Jamille, Latienne, Quelle Bold, and Tacitus. His Kinesis is an Adobe Original. His lettering and typefaces have been shown in numerous exhibitions and have received awards from the Type Directors Club and the Association Typographique Internationale.

Mark graduated with a BFA degree from Kent State University and completed his graduate studies in 1983 at the School of Design in Basel, Switzerland. He has lectured, conducted workshops, and taught graphic design, typography, letterform design, and type history at colleges in the United States and Europe. He has also been a typographic consultant to the Hewlett-Packard Research Laboratories in Bristol, England, and for URW Software & Type GmbH in Hamburg, Germany.

Musical Events on Stage in 2006

Quality Writings

A Master's Symposium on Architectural Styles

It's 84% of what you're seeing

A [Short] History of Contemporary Foundries

WEEKLY RECORD

The Old Orchard near Sebago Lake

TIBERIUS CLAUDIUS DRUSUS NERO GERMANICUS

The Trading Game

Smally, Patina, Roberts & Endicott

Early Paintings of Noted Personages in the National Gallery

UNDERGROUND

Lectures at the Edgewater Institute Auditorium

THE THIRTY-SEVENTH ARCHEOLOGICAL SYMPOSIUM IN ROME 2006

EQUESTRIAN ARTS EXHIBITION

BELGIUM · IRELAND · DENMARK · FRANCE · GERMANY · GREAT BRITAIN · MEXICO

Through the Eyes of a Child: Personality & Ego in the Playroom

Printing Types and Ornaments

The Great Lakes Concert Hall adjacent to Potter Hardware

China's New Artists

J'entrevoyais à l'extrémité de la place quatre

Ich weiß es nicht

The Archés Guide to Fine Cuisine · Second Edition

DECATURIS UNIVERSITATIS

The twinkle that softens a rebuke; the scorn that can lurk under civility

Orange-Grapefruit Marmalade

Teri Kahan

In Hawaiian, *kaha* means to draw, make marks, turn, or surf. The same letters make up the last name of designer Teri Kahan, and it is no mere coincidence. Teri loves to draw, and a passion for nature, the ocean, and all things Hawaiian inspires her life and artwork.

The free-spirited Southern California artist wears many hats: graphic designer, type designer, calligrapher, illustrator, photographer, and educator. With a career spanning almost 30 years, she currently specializes in logos and corporate communications.

Teri has designed fonts for ITC and also develops proprietary fonts. A notable example is the Lexus font designed for Toyota Motor Corporation, USA. She has received numerous design awards and been published in countless books and magazines. She also exhibits as a fine artist, and her serene shoreline photomontages were recently exhibited in the prestigious juried Festival of Arts in Laguna Beach, California.

Teri discovered her passion for the letter arts at a young age and shares her interests by teaching workshops at colleges, conferences, and museums. Proficient in multiple media, her courses range from pencil to pixel, encompassing both the traditional and digital realms of lettering and design. See Teri's work at www.terikahandesign.com

Like palm trees swaying in the ocean breeze

Puamana

ABCDEFGHIJKLMNOPQRS
TUVWXYZ&abcdefghijklmnopq
rstuvwxyz!234567890@!?(*/~

ITCPuamana & ITCKahana

ITCPuamana captures the essence of the tropics, suggesting the sway of palm trees in the ocean air. "Puamana" is a Hawaiian word with several meanings; among them are "sea breeze" and "the blossoming of miraculous power." With its ragged edges and italic slant, this brush-written alphabet has a visual texture that graces the page with spirited movement.

In HAWAIIAN
KAHA MEANS
TURN OR SURF
ABCDEFGHIJKLMNOPQ
RSTUVWXYZ&ABCDEFGH
IJKLMNOPQRSTUVWXYZ
1234567890!?(*/~}-$)

As if gliding on an ocean tide, ITCKahana floats across the page with the pulse and sway of the sacred Hawaiian hula dance. The word "kahana" is more than just a namesake. In Hawaiian, "kaha" means "to mark, draw, place, turn or surf." An enchanting decorated alphabet in the lowercase position expands this typeface's usefulness.

This "Design Font" is composed of 68 pictographs which capture the sentiments of relationship, connection and synchronicity. The clean, simple illustration style of ITCConnectivities originates from the look of hand-carved rubber stamps, and lends itself well to logos and graphics.

ITCConnectivities & ITCHolistics

Like a tree rooted in ancient philosophy with branches reaching into the new age, ITCHolistics encompasses 82 pictographs of astrology, healing, magic, nature and spirituality. As in the companion font above, the illustration style originates from hand-carved rubber stamps.

James Montalbano

James Montalbano's professional career began as a public school graphic arts teacher. After receiving an MEd in technology education, he studied lettering with Ed Benguiat, began drawing type, and working in the wild world of New York City type shops and magazine art departments. His career continued as a magazine art director, moving on to become a design director responsible for twenty trade magazines whose subject matter no one should be required to remember. He tried his hand at designing pharmaceutical packaging, but that only made him ill.

Montalbano is principal of Terminal Design, Inc. (www.terminaldesign.com). His Brooklyn, New York, firm specializes in typeface design, font development, and digital lettering. He has designed custom fonts and lettering for editorial, corporate, government, and publishing clients, including *Brides, Fortune, Glamour, Money, Vanity Fair,* and *Vogue* magazines; The American Medical Association, AT&T, Little Brown & Co. Inc., Miller Brewing, J.C. Penny, Scribner, and The U.S National Park Service. Over the last ten years he has been working on the Clearview™ type system for text, display, roadway, and interior guide signage. His work has been featured in *Creative Review, ID* magazine, *The New York Times, Print,* and *Wired.* He is a past president of the Type Directors Club and teaches at Parsons School of Design.

Enclave™

Five big quacking zephyrs jolt my wax bed.

Sympathizing would fix Quaker objectives.

Cozy sphinx waves quart jug of bad milk.

Thief, give back my prized wax jonquils!

Jackdaws love my big sphinx of quartz.

Pack my box with five dozen liquor jugs.

Quick waxy bugs jump the frozen veldt.

Blowzy red vixens fight for a quick jump.

Judges vomit; few quiz pharynx block.

How quickly daft jumping zebras vex.

The five boxing wizards jump quickly.

Foxy nymphs grab quick-lived waltz.

Brick quiz whangs jumpy veldt fox.

Quick wafting zephyrs vex bold Jim.

Nymphs vex, beg quick fjord waltz.

Sphinx of black quartz judge my vow.

TDC² 2006 JUDGES' CHOICES AND DESIGNERS' STATEMENTS

Yvonne Diedrich JUDGE

Blackletter scripts exist in many variations. They evolved out of the medieval manuscript tradition and are distinguished by their rigidity of form. As printing encouraged diversity in the written word, scripts began to evolve into instruments of artistic expression.

This design is a fine example that exercises the historical variety in a freely hybrid manner. Its transitional structure draws on the tradition of Textura, the oldest form of blackletter, with its angular, wide-nibbed pen strokes interrelated with fine hairlines and sharp finals. The short compressed x-height of the lowercase creates an interesting bridging to the Gothic minuscule. Reminiscent of Bocskay's calligraphic virtuosity, this typeface has strong character. Its dominant caps comprise a vital interpretation of the historical models with expressive swash flourishes. The swash finals have been superbly executed with subtle nib detailing.

Another elaborate feature of this design is the addition of alternate glyphs, forming a rich appearance as if letters had risen from the hand of the calligrapher. When set in text, this face creates a strong consistency of tone, a very even rhythm across the page. Overall this is a well-executed design of beautiful detailing and powerful calligraphic texture.

Gabriel Martínez Meave DESIGNER

In these times of globalization, minimalism, and widespread use of sans serif, designing a Gothic font could seem to be an unforgivable aberration. However, blackletters have traditions and uses other than heavy-metal albums and Teutonic-inspired designs. In Mexico, for instance, Gothic fonts were used in the first books printed in the continent (1539). Though they were replaced by Roman typefaces in the early 1600s, they never entirely vanished from the popular taste, reaching a peak in the 19th and early 20th centuries, when they were seen everywhere, from tequila labels to taxicabs.

This use of blackletters to this day in vernacular, nondesigner lettering has never ceased to amaze me. In these popular signs, the shapes of Bâtarde, Fraktur, Rotunda, and Textura have been mixed and reinvented by people who were not aware of the context these traditional styles had in old Europe. They seem to just enjoy the complex, convoluted, intoxicating forms of the letters.

Digital technology, on the other hand, enables us to render the powerful shapes of Gothic letterforms to their fullest expression and calligraphic detail, free from the constrains of metal type. Darka is a personal exercise of these ideas: an eclectic, Latin-flavored blackletter that plays strictly but freely with the great Gothic calligraphic styles I am so fond of.

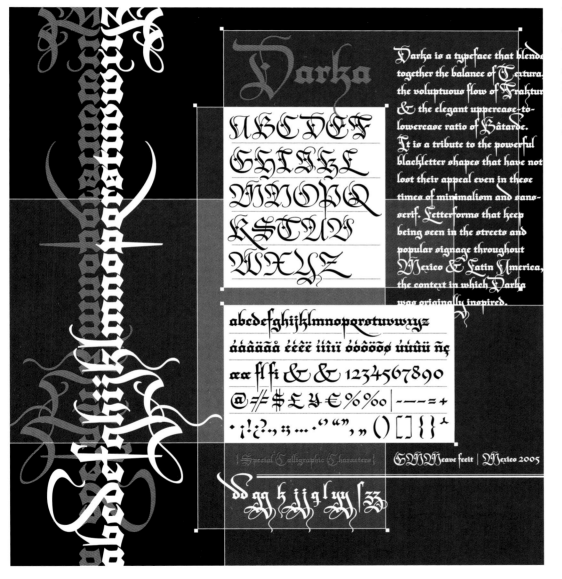

Darka is a typeface that blends together the balance of Textura, the voluptuous flow of Fraktur & the elegant uppercase-to-lowercase ratio of Bâtarde. It is a tribute to the powerful blackletter shapes that have not lost their appeal even in these times of minimalism and sansserif. Letterforms that keep being seen in the streets and popular signage throughout Mexico & Latin America, the context in which Darka was originally inspired.

TYPEFACE
Darka

TYPEFACE DESIGNER
Gabriel Martínez Meave
Mexico City, Mexico

FOUNDRY
Kimera Type Foundry

Mark Jamra JUDGE

Vista is a robust and intelligent design. I was attracted to it by the apparent willingness of the designer to try out some unconventional ideas in a sans serif type—ideas that rise above a mere quest for quirkiness and that seem to follow a personal and well-considered strategy of invention. This is coupled with the designer's obvious ability to translate those ideas into glyphs with a strong formal integrity and proportional balance.

Simplicity and thoroughness are also decisive factors here. The concept for the alternate caps is showcard-like, humorous, and cleverly straightforward. I find the black weights have a quality akin to wood types, while the alternate lowercase characters are capable of subtly transforming the underlying tone of the whole design. Close attention to form is also apparent in the math symbols, currency symbols, reference marks, and diacritical marks—with little gems of inventiveness showing up throughout the complement.

A good measure of confidence and creative maturity is visible here, most notably in the merging of adventurousness and restraint. It's important to note that the excellent spacing is another feature that made this design stand out from the majority of submissions. The glyph and word spacing create a rhythm and color that bring the personality of the design to full effect in a display line or text. In all, an important combination of talents is evident: ambition and intellect in challenging typographic conventions and the capabilities in craftsmanship and production skills that are necessary to yield a well-functioning and broadly useable typeface.

Xavier Dupré DESIGNER

The concept for Vista began in July 2002 when I sketched a few characters in a notebook while staying in Sumatra on a one-month holiday. Most of the shop signs in Sumatra feature idiosyncratically decorative lettering, inspired by the American West and other unusual shapes.

In reaction to this, I intended to design a semi-serif typeface for text and display, useful for general application. I was inspired by Erik Spiekerman's FF Meta, which is very successful at combining the humanist appeal of calligraphic forms with the pragmatic simplicity of the sans. Then, two years later in May 2004, I revisited this unfinished family and redesigned all the characters. I threw out the serif companion to make the family simpler, narrower, and more useful. I found the right proportions for a text font—not too condensed to preserve comfort in reading, not too wide for economy of space.

udsigten DANISH
der Blick GERMAN
aanschijn DUTCH
the view ENGLISH
la vue FRENCH
la vista SPANISH

TYPEFACE
Vista Sans

TYPEFACE DESIGNER
Xavier Dupré
Bangkok, Thailand

FOUNDRY
Emigre, Inc.

MEMBERS OF TYPEFACE
FAMILY/SYSTEM
*36: Regular, Alternate, Alternate
Italic, Black Standard, Bold, Book,
Italic, Light, Medium, Small Caps,
and Small Caps Italic*

Teri Kahan JUDGE

Years ago, when I used to read *U&lc* in print, I would dream of becoming involved at this echelon of typography. It still astounds me that my path has led to significant opportunities to grow as an artist and to establish relationships with others who are passionate about lettering and design. So it was that collaborating with the four gifted and knowledgeable members of the TDC jury increased my appreciation for the people of the art, the depth of the field, and the many talents of contemporary font designers. By looking through the eyes and minds of the entire jury, we managed a nuanced appreciation of the subtleties within each of the submitted fonts. Some stood out for their consistencies in weight, form, flavor, maturity, flair. Some were distinguishable by their sheer beauty.

As a lover of brush scripts, it is no wonder my judge's choice selection was Sweepy, the handsome, flowing font by Michael Clark. Though I did not know who created it at the time of judging (designer names are deliberately kept confidential), it turns out that I have long been an admirer of this artist's lettering talents. The movement of the hand is keenly reflected in the verve of his alphabet—slightly curving downstrokes, exaggerated exits that make for successful joining, a strong slant, beautiful swashes. Open spacing enhances the grace and legibility. The capitals are unique in that they are informal and condensed in contrast to the more open, formal lowercase forms. The myriad ligatures, flourishes, and alternate glyphs provide many opportunities for creative application.

The Type Directors Club continues to highlight the rich and varied tapestry that is modern typography. I am delighted to have met many of their members and honored to have been a part of this process.

Michael Clark DESIGNER

I have always been predisposed to titling faces. As a lettering artist, I create enough garbage to pick through it, looking for potential typefaces. The problem, as everyone knows, is setting aside the time to do the digital work. Sweepy is the outgrowth of a variety of lettering styles, done with Speedball pens, that I use in commercial applications.

Pooper Black was the first of this genre that I chose to rein into a typographic format. As its popularity grew I knew I needed to do a lighter version. What transpired though was a shift in my thinking: why not create a semi-joining "script." The final product is a fun and flowing font.

Aquilegia Buddleia Clematis
Delphinium Euphorbia Foxglove
Gaillardia Honeysuckle Iceplant
Juniper Kiwi Liriope Miscanthus
Nicotiana Oxalis Primrose Quince
Rudbeckia Switchgrass Thyme
Undulata Viburnum Wisteria
Xylem Yucca and Zinna
Alternates include: t f o
H th tl fl Th v y f s p
v tt y r rr f t
£ ? ! g € / () q B
à é î ö ú ñ ç

TYPEFACE
P22 Sweepy

TYPEFACE DESIGNER
Michael Clark
Richmond, Virginia

FOUNDRY
P22 Type Foundry and International House of Fonts

MEMBERS OF TYPEFACE
FAMILY/SYSTEM
P22 Sweepy and P22 Sweepy OpenType

James Montalbano JUDGE

I have always found that the most successful type designs are ones that have been created for a specific purpose. As the designer explains, this is not a slavish historical revival but a modern interpretation of a classic work. The attention to detail is superb, the range of style and weight are appropriate for modern uses, and all the while the influence of the source is never obscured. No smudges or odd bumps from page proofs that so often make their way into revivals due to some misplaced desire to have the fonts look "old" or "authentic."

From the moment I saw this example in the competition I was impressed by two things: the excellence of the actual type design and, equally important, the quality of the samples provided for the judging. Each piece was a wonderful piece of typography in its own right and would have won most typographic design competitions as well. This allowed the type design to be judged in the environment for which it was created. That's truly the only way any type can be judged.

Iñigo Jerez DESIGNER

This project takes as its starting point the first edition of *Don Quijote*, printed in 1605 by Juan de la Cuesta, but it is not a work of archeology intended to improve the original edition with digital media. The objective of this alphabet is to create a new tool that catches and expresses the style of that *Quijote* and transmits the spirit of Cervantes's book.

In the personal interpretation of this idea a series of licenses were adopted that, strictly speaking, are not of the 17th century, like the exaggeration of some forms, the inclusion of new glyphs, and the creation of a boldface. Therefore Quixote is not a rigorously historic version, despite reflecting some details and anecdotes of the original. The intention of the project is to pay homage to one of the greatest milestones of universal literature with an alphabet especially designed to compose a new edition of *El Ingenioso Hidalgo Don Quijote de la Mancha*.

PRIMERA PARTE
DEL INGENIOSO HIDALGO
DON QUIXOTE
DE LA MANCHA

Capítulo primero

Que trata de la condición y ejercicio del famoso y valiente hidalgo don Quijote de la Mancha

En un lugar de la Mancha, de cuyo nombre no quiero acordarme, no ha mucho tiempo que vivía un hidalgo de los de lanza en astillero, adarga antigua, rocín flaco y galgo corredor. Una olla de algo más vaca que carnero, salpicón las más noches, duelos y quebrantos los sábados, lantejas los viernes, algún palomino de añadidura los domingos, consumían las tres partes de su hacienda. El resto della concluían sayo de velarte, calzas de velludo para las fiestas, con sus pantuflos de lo mesmo, y los días de entresemana se honraba con su vellorí de lo más fino. Tenía en su casa una ama que pasaba de los cuarenta y una sobrina que no llegaba a los veinte, y un mozo de campo y plaza que así ensillaba el rocín como tomaba la podadera. Frisaba la edad de nuestro hidalgo con los cincuenta años. Era de complexión recia, de carnes, eni...

Quixote Regular, *Italic*, **Bold, *Bold Italic*** & Caps

Textaxis.com

TYPEFACE
Quixote

TYPEFACE DESIGNER
Iñigo Jerez
Barcelona, Spain

FOUNDRY
textaxis.com

MEMBERS OF TYPEFACE
FAMILY/SYSTEM
Regular, Italic, Bold, Bold Italic, and Caps

TDC² 2006 ENTRIES SELECTED FOR EXCELLENCE IN TYPE DESIGN

TYPEFACE
Rayuela Chocolate 2.0

TYPEFACE DESIGNER
Alejandro Lo Celso
Cholula, Mexico

FOUNDRY
PampaType Digital Foundry

ABCDEFGHIJKLMNOPQRSTU
VWXYZabcdefghijklmnopqrstuv
wxyz0123456789*ABCDEFGHIJKL*
MNOPQRSTUVWXYZabcdefghijkl
*mnopqrstuvwxyz*ԱՔԳԴԵՁԷԸԼ*ՕԱ*
ԻԼԽԾԿՀՁՂՃՄՅՆՇՈՉՊՋՌՍՎՏ
ՐՑՒՓՔՕՖ*աբգդեզէ*ը*թժիլ*խ*ծկհ*
*ձղճմյ*ն*շ*ո*չ*պ*ջ*ռ*ս*վ*տ*րց*ւ*փ*ք*օ*ֆ*ո*❀

խ *u n* *n* d

ÀÁÂÄĀĂÅĄÆǼĆĈĊČÇĎĐÈÉÊĚËĒĔĘƏĜĞĠĢĤĦÌÍÎÏİĨĪĮIJ IJ ĴK̈ĶĹĽĿŁĻŃŇÑŅŊ
ÒÓÔÖÕŌŎŐØǾŒÞŔŘṚŖŖŚŜŠŞȘŢŦṬÙÚÛÜŨŪŬŮŰŲŴẂŴẄŸÝŶŸŹŽŻàáâäãāăå
åąæǽćĉċčçďđèéêěëēĕęəĝğġģḣĥìíîïïīĭįıijĵǰķĸĺľŀłļńňñņŋ'nŋòóôöõōŏőøǿœþŕřṛŗŗś
ŝšşșßťţùúûüũūŭůűųẃŵẁŵŵỳýŷÿźžżƒﬀﬁﬃﬀﬁﬀﬂﬄﬂﬂﬂﬂﬀﬀﬀﬄ&`´ˆˇ˝ˉ˜¨˙˚¸˛,·,;:....··
–—!¡?¿'"'''""„,‹›«»()[]{}#%‰½⅓¼⅔¾*†‡§¶@©®™ªº⁰¹²³¤€$£¥¢ƒ€$£¥¢µℓ№℮01234
56789+−×÷±=≠≈<>≥≤*ÀÁÂÄÃĀĂÅĄÆǼĆĈĊČÇĎĐÈÉÊĚËĒĔĘƏĜĞĠĢĤĦÌÍÎÏİĨĪĮIJIJ ĴĶ*
ĹĽĿŁĻŃŇÑŅŊÒÓÔÖÕŌŎŐØǾŒÞŔŘṚŖŖŚŜŠŞȘŢŦṬÙÚÛÜŨŪŬŮŰŲŴẂŴẄŸÝŶŸŹŽŻ
àáâäãāăåąæǽćĉċčçďđèéêëëēĕęəĝğġģḣĥìíîïïīĭįıijĵǰķĸĺľŀłļńňñņŋ'nŋòóôöõōŏőøǿœþŕřṛ
*ŗŗśŝšşșßťţùúûüũūŭůűųẃŵẁŵŵỳýŷÿźžżƒﬀﬁﬃﬀﬁﬀﬂﬀﬂﬀﬂﬀﬂﬀﬂﬀﬂﬀ&*խ* խ խ խ խ խ խ խ*'''ˆˆ˝:_

TYPEFACE
Calouste

TYPEFACE DESIGNER
Miguel Sousa
Lisbon, Portugal

LANGUAGE
Latin and Armenian

MEMBERS OF TYPEFACE
FAMILY/SYSTEM
Regular and Italic

281

TYPEFACE

Relato Sans

TYPEFACE DESIGNER

Eduardo Manso
Barcelona, Spain

FOUNDRY

Emtype Foundry

MEMBERS OF TYPEFACE
FAMILY/SYSTEM

*Light, Regular, Medium, Semibold,
Bold, and Black Roman and Italics,
Small Caps, and Small Cap Italics for
all weights*

Historia universal de la infamia

ATHLETIC ARE LOOKING FOR A SIXTH PREMIERSHIP

Reinhal el Imperio

Birmingham will be without influential

Hamburg ℧ Barcino

The newsletter publisher & Antho ok

6 WEIGHTS
24 FONTS

emtype.net

Sphinx of black quartz, judge my vow. Thief, give back my prized wax jonquils. The quick br over the lazy dog. Sixty zippers were quickly picked from the woven jute bag. Jaded zombies acted quaintly b g their oxen forward. In a formula deus, qualem paulus creavit, dei negatio. Such a religion as christianity, w ot touch reality at a single point and which goes to pieces the moment reality asserts its rights at any point must be inevitably the deadly enemy of the wisdom of this world which is to say of science and it will give the name of good to whatever means serve to poison, calumniate and cry down all intellectual discipline. ***Paul well knew that lying that faith was necessary.*** *Later on the church borrowed the fact from Paul. The god that Paul invented for himself, a god who reduced to absurdity the wisdom of this world especially the two great enemies of superstition, philology and medicine, is in truth only an indication of Paul resolute determination to accomplish that very thing himself to give one own will the name of god, thora that is essentially Jewish. Paul wants to dispose of the wisdom of this world his enemies are the good philologians and physicians of the Alexandrine school on them he makes his war.*

Η επικοινωνιακή πολιτική only ενός μουσείου
Frutiger Next Greek regular

περιλαμβάνει δραστηριότητες signage
Frutiger Next Greek regular italic

που every πραγματοποιούνται εντός
Frutiger Next Greek medium

και εκτός sometimes του φυσικού του χώρου
Frutiger Next Greek medium italic

πριν όμως typeface design εξετάσουμε
Frutiger Next Greek bold

τους authors παραπάνω τομείς
Frutiger Next Greek bold italic

θα επιχειρήσουμε μια colour θεωρητική
Frutiger Next Greek heavy

προσέγγιση find του ζητήματος
Frutiger Next Greek heavy italic

της επικοινωνιακής standar πολιτικής
Frutiger Next Greek black

τούτο κρίνεται always απαραίτητο.
Frutiger Next Greek black italic

www.Linotype.com

TYPEFACE
Frutiger Next Greek

TYPEFACE DESIGNERS
Adrian Frutiger and Eva Masoura
Bad Homburg, Germany

FOUNDRY
Linotype GmbH

LANGUAGE
Greek

MEMBERS OF TYPEFACE
FAMILY/SYSTEM
Regular, Regular Italic, Medium, Medium Italic, Bold, Bold Italic, Heavy, Heavy Italic, Black, and Black Italic

TYPEFACE
Garamond Premier Pro

TYPEFACE DESIGNER
Robert Slimbach
Mountain View, California

FOUNDRY
Adobe Systems, Incorporated

LANGUAGE
Latin, Cyrillic, and Greek

MEMBERS OF TYPEFACE
FAMILY/SYSTEM
Regular, Bold, Bold Italic, Italic,
Medium, Medium Italic, Semibold,
and Semibold Italic

Caption: Bold, Bold Italic, Italic,
Medium, Medium Italic, Semibold,
and Semibold Italic

Subhead: Bold, Bold Italic, Italic,
Medium, Medium Italic, Semibold,
and Semibold Italic

Display: Bold, Bold Italic, Italic,
Semibold, and Semibold Italic

Garamond Premier

ABCDE *abcdefghijklm nopqrstuvwxyz*

ΑΒΓΔΕΖΗΘΙΚΛΜΝΞΟΠΡΣΥΦΧΨΩ

αβγδεζηθικλμν ξοπρστυφχψω FGHIJK

ABCDEFGHIJKLMNOPQRSTUVWXYZ

LMNOP *абвгдежзийкл мнопрстуфхц*

АБВГГДЕЖЗИЙКЛМНОПРСТУФХЦЧ

abcdefghijklm nopqrstuvwxyz QRSTU

ШЩЪЫЬЭЮЯЁЂЃЄЅІЇЈЉЊЋЌЎЏЄѲѴ

VWXYZ

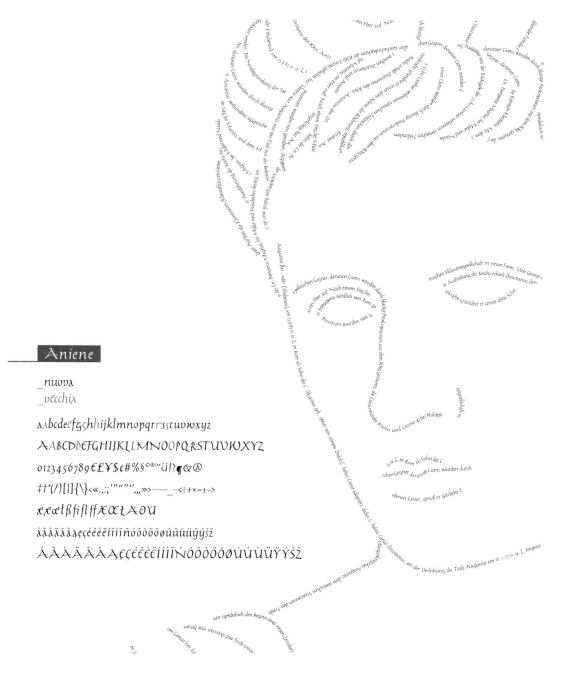

Aniene

_nuova
_vecchia

aʌbcdeɛfɡʒhhijklmnopqrrꞅꞅʃtuvwxyz
AʌABCDDꝊEFGHIJKLLMNOOPQRꞄSTUVꞶXYZ
0123456789€£¥$¢#%§®®™¿¡!?¶&@
#ꝉ'(/)[|]{\}«‹».,.;:'""""'„,»»‒——_-‹:+×=±~›
ɣɣɑɛœꝉßfiflffÆŒŁʌØÙ
áâàäãåạęçéêèëíîìïñóôòöõøúûùüÿýšž
ÁÂÀÄÃÅĄĘÇÉÊÈËÍÎÌÏÑÓÔÒÖÕØÚÛÙÜŸÝŠŽ

TYPEFACE
Aniene

TYPEFACE DESIGNER
Adriane Krakowski
Braunschweig, Germany

FOUNDRY
Elsner+Flake

MEMBERS OF TYPEFACE
FAMILY/SYSTEM
Aniene Nuova and Aniene Vecchia

285

TYPEFACE
FF Headz

TYPEFACE DESIGNER
Florian Zietz
Hamburg, Germany

FOUNDRY
FontFont

Every complete head is made up of four individual characters (upper part of the head, eyes and nose, mouth, and chin). The number of combinations that can be created is ten to the fourth power (ten thousand).

TYPEFACE
Adobe Arabic

TYPEFACE DESIGNER
Tim Holloway
Edgware, England

FOUNDRY
Adobe Systems, Incorporated

LANGUAGE
Arabic

MEMBERS OF TYPEFACE
FAMILY/SYSTEM
Regular, Italic, Bold, and Bold Italic

لمّا كان الاعتراف بالكرامة المتأصلة في جميع أعضاء الأسرة البشرية وبحقوقهم المتساوية الثابتة هو أساس الحرية والعدل والسلام في العالم . ولما كان تناسي حقوق الإنسان وازدراؤها قد أفضيا إلى أعمال همجية آذت الضمير الإنساني . وكان غاية ما يرنو إليه عامة البشر انبثاق عالم يتمتع فيه الفرد بحرية القول والعقيدة ويتحرر من الفزع والفاقة . ولما كان من الضروري أن يتولى القانون حماية حقوق الإنسان لكيلا يضطر المرء آخر الأمر إلى التمرد على الاستبداد والظلم . ولما كانت شعوب الأمم المتحدة قد أكدت في الميثاق من جديد إيمانها بحقوق الإنسان الأساسية وبكرامة الفرد وقدره وبما للرجال والنساء من حقوق متساوية وحزمت أمرها على أن تدفع بالرقي الاجتماعي قدمًا وأن ترفع مستوى الحياة في جو من الحرية أفسح . ولما كانت الدول الأعضاء قد تعهدت بالتعاون مع الأمم المتحدة على ضمان إطراد مراعاة حقوق الإنسان والحريات الأساسية واحترامها . ولما كان للإدراك العام لهذه الحقوق والحريات الأهمية الكبرى للوفاء التام بهذا التعهد . فإن الجمعية العامة . تنادي بهذا الإعلان العالمي لحقوق الإنسان . على أنه المستوى المشترك الذي ينبغي أن تستهدفه كافة الشعوب والأمم حتى يسعى كل فرد وهيئة في المجتمع، واضعين على الدوام هذا الإعلان نصب أعينهم، إلى توطيد احترام هذه الحقوق والحريات عن طريق التعليم والتربية واتخاذ إجراءات مطردة، قومية وعالمية، لضمان الاعتراف بها ومراعاتها بصورة عالمية فعالة بين الدول الأعضاء ذاتها وشعوب البقاع الخاضعة لسلطانها . يولد جميع الناس أحرارًا متساوين في الكرامة والحقوق . وقد وهبوا عقلًا وضميرًا وعليهم أن يعامل بعضهم بعضًا بروح الإخاء . لكل

لمّا كان الاعتراف بالكرامة المتأصلة في جميع أعضاء الأسرة البشرية وبحقوقهم المتساوية الثابتة هو أساس الحرية والعدل والسلام في العالم . ولما كان تناسي حقوق الإنسان وازدراؤها قد أفضيا إلى أعمال همجية آذت الضمير الإنساني . وكان غاية ما يرنو إليه عامة البشر انبثاق عالم يتمتع فيه الفرد بحرية القول والعقيدة ويتحرر من الفزع والفاقة . ولما كان من الضروري أن يتولى القانون حماية حقوق الإنسان لكيلا يضطر المرء آخر الأمر إلى التمرد على الاستبداد والظلم . ولما كانت شعوب الأمم المتحدة قد أكدت في الميثاق من جديد إيمانها بحقوق الإنسان الأساسية وبكرامة الفرد وقدره وبما للرجال والنساء من حقوق متساوية وحز- مت أمرها على أن تدفع بالرقي الاجتماعي قدمًا وأن ترفع مستوى الحياة في جو من الحرية أفسح . ولما كانت الدول الأعضاء قد تعهدت بالتعاون مع الأمم المتحدة على ضمان إطراد مراعاة حقوق الإنسان والحريات الأساسية واحترامها . ولما كان للإدراك العام لهذه الحقوق والحريات الأهمية الكبرى للوفاء التام بهذا التعهد . فإن الجمعية العامة . تنادي بهذا الإعلان العالمي لحقوق الإنسان . على أنه المستوى المشترك الذي ينبغي أن تستهدفه كافة الشعوب والأمم حتى يسعى كل فرد وهيئة في المجتمع، واضعين على الدوام هذا الإعلان نصب أعينهم، إلى توطيد احترام هذه الحقوق والحريات عن طريق التعليم والتربية واتخاذ إجراءات مطردة، قومية وعالمية، لضمان الاعتراف بها ومراعاتها بصورة عالمية فعالة بين الدول الأعضاء ذاتها وشعوب البقاع الخاضعة لسلطانها . يولد جميع الناس أحرارًا متساوين في الكرامة والحقوق . وقد وهبوا عقلًا وضميرًا وعليهم أن يعامل بعضهم بعضًا بروح الإخاء . لكل

TYPEFACE
Hogariet

TYPEFACE DESIGNER
Habib N. Khoury
Fassouta, Israel

FOUNDRY
Avantype Foundry

LANGUAGE
Hebrew

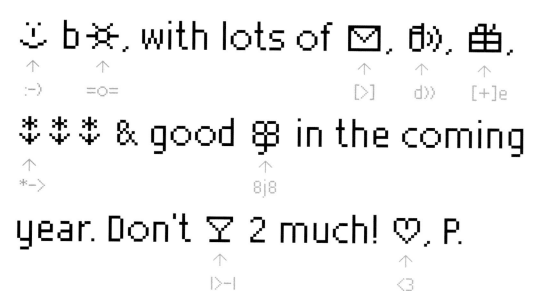

💬 it with ⚓⚓

expressive writing through automatic picture ligatures

☺ b✳, with lots of ✉, 🍷, 🎁,

⚓⚓⚓ & good 🌸 in the coming

year. Don't 🍸 2 much! ♡, P.

| :-) | =o= | | [>] | d》 | [+]e |

| *-> | | 8j8 | | | |

| |>-| | | <3 | | |

FF PicLig uses OpenType's "discretionary ligatures" to combine several characters into an icon, a "picture ligature".

fi → fi → typographic ligature 8j8 → 🌸 → picture ligature

🖳 http://www.piclig.net

TYPEFACE
FF PicLig

TYPEFACE DESIGNER
Christina Schultz
Berlin, Germany

FOUNDRY
FontFont

TDC3: 1956

TDC3 1956

"The aim: to feature outstanding material in which typography is the predominant visual element..." So reads the introduction to this Type Directors Club competition catalog from 1956. Nothing has changed, as you have seen in the winning samples throughout this Annual.

We began reproducing the earliest Type Directors Club competition catalogs in last year's Annual to ensure those early documents would live on. Complete sets of TDC catalogs are extremely rare, and those that exist are deteriorating with age.

Reproduced here is the second catalog (though it is named "Third Annual," because the first TDC competition, held in 1954 and open only to TDC members, had no catalog). Its twenty-four pages contain examples that have inspired many over the years and retain their power to teach if, as has been said, we will just open our eyes and listen.

The TDC Board of Directors

Reproduction Notes: *Designed by Arthur B. Lee. 8 3/8 x 10 15/16 in. (21.3 x 27.8 cm), saddlestitched. All pages have been reduced slightly to show trim. Additional information on this catalog can be found in the colophon on its page 26. Additional information on the development of the TDC Competitions can be found on page 266 in* Typography 23.

THIRD ANNUAL

AWARDS

FOR TYPOGRAPHIC

DESIGN EXCELLENCE

TYPE DIRECTORS CLUB OF NEW YORK

THE AIM: TO FEATURE OUTSTANDING MATERIAL IN WHICH
TYPOGRAPHY IS THE PREDOMINANT VISUAL ELEMENT...

This booklet contains reproductions of the third annual typographic award winners chosen for 1957. The selections were made from more than 1500 entries, and demonstrate how type can provide impact and visual excitement in today's advertising and promotional material. These examples also show that the typographic designer knows how to produce visual excitement where it is needed most. Although the material was entered by categories to try and cover as wide a range as possible, it was judged primarily for its impact, typographic qualities and visual excitement. Throughout the entire exhibit the effects were achieved by the tasteful use of one or more of the following characteristics:

1. *Contrast of size* — extremely large letter forms used with small sizes create visual excitement because our eyes are accustomed to see reading matter without much contrast. Normal contrast in size is easy for the eye to see, however extreme contrasts are unusual.

2. *Contrast of direction* — horizontal opposed to vertical; also, condensed faces create a vertical line while extended faces cause a horizontal movement.

3. *Contrast of tone value* — here again, extreme contrast is used to obtain visual shock, something very black contrasting something very light sets up visual extremes.

4. *Contrast of space* — the blank space in contrast to the type elements is a subtle way to help achieve a visual shock.

5. *Contrast of type forms* — the use of a rigid mechanical type such as a gothic in combination with a smooth flowing italic or script.

6. *Contrast of color* — large areas of dark value used with small quantities of a brilliant color, or the play of pastel shades in contrast to large areas of dark values. The overprinting of colors is a way to create visual shock.

7. *Contrast of type with illustration* — light illustrations used with dark areas of type and unusual integration of type with illustrations.

THIRD ANNUAL
AWARDS
FOR TYPOGRAPHIC
DESIGN EXCELLENCE

The panel of judges include:
Chairman, MAHLON A. CLINE
AARON BURNS
FREEMAN CRAW
GLENN FOSS
EDWARD GOTTSCHALL
ARTHUR B. LEE
CLIFTON LINE
ALEXANDER NESBITT
HERBERT ROAN

Record Album Cover by Saul Bass
for Capitol Records.

Record Album Cover by Robert M. Jones
for RCA Victor.

Certificate by Gene Frederico for
American Institute of Graphic Arts.

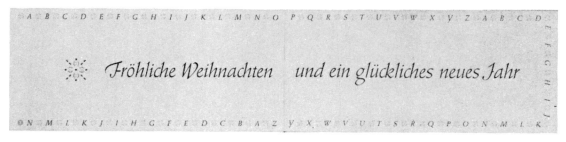

Booklet Keepsake by Bauer Alphabets.

296

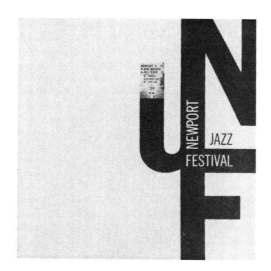

Cover for Record Booklet by
Ivan Chermayeff for Columbia Records.

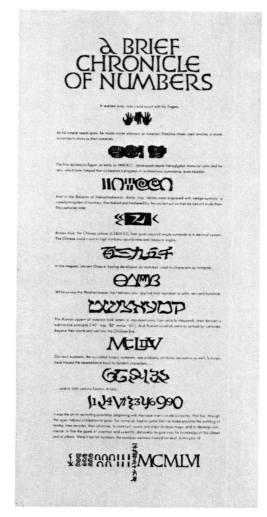

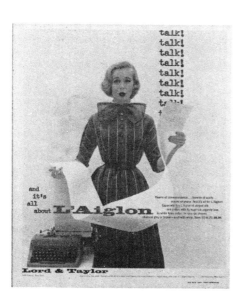

*Magazine ad by Gene Frederico (Douglas D.
Simon Advertising) for Lord & Taylor.*

*Keepsake by Aaron Burns and
Ellen Raskin for IBM.*

(Above and below) Newspaper advertisements by Arnold Varga for Cox's.

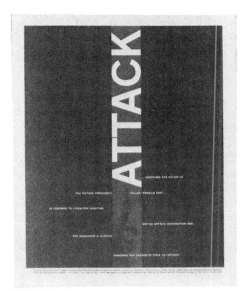

Magazine ad by Saul Bass for
United Artists Corporation.

Booklet by Freeman Craw (Tri-Arts Press)
for American Type Founders.

Record Album Cover by Robert M. Jones
for RCA Victor.

Direct Mail piece by George Tscherny
for C & I Art School.

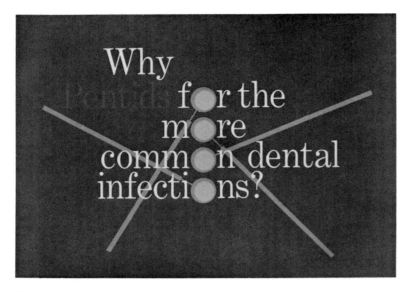

Direct Mail piece by
Herb Lubalin (Sudler & Hennessey)
for E. R. Squibb & Sons.

Poster by Bob Gill
for The Little Studio Ltd.

Record Album Cover by Robert M. Jones
for RCA Victor.

Direct Mail piece by Herb Lubalin and
John Graham for NBC Television.

Direct Mail post card by
Peter Palazzo for I. Miller.

Advertisement by Herb Lubalin
(Sudler & Hennessey) for Ciba.

Direct Mail folder by Herb Lubalin
(Sudler & Hennessey) for Upjohn.

Direct Mail booklet cover
by Hy Farber.

Announcement folder by Bob Gill.

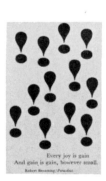

Greeting Card
by Hap Smith.

Direct Mail card by Gene Frederico for William Helburn.

Magazine ad by Louis Danziger
for Gelvatex Coatings Corporation.

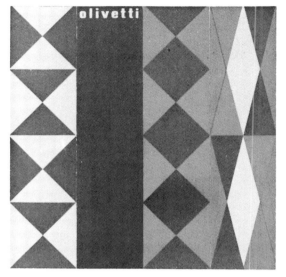

Invitation folder printed by Davis-Delaney for Olivetti.

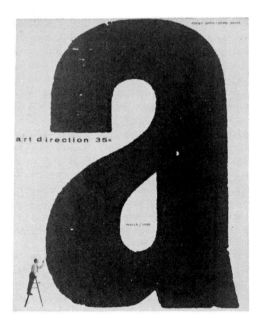

Magazine Cover by Norman Gollin
for Art Direction Magazine.

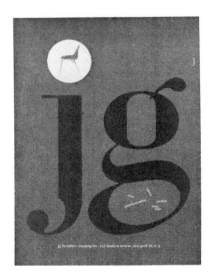

Magazine ad by George Tscherny
for J. G. Furniture Co.

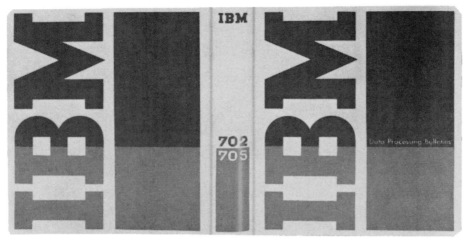

Catalog Binder cover by Paul Rand for IBM.

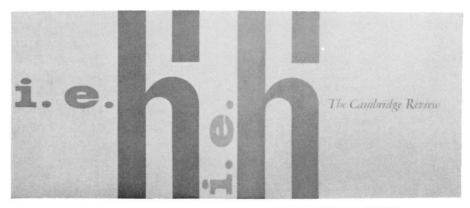

Poster and Magazine Cover by Ivan Chermayeff for The Cambridge Review.

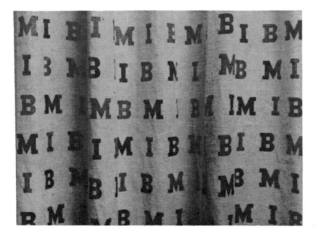

Drapes designed by Paul Rand for IBM.

Letterhead, Envelope and Card by
James S. Ward (Peter Quay Yang Associates)

Advertisement by Louis Dorfsman for CBS Radio.

Letterhead and Envelope
by Robert Nelson
for XP Student Council,
Augsburg College.

Letterhead and Envelope
by Ivan Chermayeff.

Magazine ad by Bob Farber (Irving
Serwer Co., Inc.) for Tish-u-Knit.

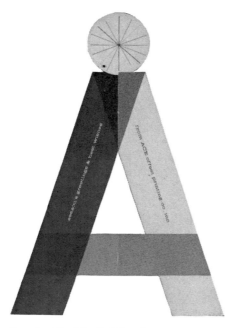

Greeting Card by Cal Freedman (Cal Art & Associates) for Ace Offset Printing Co.

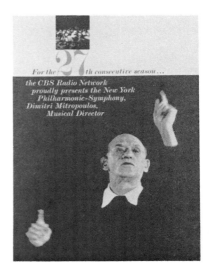

Magazine ads by Will Burtin for American Type Founders.

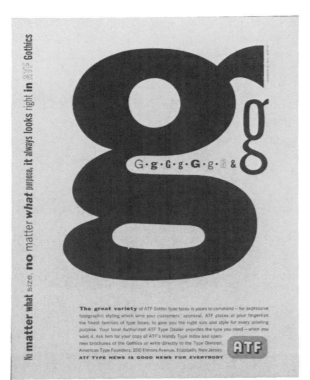

Magazine ad by Louis Dorfsman for CBS Radio.

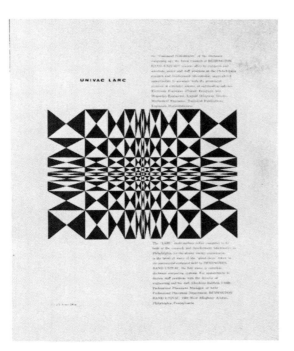

Magazine ad by Mel Richman Inc.
for Remington Rand Univac.

Booklet by Ted Bergman and
Mordecai R. Craig (James Eng Assoc.)
for Purdue Frederick Co.

Exhibition Catalog by Helen Frederico
for Museum of Modern Art.

Trade ad by Allen Porter
for Carroll Sagar & Associates.

*Letterhead, Envelope and Card
by Schroeder-Lewis.*

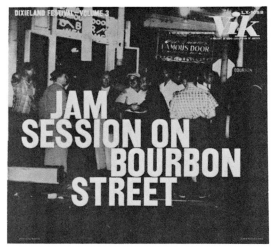

*Record Album Cover by Acy Lehman
for Radio Corporation of America.*

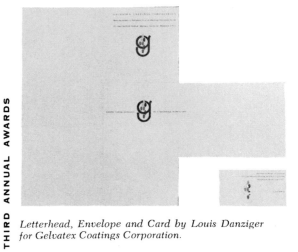

*Letterhead, Envelope and Card by Louis Danziger
for Gelvatex Coatings Corporation.*

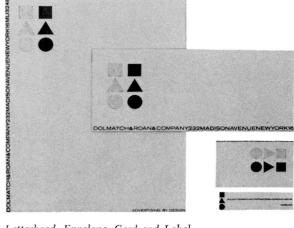

*Letterhead, Envelope, Card and Label
by Herbert Roan (Dolmatch & Roan & Co.)*

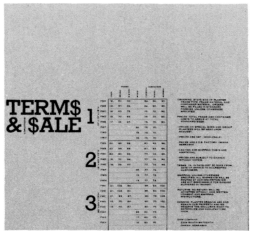

*Direct Mail folder by Robert Nelson
for Daw Company.*

*Letterhead, Envelope and Business
Forms by Morton Goldshall.*

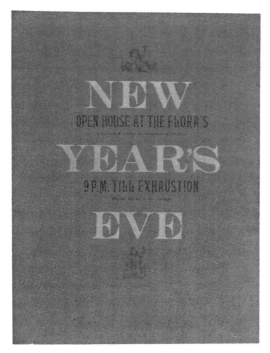
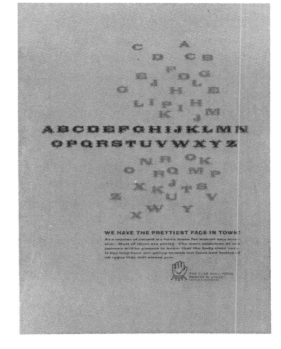

Announcements by Robert M. Jones for The Glad Hand Press.

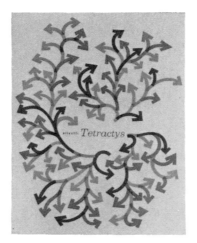

*Folder printed by
Davis-Delaney for Olivetti.*

*Magazine Cover by John Massey
for the Water Well Journal.*

*Program booklet by A. Richard DeNatale
for Reynolds Metals Company.*

*Magazine ad by Louis Danziger
for Advertising Composition Co.*

*Letterhead and Envelope by Jerome Gould
for Gould and Associates.*

*Poster and Magazine Cover
by Ivan Chermayeff for
The Cambridge Review.*

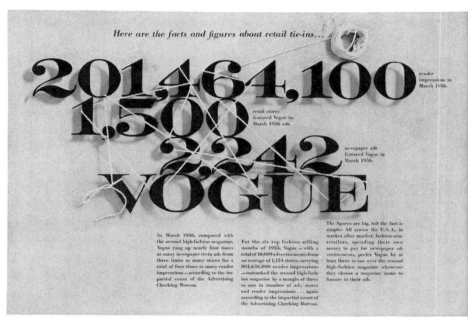

Magazine ad by Richard Loew for Vogue Magazine.

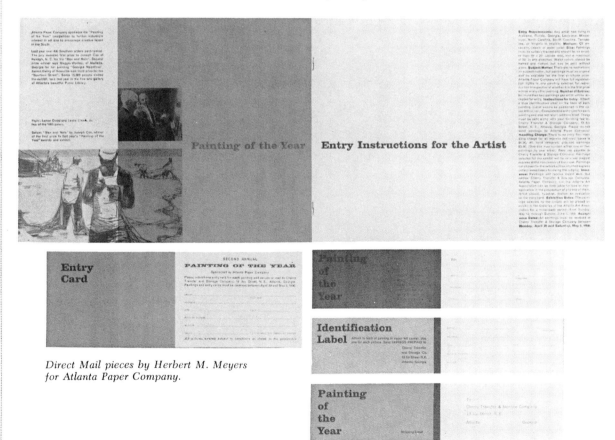

Direct Mail pieces by Herbert M. Meyers for Atlanta Paper Company.

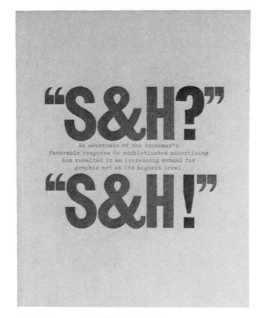

Advertisement by Herb Lubalin
for Sudler & Hennessey.

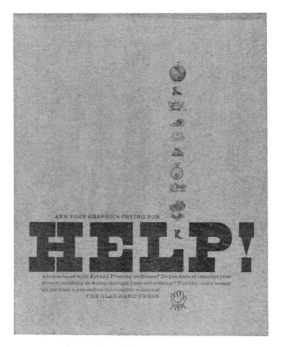

Direct Mail piece by Robert M. Jones
for The Glad Hand Press.

Direct Mail card by
Allen Lazaroff for
11th Annual West Coast Exhibition
of Advertising and Editorial Art.

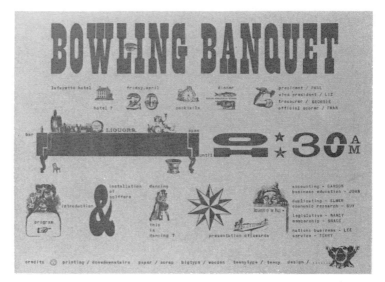

Special occasion piece by Asdur Takakjian for Nation's Business.

*Letterheads, Envelopes and Business
Stationery by Louis Danziger
for Kittleson Company.*

*Catalog Cover by Design Department
of Corning Glass Works.*

*Direct Mail cards by Herbert M. Meyers
for 5th Annual Exhibition of
Advertising and Editorial Art.*

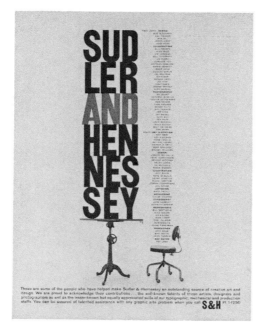

Advertisement by Herb Lubalin
for Sudler & Hennessey.

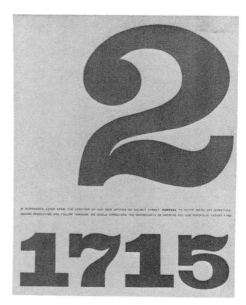

Direct Mail piece by Schroeder-Lewis.

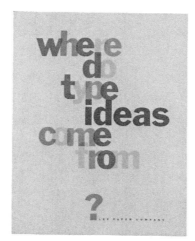

Direct Mail folder by Morton Goldshall
for Lee Paper Company.

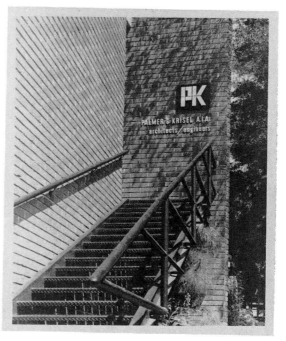

Architectural sign by Allen Porter
for Palmer & Krisel.

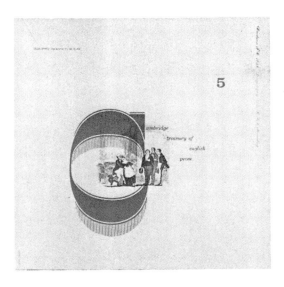

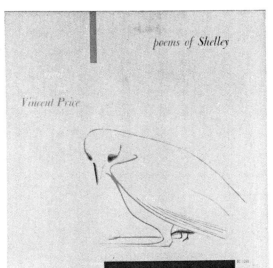

Record Album Covers by Matthew Leibowitz.

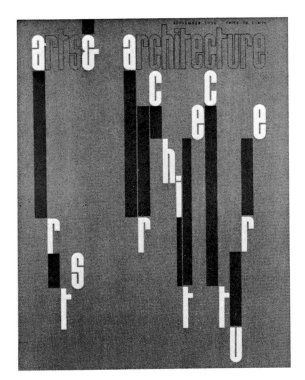

Magazine Cover by Charles Kratka
for Arts and Architecture.

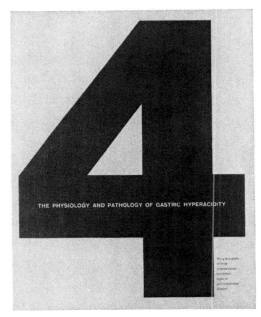

Direct Mail folder by Herb Lubalin
(Sudler & Hennessey) for Wm. S. Merrell Co.

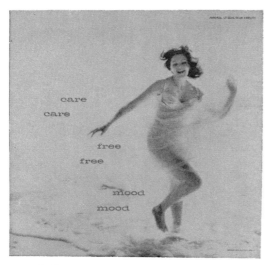

Record Album Cover by
Norman Gollin and Don Ornitz
for Imperial Records.

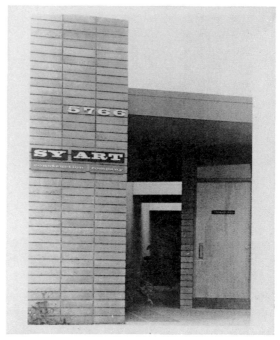

Architectural Sign by
Allen Porter and Fred Usher
for Sy Art Construction Co.

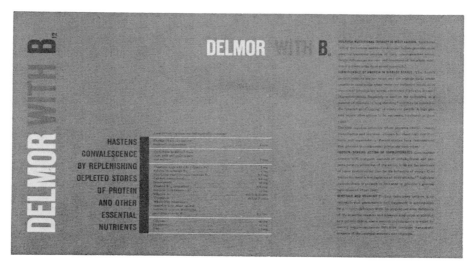

Direct Mail folder by Roy Kuhlman (Sudler & Hennessey) for Merck, Sharp & Dohme.

*Editorial pages by Henry Wolf
for Esquire Magazine.*

*Magazine editorial pages by
Will Burtin for The Upjohn Co.*

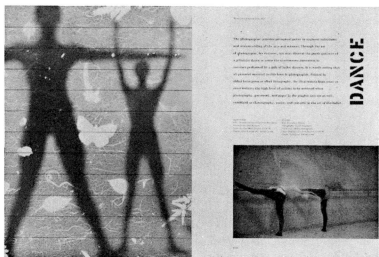

*House magazine pages by
Bradbury Thompson for
Westvaco Inspirations.*

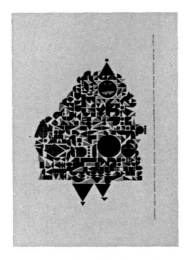

*Christmas card by Marilyn and
John Neuhart for The Hand Press.*

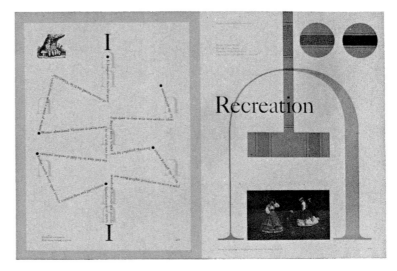

House magazine pages by Bradbury Thompson for Westvaco Inspirations.

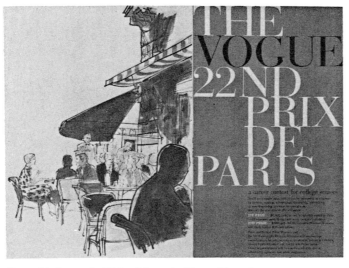

Direct Mail piece by Richard Loew for Vogue Magazine.

*Announcement card by
Marilyn and John Neuhart
for The Hand Press.*

*Architectural Sign by
Lee and Adrian Lozano.*

Design	ARTHUR B. LEE
TDC Emblem	HAL ZAMBONI
Typography	THE COMPOSING ROOM
	TUDOR TYPOGRAPHERS
	BAUER ALPHABETS
Type Faces	HORIZON LIGHT, CALEDONIA,
	COPPERPLATE GOTHIC BOLD
Printing	THE LENMORE PRESS
Paper	ARTEMIS COVER AND SUPERFINE
	TEXT BY MOHAWK

Membership List:

ARNOLD BANK
AMOS G. BETHKE
IRWIN L. BOGIN
BERNARD BRUSSEL-SMITH
AARON BURNS
WILL BURTIN
BURTON CHERRY
TRAVIS CLIETT
MAHLON A. CLINE
FREEMAN CRAW
MARTIN CONNELL
EUGENE DE LOPATECKI
O. ALFRED DICKMAN
LOUIS DORFSMAN
GENE DUNN
EUGENE M. ETTENBERG
GENE FEDERICO
SIDNEY FEINBERG
CHARLES J. FELTEN
BRUCE FITZGERALD
GLENN FOSS
TED F. GENSAMER
VINCENT GIANNONE
LOUIS L. GLASSHEIM
WILLIAM P. GLEASON
EDWARD M. GOTTSCHALL
HOLLIS W. HOLLAND
HAROLD HORMAN
EDWARD N. JENKS
RANDOLPH R. KARCH
EMIL J. KLUMPP
EDWIN B. KOLSBY
RAY KONRAD
ARTHUR B. LEE
CLIFTON LINE
GILLIS L. LONG
MELVIN LOOS
JOHN H. LORD

HERB LUBALIN
EDGAR J. MALECKI
FRANK MERRIMAN
FRANCIS MONACO
ROSS MORRIS
TOBIAS MOSS
LOUIS A. MUSTO
ARIOSTO NARDOZZI
ALEXANDER NESBITT
GERARD J. O'NEILL
JERRY O'ROURKE
DR. G. W. OVINK
EUGENE P. PATTBERG
WILLIAM PENKALO
JAN VAN DER PLOEG
GEORGE A. PODORSON
FRANK E. POWERS
ERNEST REICHL
HERBERT ROAN
EDWARD RONDTHALER
FRANK ROSSI
GUSTAVE L. SAELENS
WILLIAM H. SCHULZE
JAMES SECREST
WILLIAM L. SEKULER
EDWIN W. SHAAR
HERBERT STOLTZ
WILLIAM A. STREEVER
DAVID B. TASLER
WILLIAM TAUBIN
GEORGE F. TRENHOLM
ABRAHAM A. VERSH
MEYER WAGMAN
STEVENS L. WATTS
JOSEPH F. WEILER
HERMANN ZAPF
HAL ZAMBONI
MILTON K. ZUDECK

Sustaining Members:

ADVERTISING AGENCIES SERVICE COMPANY INC.

THE COMPOSING ROOM INC.

ELECTROGRAPHIC CORPORATION

SUPERIOR TYPOGRAPHY INC.

WESCOTT AND THOMSON INC.

TUDOR TYPOGRAPHERS

ATLANTIC ELECTROTYPE & STEREOTYPE COMPANY

STERLING ENGRAVING COMPANY

MOHAWK PAPER COMPANY

A. T. EDWARDS TYPOGRAPHY, INC.

AMSTERDAM CONTINENTAL TYPES AND
 GRAPHIC EQUIPMENT INC.

TDC OFFICERS, MEMBERS, AND INDEXES

TDC OFFICERS

BOARD OF DIRECTORS 2005/2006

OFFICERS

President
Gary Munch
Munchfonts

Vice President
Alex W. White
Alexander W. White Art Direction

Secretary/Treasurer
Charles Nix
Scott & Nix, Inc.

Directors-at-Large
Christopher Andreola
adcStudio

Matteo Bologna
Mucca Design

Graham Clifford
Graham Clifford Design

Ted Mauseth
Mauseth Design LLC

Susan L. Mitchell
Farrar Straus & Giroux

Diego Vainesman
MJM Creative Services

Maxim Zhukov

Chairman of the Board
James Montalbano
Terminal Design, Inc.

Executive Director
Carol Wahler

BOARD OF DIRECTORS 2006/2007

OFFICERS

President
Alex W. White
Alexander W. White Art Direction

Vice President
Charles Nix
Scott & Nix, Inc.

Secretary/Treasurer
Diego Vainesman
MJM Creative Services

Directors-at-Large
Christopher Andreola
adcStudio

Matteo Bologna
Mucca Design

Graham Clifford
Graham Clifford Design

Ted Mauseth
Mauseth Design LLC

Chad Roberts
Louise Fili, Ltd.

Ann Twomey
Hachette Book Group USA

Maxim Zhukov

Chairman of the Board
Gary Munch
Munchfonts

Executive Director
Carol Wahler

COMMITTEE FOR TDC52

Chairman
Diego Vainesman

Designer
Andrew Kner

Associate Designer
Michele L. Trombley

Coordinator
Carol Wahler

Assistants to Judges
Chris Andreola, Peter Bain, Lilian Citron, Deborah Gonet, Aaron Knapp, Nana Kobayashi, Mike Krol, Ted Mauseth, Gary Munch, Omar Mvra, Daniel Pelavin, Travis Simon, Bruno Toporowsky, Allan R. Wahler, Alex W. White, and Maxim Zhukov

TYPE DIRECTORS CLUB

127 West 25 Street
8th Floor
New York, NY 10001
212-633-8943 Fax: 212-633-8944
E-mail: director@tdc.org
www.tdc.org

Carol Wahler,
Executive Director

For membership information please contact the Type Directors Club office.

TYPE DIRECTORS CLUB PRESIDENTS

Frank Powers, *1946, 1947*
Milton Zudeck, *1948*
Alfred Dickman, *1949*
Joseph Weiler, *1950*
James Secrest, *1951, 1952, 1953*
Gustave Saelens, *1954, 1955*
Arthur Lee, *1956, 1957*
Martin Connell, *1958*
James Secrest, *1959, 1960*
Frank Powers, *1961, 1962*
Milton Zudeck, *1963, 1964*
Gene Ettenberg, *1965, 1966*
Edward Gottschall, *1967, 1968*
Saadyah Maximon, *1969*
Louis Lepis, *1970, 1971*
Gerard O'Neill, *1972, 1973*
Zoltan Kiss, *1974, 1975*
Roy Zucca, *1976, 1977*
William Streever, *1978, 1979*
Bonnie Hazelton, *1980, 1981*
Jack George Tauss, *1982, 1983*
Klaus F. Schmidt, *1984, 1985*
John Luke, *1986, 1987*
Jack Odette, *1988, 1989*
Ed Benguiat, *1990, 1991*
Allan Haley, *1992, 1993*
B. Martin Pedersen, *1994, 1995*
Mara Kurtz, *1996, 1997*
Mark Solsburg, *1998, 1999*
Daniel Pelavin, *2000, 2001*
James Montalbano, *2002, 2003*
Gary Munch, *2004, 2005*
Alex W. White. *2006*

TDC MEDAL RECIPIENTS

Hermann Zapf, *1967*
R. Hunter Middleton, *1968*
Frank Powers, *1971*
Dr. Robert Leslie, *1972*
Edward Rondthaler, *1975*
Arnold Bank, *1979*
Georg Trump, *1982*
Paul Standard, *1983*
Herb Lubalin, *1984 (posthumously)*
Paul Rand, *1984*
Aaron Burns, *1985*
Bradbury Thompson, *1986*
Adrian Frutiger, *1987*
Freeman Craw, *1988*
Ed Benguiat, *1989*
Gene Federico, *1991*
Lou Dorfsman, *1995*
Matthew Carter, *1997*
Rolling Stone magazine, *1997*
Colin Brignall, *2000*
Günter Gerhard Lange, *2000*
Martin Solomon, *2003*
Paula Scher, *2006*

SPECIAL CITATIONS TO TDC MEMBERS

Edward Gottschall, *1955*
Freeman Craw, *1968*
James Secrest, *1974*
Olaf Leu, *1984, 1990*
William Streever, *1984*
Klaus F. Schmidt, *1985*
John Luke, *1987*
Jack Odette, *1989*

2006 SCHOLARSHIP RECIPIENTS

Melanie Duarte
Maine College of Art

Wei Lieh Lee
School of Visual Arts

Poliana Kirst
Fashion Institute of Technology

Louise Ma
The Cooper Union

Adam Mignanelli
Parsons School of Design

Mitja Miklavčič
University of Reading, UK

Eric Wrenn,
Pratt Institute

2006 STUDENT AWARD WINNERS

First Place ($500)
Daniel Janssen *(University of Applied Sciences Hamburg, Germany)*

Second Place ($300)
Ryan Feerer *(School of Visual Arts, New York)*

Third Place ($200)
Peter Brugger *(Hochschule Pforzheim, Germany)*

INTERNATIONAL LIAISON

Chairpersons
ENGLAND
David Farey
HouseStyle
27 Chestnut Drive
Bexleyheath
Kent DA7 4EW

FRANCE
Christopher Dubber
Signum Art
94, Avenue Victor Hugo
94100 Saint Maur Des Fosses

GERMANY
Bertram Schmidt-Friderichs
Verlag Hermann Schmidt
Mainz GmbH & Co.
Robert Koch Strasse 8
Postfach 42 07 28
55129 Mainz Hechtsheim

JAPAN
Zempaku Suzuki
Japan Typography Association
Sanukin Bldg. 5 Fl.
1-7-10 Nihonbashi-honcho
Chuo-ku, Toyko 104-0041

MEXICO
Prof. Felix Beltran
Apartado de Correos
M 10733 Mexico 06000

SOUTH AMERICA
Diego Vainesman
181 East 93 Street, Apt. 4E
New York, NY 10128

SWITZERLAND
Erich Alb
Lindenbuehl 33
CH 6330 Cham

VIETNAM
Richard Moore
21 Bond Street
New York, NY 10012

TDC MEMBERSHIP

Saad Abulhab '04
Marcelle Accardi '98s
Christian Acker '02
Pete Aguanno '06
Masood Ahmed '06s
Erich Alb '96
Sallie Reynolds Allen '06
Natascha Ampunant '02
Jack Anderson '96
Gabriela Varela Andrade '05
Lück Andreas '06
Christopher Andreola '03
Debi Ani '01
Martyn Anstice '92
Pratima Aravabhoomi '06s
J.R. Arebalo, Jr. '03
Don Ariev '98
Robyn Attaway '93
Bob Aufuldish '06
Levi Bahn '06a
George Baier IV '04s
Peter Bain '86
Bruce Balkin '92
Juergen Bamberg '04
Stephen Banham '95
Jennifer Bankenstein '05
Joshua Bankes '06
Neil Barnett '01
Frank Baseman '03
Mark Batty '03
Anna Bauer '05s
Barbara Baumann '96
Gerd Baumann '95
Greg Beechler '05s
Sofie Beier '06s
Paul Belford '05
Felix Beltran '88
Ed Benguiat '64
Kai Bergmann '06
Anna Berkenbusch '89
William Berkson '06
John D. Berry '96
Peter Bertolami '69
Marianne Besch '06
Davide Bevilacqua '99
Tadeusz Biernot '00
Klaus Bietz '93
Henrik Birkvig '96
R. P. Bissland '04

Roger Black '80
Linda Blackwell Bently '05
Marc Blaustein '01
Claas Blüher '01
Anders Bodebeck '04
Christine Boerdner '06
Matteo Bologna '03
Teresa Bonner '05
Gianni Bortolotti '98
Rachel Bosley '06s
Thad Boss '01
Brandt Brinkerhoff '05s
Ed Brodsky '80
Craig Brown '04
Johannes Bruckner '05s
Bill Bundzak '64
David Cabianca '05
Chase Campbell '06s
Mike Campbell '04
Ronn Campisi '88
Aaron Carambula '05
William Carlson '06s
Ingrid Carozzi '06s
Scott Carslake '01
Matthew Carter '88
Ken Cato '88
Eduard Cehovin '03
Virginia Chan '00s
Florence Chapman '06s
Len Cheeseman '93
Eric Ping-Liang Chen '04
Jeff Chen '02s
David Cheung, Jr. '98
Kai-Yan Choi '90
Johng Won Choi '05s
Hyun Joo Choi '06s
Crystal Chou '06s
Seungmin Chung '03s
Stanley Church '97
Traci Churchill '06
Nicholas Cintron '03s
Alicia Clarens '05
Travis Cliett '53
Graham Clifford '98
Tom Cocozza '76
Stuart Cohen '96
Kathleen Cole '05s
Angelo Colella '90
Ed Colker '83

Nick Cooke '01
Heather Corcoran '05
Rodrigo Corral '02
Madeleine Corson '96
Fabio Costa '03
Susan Cotler-Block '89
Kristin Cox '05s
Daniel Coyne '05a
James Craig '04
Freeman Craw* '47
Martin Crockatt '02
Laura Crookston-Deleot '00
Andeeas Croonenbroeck '06
Bart Crosby '95
Matthew Crow '06
Ray Cruz '99
Brian Cunningham '96
Rick Cusick '89
Susan Darbyshire '87
Giorgio Davanzo '06
Einat Lisa Day '97s
Filip De Baudringhien '03
Josanne De Natale '86
Roberto de Vicq de Cumptich '05
Matej Decko '93
Kymberly DeGenaro '06
Olivier Delhaye '06
Liz DeLuna '05
Alfonso Demetz '06
Richard R. Dendy '00
Mark Denton '01
James DeVries '05
N. Cameron deZevallos '06s
Cara DiEdwardo '06
Chank Diesel '05
Claude A. Dieterich '84
Kirsten Dietz '00
Joseph DiGioia '96
Sandra DiPasqua '04
Sebastian Doerken '05s
Lou Dorfsman '54
Dino Dos Santos '04
Bill Douglas '06
Pascale Dovic '97
Stephen Doyle '98
Christopher Dubber '85
Claus Due '05
Joseph P. Duffy III '03
Tim Duke '05s

Kim Duksoo '04s
Denis Dulude '04
Arem Duplessis '06
Simon Dwelly '98
Lutz Dziarnowski '92
Lasko Dzurovski '00
Don Easdon '05
Beau Eaton '05s
Dayna Elefant '06
Elizabeth Elsas '05
Garry Emery '93
Stefan Engelhardt '01
HC Ericson '01
Joseph Michael Essex '78
Manuel Estrada '05
Florence Everett '89
Peter Fahrni '93
John R. Falker '00
David Farey '93
Saied Farisi '06
Matt Ferranto '04
Debra Ferrer '05
Mark Fertig '04
Robert Festino '05
Vicente Gil Filho '02
Louise Fili '04
Simon Fitton '94
Kristine Fitzgerald '90
Julie Flahiff '04
Marie Flores '05s
Gonçalo Fonseca '93
John Fontana '04
James Ford '05s
Lorraine Forte '05
Carin Fortin '02
Dirk Fowler '03
Thomas Fowler '93
Mark Fox '06
Alessandro Franchini '96
Laura Franz '06
Carol Freed '87
Ryan Pescatore Frisk '04s
Janet Froelich '06
Adrian Frutiger ** '67
Jason Fryer '04s
Takayoshi Fujimoto '06s
Kyoto Fukuma '05s
Kenny Funk '05
Louis Gagnon '02

Ohsugi Gaku '01
David Gallo '06s
Paul Garbett '05
Catalina Garcia '03s
Christof Gassner '90
Martina Gates '96s
David Gatti '81
Wolfgang Geramb '06
Pepe Gimeno '01
Lou Glassheim * '47
Howard Glener '77
Mario Godbout '02
Giuliano Cesar Gonçalves '01
Deborah Gonet '05
Carole Goodman '06
Edward Gottschall '52
Mark Gowing '06
Norman Graber '69
Diana Graham '85
Austin Grandjean '59
Marion Grant '04s
Katheryne Gray '04
Stephen Green '97
Virgina Green '05s
Ramon Grendene '06s
Simon Grendene '02s
James Grieshaber '96
Rosanne Guararra '92
Christine Gude '97
Nora Gummert-Hauser '06
Matthias Gunkel '05
Ramiz Guseynov '04
Einar Gylfason '95
Peter Gyllan '97
Tomi Haaparanta '01
Brock Haldeman '02
Allan Haley '78
Debra Hall '96
Angelica Hamann '03
Dawn Hancock '03
Graham Hanson '04
Egil Haraldsen '00
Rachel Hardy '06s
Keith Harris '98
Knut Hartmann '85
Lukas Hartmann '03
Williams Hastings '05s
Diane Hawkins '04
William Hayden '05s

Luke Hayman '06
Bonnie Hazelton '75
Amy Hecht '01
Eric Heiman '02
Arne Heine '00
Hayes Henderson '03
Michael Hendrx '06
Rebecca Henretta '05s
Bosco Hernandez '05
Earl M. Herrick '96
Ralf Hermannn '02s
Klaus Hesse '95
Darren Hewitson '05s
Fons M. Hickmann '96
Jay Higgins '88
Cheryl Hills '02
Helmut Himmler '96
Kit Hinrichs '04
Norihiko Hirata '96
Michael Hodgson '89
Robert Hoffman '05s
Fritz Hofrichter '80
Michael Hoinkes '06
David Hollingsworth '03a
Clark Hook '06
Amy Hooper '05
Kevin Horvath '87
Fabian Hotz '01
Diana Hrisinko '01
Christian Hruschka '05
Yuonheng Hsu '05s
Anton Huber '01
Jack Huber '06
John Hudson '04
Simon Huke '05s
Randy Hunt '06s
Dennis Y Ichiyama '06
Mariko Iizuka '05
Yanek Iontef '00
Alexander Isley '05
Donald Jackson ** '78
Alanna Jacobs '05
Ed Jacobus '03
Michael Jager '94
Torsten Jahnke '02
Preeti Jalan '05s
Aleksi Jalonen '05s
Mark Jamra '99
Jennifer Jerde '06

Jenny Ji '04s
Giovanni Jubert '04s
William Jurewicz '04
John Kallio '96
Stefan Kalscheid '06s
Tai-Keung Kan '97
I-Ching Kao '02
Diti Katona '06
Carolyn Keer '06
Richard Kegler '02
Brunnette Kenan '99
Russell Kerr '05s
Habib Khoury '06
Ben Kiel '06
Satohiro Kikutake '02
Yeon Jung Kim '05
Yong Keun Kim '05s
Rick King '93
Katsuhiro Kinoshita '02
Nathalie Kirsheh '04
Rhinnan Kith '01s
Arne Alexander Klett '05
Akira Kobayashi '99
Nana Kobayashi '94
Claus Koch '96
Boris Kochan '02
Masayoshi Kodaira '02
Jesse Taylor Koechling '98s
Jonny Kofoed '05
Steve Kopec '74
Damian Kowal '05
Marcus Kraus '97
Matthias Kraus '02
Stephanie Kreber '01
Bernhard J. Kress '63
Ivan Krevolin '05s
Gregor Krisztian '05
Kewvin Krueger '06
Toshiyuki Kudo '00
Felix Kunkler '01
Christian Kunnert '97
James Kuo '05
Dominik Kyeck '02
Gerry L'Orange '91
Raymond F. Laccetti '87
Ying Ching Lai '06s
Ellen Lampl '05
Melchior Lamy '01
John Langdon '93

Guenter Gerhard Lange '83
Jean Larcher '01
Marcia Lausen '05
Amanda Lawrence '06
Christine Lee '02s
Jee-Eun Lee '05s
Julianna Lee '04
Wei Lieh Lee '05s
Jennifer Lee-Temple '03
Pum Lefebure '06
Elizabeth Leih '05s
David Lemon '95
Jean-Paul Leonard '06
Olaf Leu '65
Joshua Levi '06
Howard Levine '05
Laura Lindgren '05
Jan Lindquist '01
J. Nils Lindstrom '06
Christine Linnehan-Sununu '04
Domenic Lippa '04
Wally Littman '60
Uwe Loesch '96
Oliver Lohrengel '04
John Howland Lord ** '47
Christopher Lozos '05
Alexander Luckow '94
Frank Luedicke '99
Gregg Lukasiewicz '90
Danusch Mahmoudi '01
Boris Mahovac '04
Donna Meadow Manier '99
Marilyn Marcus '79
Peter Markatos '03s
Nicolas Markwald '02
Gabriel Meave Martinez '01
Rammer Martinez '05s
Magui Martinez-Pena '05
Vanessa Marzaroli '06
Shigeru Masaki '06
Maurizio Masi '05
Christopher Masonga '03s
Steve Matteson '06
Ted Mauseth '01
Andreas Maxbauer '95
Loie Maxwell '04
Trevett McCandliss '04
Rod McDonald '95
Mark McGarry '02

Joshua McGrew '05s
Kelly McMurray '03
Marc A. Meadows '96
Matevz Medja '02
Roland Mehler '92
Uwe Melichar '00
Bob Mellett '03s
Francesa Messina '01
Frédéric Metz '85
JD Michaels '03
Joe Miller '02
Ron Miller '02
John Milligan '78
Jennifer Miraflor '06s
Elena Miranda '05
Michael Miranda '84
Ralf Mischnick '98
Susan L. Mitchell '96
Bernd Moellenstaedt '01
Preeti Monga '05
Sakol Mongkolkasetarin '95
Stephanie Mongon '05s
James Montalbano '93
Richard Earl Moore '82
Minoru Morita '75
Jimmy Moss '04
Emmaniel Mousis '05s
Kirk Mueller '06s
Lars Müller '97
Joachim Müller-Lancé '95
Gary Munch '97
Matthew Munoz '04
Claire Murphy '05
Jerry King Musser '88
Louis A. Musto '65
Steven Mykolyn '03
Cristiana Neri-Downey '97
James Nesbitt '06
Helmut Ness '99
Adam Neumann '05s
Nina Neusitzer '03s
Robert Newman '96
Vincent Ng '04
Charles Nix '00
Shuichi Nogami '97
Gertrud Nolte '01s
Alexa Nosal '87
Beth Novitsky '06
Tim Oakley '06

Robb Ogle '04
Wakako Okamoto '06s
Ezidinma Okeke '05
Akio Okumara '96
Robson Oliveira '02
Jourdanet Olivier '05
Toshihiro Onimaru '03
Andy Outis '06s
Petra Cerne Oven '02s
Robert Overholtzer '94
Michael Pacey '01
Jesse Packer '04s
Frank Paganucci '85
Amy Papaelias '05s
Stavros Papandreou '05s
Anthony Pappas '05
Enrique Pardo '99
Jim Parkinson '94
Donald Partyka '05
Guy Pask '97
Lilliana Passalacqua '05s
Dennis Pasternak '06
Gudrun Pawelke '96
Lauren Payne '04
David Peacock '06s
Harry Pearce '04
Daniel Pelavin '92
Tamaye Perry '05
Giorgio Pesce '05
Steve Peter '04
Oanh Pham-Phu '96
Frank Philippin '06
Max Phillips '00
David Philpott '04
Clive Piercy '96
Ian Pilbeam '99
Michael James Pinto '05
Johannes Pohlen '06s
J.H.M. Pohlen '06
Marcin Pokorski '05s
Bernhard Pompey '04s
Albert-Jan Pool '00
Tiffany Powell '05s
Will Powers '89
Kevin Pratt '05s
Vittorio Prina '88
James Propp '97
Chuck Queener '06
Jochen Raedeker '00

Erwin Raith '67
Mamta Rana '05
Sal Randazzo '97
Bob Rauchman '97
Robynne Raye '05
Byron Regej '05s
Heather L. Reitze '01
Renee Renfrow '04
James Reyman '05
Fabian Richter '01
Claudia Riedel '04s
Helge Dirk Rieder '03
Robert Rindler '95
Tobias Rink '02
Phillip Ritzenberg '97
Jose Rivera '01
Chad Roberts '01
Eva Roberts '05
Phoebe Robinson '02
Luis Roca '05
Salvador Romero '93
Edward Rondthaler* '47
Kurt Roscoe '93
Roy Rub '05s
Josh Rubinstein '06s
Giovanni Carrier Russo '03
Erkki Ruuhinen '86
Jason Ryals '05s
Timothy J. Ryan '96
Carol-Anne Ryce-Paul '01s
Michael Rylander '93
Greg Sadowski '01
Jonathan Sainsbury '05
Rehan Saiyed '06
Mamoun Sakkal '04
Ilja Sallacz '99
David Saltman '66
Ina Saltz '96
Ksenya Samarskaya '05s
Rodigo Sanchez '96
Michihito Sasaki '03
Nathan Savage '01
John Sayles '95
David Saylor '96
Nina Scerbo '06
Hartmut Schaarschmidt '01
David Schimmel '03
Peter Schlief '00s
Hermann J. Schlieper '87

Holger Schmidhuber '99
Hermann Schmidt '83
Klaus Schmidt '59
Christian Marc Schmidt '02s
Bertram Schmidt-Friderichs '89
Nick Schmitz '05s
Guido Schneider '03
Werner Schneider '87
Markus Schroeppel '03
Holger Schubert '06
Clemens Schulenburg '06
Eileen Hedy Schultz '85
Eckehart Schumacher-Gebler '85
Matthew Schwartz '05
Daniel Schweinzer '06s
Peter Scott '02
Leslie Segal '03
Enrico Sempi '97
Ronald Sequeira '04s
Thomas Serres '04
Patrick Seymour '06
Li Shaobo '04
Paul Shaw '87
Elizabeth Sheehan '03
Hyewon Shin '03s
Ginger Shore '03
Philip Shore, Jr. '92
Derek Shumate '05s
Robert Siegmund '01
France Simard '03
Mark Simkins '92
Scott Simmons '94
Todd Simmons '06
Leila Singleton '04
Martha Skogen '99
Pat Sloan '05
Sam Smidt '06
Sarah Smith '05
Steve Snider '04
Jan Solpera '85
Mark Solsburg '04
Brian Sooy '98
Peter Specht '06
Erik Spiekermann '88
Denise Spirito '02
Christoph Staehli '05
Frank Stahlberg '00
Rolf Staudt '84
Dimitris Stefanidis '06

Olaf Stein '96
Notburga Stelzer '02
Charles Stewart '92
Michael Stinson '05
Anke Stohlmann '06
Clifford Stoltze '03
Sumner Stone '05
Peter Storch '03
Lorna Stovall '05
William Streever '50
Ilene Strizver '88
Alison Stuerman '04s
Hansjorg Stulle '87
Derek Sussner '05
Zempaku Suzuki '92
Caroline Szeto '02s
Barbara Taff '05
Douglas Tait '98
Yukichi Takada '95
Yoshimaru Takahashi '96
Katsumi Tamura '03
Jack Tauss '75
Pat Taylor '85
Rob Taylor '04
Anthony J. Teano '62
Marcel Teine '03
Régine Thienhaus '96
Wayne Tidswell '96
Eric Tilley '95
Colin Tillyer '97
Siung Tjia '03
Alexander Tochilovsky '05
Laura Tolkow '96
Klemen Tominsek '05s
Jakob Trollbäck '04
Klaus Trommer '99
Niklaus Troxler '00
Minao Tsukada '00
Viviane Tubiana '05
Manfred Tuerk '00
Marc Tulke '00
François Turcotte '99
Michael Tutino '96
Anne Twomey '05
Andreas Uebele '02
Thomas Gerard Uhlein '05
Diego Vainesman '91
Patrick Vallée '99
Christine Van Bree '98

JanVan Der Ploeg '52
Jeefrey Vanlerberghe '05
Yuri Vargas '99
Brady Vest '05
Barbara Vick '04
Mathias Vietmeier '06
Anna Villano '99s
Robert Villanueva '02s
Prasart Virakul '05
Thilo von Debschitz '95
Frank Wagner '94
Oliver Wagner '01
Allan R. Wahler '98
Jurek Wajdowicz '80
Sergio Waksman '96
Garth Walker '92
Katsunori Watanabe '01
Steven W. Watson '06
Harald Weber '99
Kim Chun Wei '02
Eric Cai Shi Wei '06
Kurt Weidemann '66
Claus F. Weidmueller '97
Sylvia Weimer '01
Ramon Wengren '02
Marco Wenzel '02
Sharon Werner '04
Judy Wert '96
Alex W. White '93
Christopher Wiehl '03
Heinz Wild '96
Richard Wilde '93
James Williams '88
Steve Williams '05
Grant Windridge '00
Mike Winegardner '05
Carol Winer '94
Conny J.Winter '85
Delve Withrington '97
Burkhard Wittemeier '03
Pirco Wolfframm '03
Peter Wong '96
Willy Wong '06
Fred Woodward '95
René Wynands '04
Sarem Yadegari '03s
Erica Yamada '05s
Oscar Yañez '06
Henry Yee '06

Garson Yu '05
David Yun '04s
Christine Zangrilli '06s
Hermann Zapf ** '52
David Zauhar '01
Philip Zelnar '04s
Maxim Zhukov '96
Roy Zucca '69
Jeff Zwerner '97

SUSTAINING MEMBERS
Conair Corporation '06
Diwan Software '03
Hachette Book Group '05
Massholfer/Gutmayer '06
Pentagram Design, Inc., New York '04

* Charter member
** Honorary member
s Student member
a Associate member

Membership as of May 24, 2006

TYPE INDEX

General Index

Andrew Kner DESIGNER

Andrew Kner was born in Hungary, where his family has been involved in design and publishing since the 18th century. He came to the United States in 1940 at the age of 5, and received both his BA (1957) and his MFA (1959) from Yale University.

He worked in promotion design for Time, Inc., Esquire, *and* Look *magazine before joining* The New York Times *as Art Director for the Sunday Book Review. In 1970 he became Executive Art Director at* The New York Times *Promotion Department, a position he held until 1984 when he left to join Backer & Spielvogel as Senior Vice President, Creative Director for Sales Promotion. In 1990 he left to join RC Publications as Creative Director and Art Director of* Print *and* Scenario *magazines (he art directed* Print *on a freelance basis from 1963 to 1990). He left RC Publications in April of 2000 to freelance.*

He has won over 150 awards for design and art direction. Posters he has designed are part of the poster collections of MoMA, the Smithsonian and the Louvre.

He teaches Communication Design at Parsons School of Design and the Fashion Institute of Technology. He served as President of the New York Art Directors Club from 1983 until 1985.

Michele L. Trombley ASSOCIATE DESIGNER

Upon receiving her BFA in Graphic Design from the University of Michigan, Michele Trombley began her career as associate art director at Print *magazine. She also served as associate art director of* Scenario: The Magazine of Screenwriting Art. *Michele later worked as an art director for retailers J. Crew and The Limited Stores. Michele then returned to publishing and served as art director of* Grid *magazine, a commercial real estate publication. She is currently the Creative Director of ARRAY. Her freelance clients include:* Architecture *magazine, Barnes & Noble Publishing, The New York Art Directors Club, The Society of Illustrators, and The U.S. Department of Housing and Urban Development.*